# CURT SWAN
## A LIFE IN COMICS

by Eddy Zeno

Jeff Weigel · Graphic Design
J. David Spurlock · Editorial and Creative Direction

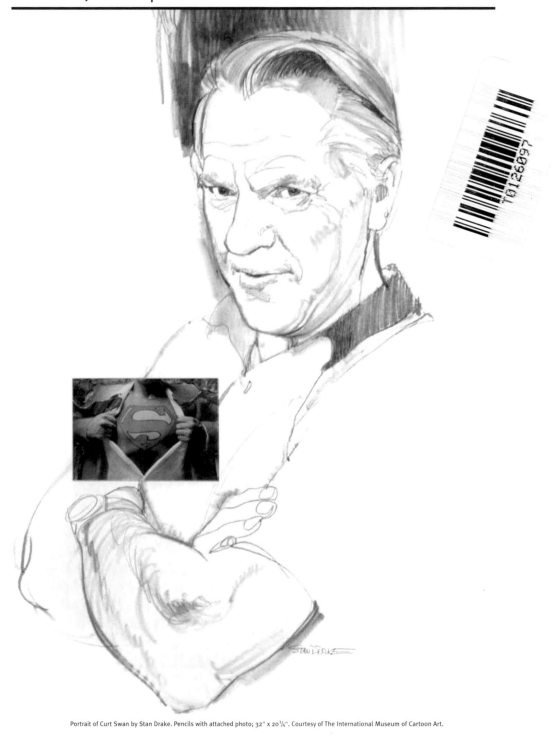

*Dedicated to :* Mitzi, Mallory and Katelyn; The Swan Family, in honor of Curt; and Jerry Siegel and Joe Shuster, for providing such a great character on which to work.

In memory of Norbert Zeno, born in the same year as Curt Swan. 1920 was a very good year.

---

## CURT SWAN: A LIFE IN COMICS

Hardcover edition ISBN 1-887591-39-7  $34.95
Limited Edition Deluxe S/N HC edition ISBN 1-887591-45-1  $49.95
Trade Paperback edition ISBN 1-887591-40-0  $19.95
Printed in China

# Acknowledgments

Very special thanks to the book's designer, Jeff Weigel, and to the author of the Curt Swan Index, Raul Wrona. Meeting one was serendipitous; meeting the other was premeditated on his part!

I'd been thinking about interviewing comic book artist Jeff Weigel, but probably would not have contacted him if I hadn't seen a representative of Big Bang Comics at a one-day minicon in October, 1999. Jeff had illustrated a few Curt Swan homages, including a recent cover for that title. Standing in front of the table of guest of honor Ramona Fradon that day, the gentleman from Big Bang was asking Ms. Fradon if she'd like to draw something for them. After they finished talk-ing, I asked the representative how I might contact this Weigel fellow, only to find out it was him. I've felt fortunate ever since to be associated with such a talented individual. Jeff has given generously of his time without thought of remu-neration so the profits from this book could go to charity. Besides designing the look of the book, he made numerous suggestions that improved the quality of the text.

Fellow Curt Swan fan Raul Wrona, on the other hand, had been looking for a way to contact me after reading an article which I'd written about Curt for Comics Buyer's Guide. The article appeared in December, 1995. Shortly after Swan passed away the following June, Raul wrote a moving letter of tribute for that same publication. He included his address in hopes that I'd respond. Sure enough, I eventually wrote to commend him for his letter and our friendship was finally established. We learned that we shared many things in common. For example, we initiated contact with Curt at virtually the same time in late 1979, and a few months later, we each received an original page of art from Action Comics #505 as a gift from the artist. Seeing this project reach fruition is a dream come true for us both.

Mark Waid deserves a round of thanks for his editorial assistance and for improving the accuracy of the Swan index, in addition to his valuable comments in the interview section. Also, my sincere gratitude to all of the following who contributed to this project in so many ways: Murphy and Helen Anderson, David Applegate, Cary Bates, Brian Bolland, Karin Swan Brooks, Mike Burkey, Jack Burnley, John Byrne, Mike Carlin, Gary Carlson, Gary and Lisa Carter, Mike Catron, Stephen Charla, Lisa Zeno Churgin, John Coates, Jon B. Cooke, Ken Danker, DC Comics, Inc., Hank Domzalski, Irwin Donenfeld, Shel Dorf, Mike Esposito, Jackie Estrada, European and Pacific Stars and Stripes Archives, Ron Fernandez, Kerry Gammill, Jim Hambrick, Mark Hanerfeld, Wally Harrington, Eugene Henderson, Dan Herman, Tom Horvitz, Dave Hunt, Carmine Infantino, International Museum of Cartoon Art, Tony Isabella, Dan Jurgens, Bill Janocha, Jim Kealy, Charles Kiley, Bob Koppany, Joe Kubert, Ron Lantz, Elliot S! Maggin, Jay Mampel, Roland Mann, Tom Mason, Karl Mattson, Ken McFarlane, Shelly Moldoff, Jim Mooney, Alan Moore, Richard Morrissey, Bob Oksner, Jerry Ordway, Roger Price, Dan Raspler, Charlie Roberts, Andy Rooney, Paul Ryan, Chuck Schadrack, Kurt and Dorothy Schaffenberger, Bill Schelly, Arlen Schumer, Julius Schwartz, Jim Shooter, David Siegel, Paul Spreckelmeyer, J. David Spurlock, Jerry Stephan, Roger Stern, The Supermuseum in Metropolis, Illinois, Chris Swan, Helene Swan, Cecilia Swan Swift, Roy Thomas, Maggie Thompson, Mort Walker, George Webb, Steven Weill, Len Wein, Al Williamson, Marv Wolfman, Michael Zeno.

# Contents:

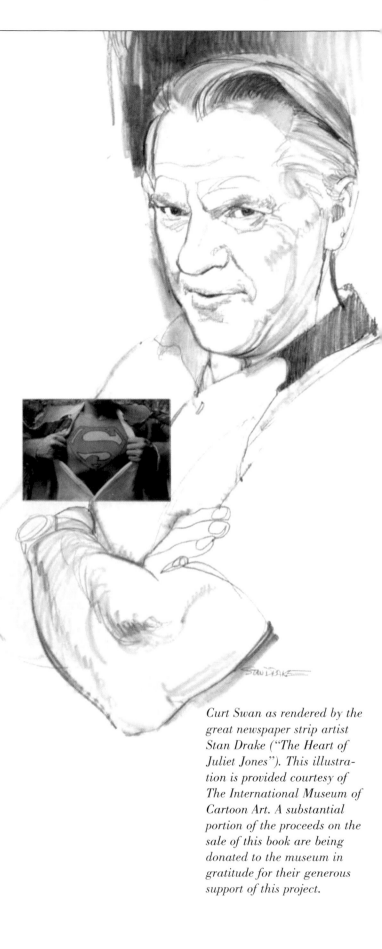

*Curt Swan as rendered by the great newspaper strip artist Stan Drake ("The Heart of Juliet Jones"). This illustration is provided courtesy of The International Museum of Cartoon Art. A substantial portion of the proceeds on the sale of this book are being donated to the museum in gratitude for their generous support of this project.*

# Foreword
## by Mort Walker

I am very happy to see this tribute to my old friend, Curt Swan. He was a very unique person who never got the rewards that his talent deserved. He was a farm boy who was largely self-taught, and I always thought his version of Superman was the most authentic and realistic ever done. I saw him through some triumphs and saw him struggle financially at times, turning to watercolors and other artwork to make ends meet when comic-book work was slow and hawking his old originals at comicons. I commiserated with him during his divorce, broken romances and poor golf scores, but he never lost his wonderful sense of manhood.

Curt was a very good man, honest, sympathetic, hard-working and generous. When I was courting my wife, Cathy, he lent me his home, leaving us a red rose to greet us at the front door.

I was writing a book once at the same time he had a lot of Superman work to do. We thought we'd get a lot

more work done if we got away from our families and friends, so we went to my condo in Vermont for a month. We would get up every morning at 5:00 and have breakfast. He'd work in his bedroom and I worked in the dining room till 3:00 p.m. Then we'd have a drink of scotch and go play golf. We'd get in around 7:00, have a scotch and dinner and go to bed at 9:00. We kept up this routine for 30 straight days until we got our work done. Never a sour note or a disagreement. What a good friend. It's an experience I'll never forget.

We continued to play golf and have fun together for many years... They found him peacefully lying in bed with comic-books around him.

The best anatomically correct Superman died with him.

Legendary cartoonist Mort Walker is creator of several successful, long-running comic strips, including *Beetle Bailey*. He is also the founder of the International Museum of Cartoon Art.

# Introduction

In this age of blaming others for everything, I'd like to blame former DC comic book editor Julius (Julie) Schwartz. It's his fault this book was not finished a lot sooner! Prior to our conversation, I thought it was enough to speak with a few pros and a couple of

*Curt Swan in 1969.*

Photo ©2002 Cartoonist Profiles

family members about Curt Swan. But Mr. Schwartz made me realize the need to interview writers of the material that Swan illustrated to learn if they were pleased with the way he interpreted their scripts. He showed me that I had not done enough research into the

World War II days, prior to the time that Curt got into comics. It became apparent that I had not explored his art and his life as thoroughly as it needed to be explored. Thanks to Mr. Schwartz, the interviews went from becoming a handful of sidebars to one of the major sections of the book. The other sections deal with career highlights, personal reminiscences and an index of Curt's comic book work. An attempt is made throughout to analyze why his art is so appealing.

As more people were contacted, a domino effect ensued. One person would suggest calling someone whom I was unaware had a relationship with Swan. When I didn't know how to reach certain individuals that were no longer working in comics, many of the interviewees would go out of their way to help locate them. Jerry Ordway, especially, was instrumental in this and in other matters. Special thanks are due Mort Walker, who never hesitated to help in any way that he could, and to Stephen Charla, curator of The International Museum of Cartoon Art, who told me of the existence of Stan Drake's portrait of Curt and offered its use. It was also a huge pleasure to be edited by some of the best pros in and out of comics, including Schwartz, Ordway, Joe Kubert, Charles Kiley and others whose conversations were transcribed and sent to them for approval.

Interestingly, you'll see how those interviewed often speak about the same critical junctures in Swan's life from different perspectives. The transcriptions are grouped

that way. There is a nice overview of Curt's long career, representing different eras. People that were contacted include those who met him during World War II and during each subsequent decade. There are insights into periods when Swan's style fell out of favor at DC and when he was having difficulty finding work. A few who barely spoke with or never met Curt shed light on the man by studying his art. Eventually, there came to be a good representation of those who were involved with Swan under a number of auspices, including: family, friends and golfing buddies, inkers, writers, bosses, and those whom he influenced artistically.

Because of his long career, which overlapped the careers of so many other comics professionals, it's important not to look at his work in isolation. The interviews reveal as much about the participants as they do about the subject of this book. They not only give a sense of Curt's history in the comics but a history of the comics themselves.

So why a book on Curt Swan? Being an unassuming guy, he himself would have been the first to ask that question if he were still alive. It is with that spirit that I'll try not to be grandiose.

Swan was born on February 17, 1920. He worked as a comic-book artist for two-thirds of his life. As noted by his son Chris, Curt did not stay in the bigfoot style he used during World War II as a cartoonist on *The Stars and Stripes*

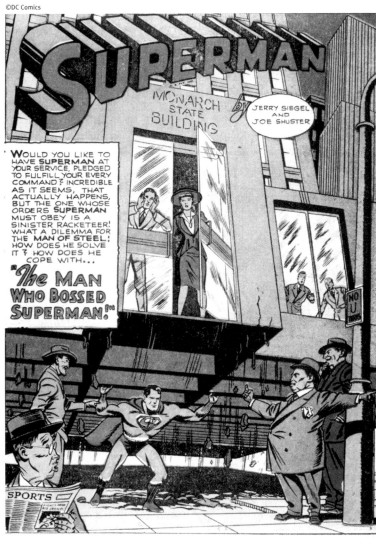

Curt was also primarily a craftsman. He had been part of different teams which turned out large quantities of product on tight schedules. Swan worked on stories he didn't write which were about characters he didn't create, under editorial dictates and company demands. But he infused the field of comic books with a wonderful style which was like no one else's, bringing unsurpassed distinction and humanity to the people that he illustrated. I hope that in these pages you will experience and appreciate Curt's development—into a master craftsman who occasionally transcended the constraints under which he worked to produce art.

Seldom has a comic-book creative freelancer been associated with one company for so long. Curt Swan worked for the company that became known as DC Comics almost exclusively until his death from an apparent heart attack, around June 12, 1996.

*At left, some of Swan's earliest work on The Man of Tomorrow, from Superman #51 (1948).*

*An image that has become a cultural icon: the transformation from mild-mannered reporter into Man of Steel. Swan defined the iconography of Superman for over three decades.*

army newspaper. He became an excellent draftsman who helped to usher in a new sense of realism in comic books when he entered the field in December, 1945. Swan focused more on illustration than on the design aspects of comics. He left that for others to develop, such as contemporaries Carmine Infantino and Nick Cardy.

Once, while I was touring the famous crystal factory in Waterford, Ireland, a glass cutter was asked if he ever had a chance to notch his own designs into the crystal. After all, he'd gone through years of apprenticeship and had memorized dozens of already existing patterns. But he answered, "No, it's all about production." It reminded me that like the highly skilled glass cutter,

*The most famous cast of supporting characters in the history of comics, as Swan rendered them in the 1980s.*

©DC Comics

*Swan's interpretation of Superman changed across the decades, aided and abetted by a long succession of inkers.*
All ©DC Comics

Rarely in comic books or comic strips has an artist who did not originate a character defined that character for generations of readers. Beginning with regular assignments on *Superboy* and later *Jimmy Olsen*, then as the "Superman family" cover artist, Swan went on to help the flagship title reach the highest circulation figures in the industry for several years. He took part in more creative dynasties of Superman than anyone. The interviews in this book cross different eras in the character's evolution. Three key editors during Curt's artistic tenure were Mort Weisinger, Julius Schwartz and Mike Carlin. As an example of his longevity drawing The Man of Steel, Swan worked on five centennial issues of *Action Comics*, #'s 300, 400, 500, 600 and 700 (May, 1963 to June, 1994). Curt's first published Superman art likely appeared in 1948. His last appeared posthumously in 1996.

**The 40s**

It was a happy event when this particular illustrator came to be assigned to the most noble superhero of them all; his elegant, All-American penciling was well suited to delineate the Big Blue Boy Scout. Swan distilled the look of Superman into a platonic form of what children would like to grow up to be. He was the first to make The Caped Kryptonian friendly and approachable.

**The 50s**

**The 60s**

Besides illustrating an adult Superman who became a role model for millions of kids, in the mid-1960s Curt became the regular penciler on the teenaged Legion of Super-Heroes. No one was better suited to show young readers how, in a few years, they might still squabble with friends but were also capable of saving the world.

There were times that he didn't care for the stories he was asked to illustrate, but one couldn't tell from the consistent high quality of the work. And Swan brought dignity to even the goofiest

stories while still making them fun to read.

Many feel that his art peaked in the 1960s during the Silver Age of comics, yet Curt knew that he was still improving as an artist throughout his life. Highlights from all five decades of his career will be discussed.

The reason for the title, "A *Life* In Comics," is because I wanted to focus on the man as well as his art. Curt was beloved by friends and family. He was generous with his fans and was also interested in helping those less fortunate than himself. As this is being written, I'm still learning about various charitable causes that he supported during his lifetime.

So why a book on Curt Swan? Ultimately, that can be summed up in one sentence. Because he did it so well for so long!

**The 70s**

**The 80s**

**The 90s**

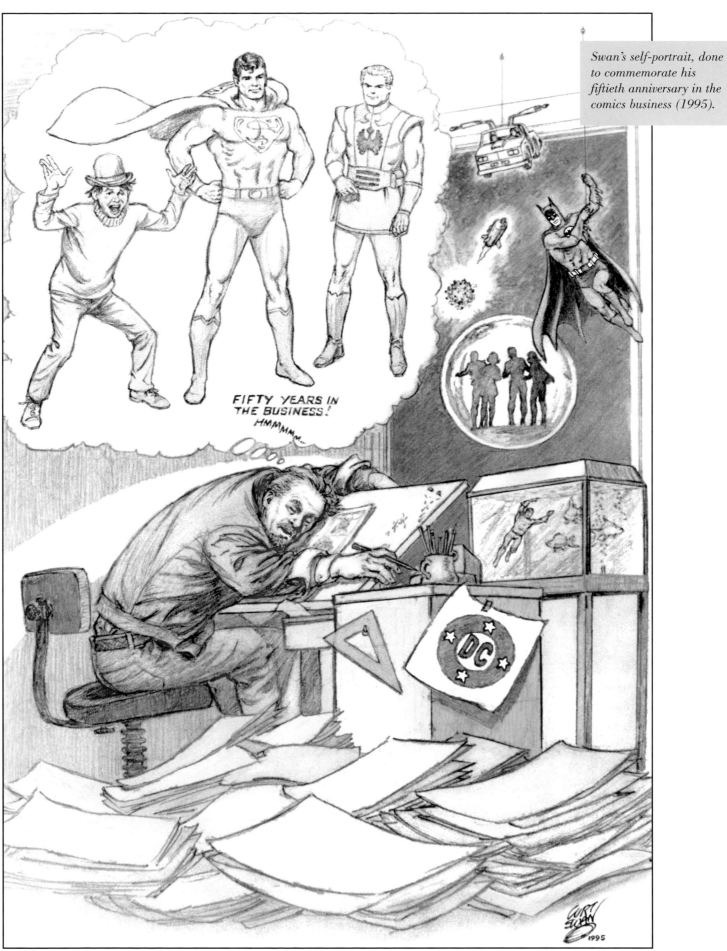

Swan's self-portrait, done to commemorate his fiftieth anniversary in the comics business (1995).

# The First Fifteen Years

Curt Swan was part of the second wave of comic-book artists, those that began their careers in the early to mid 1940s. Though he was a few years older than well-known contemporaries Gil Kane, Murphy Anderson, Carmine Infantino and Joe Kubert, they started in the business before he did. Actually, Kubert began working in comics in the late '30s.

*Pages from one of Swan's earliest assignments for DC—Simon and Kirby's Newsboy Legion. (From* Star Spangled Comics *#61, Oct., 1946.)*

## EARLY ASSIGNMENTS: THE DEVELOPMENT OF STYLE

Curt was twenty-five years old when he met with a few friends, including Eddie 'France' Herron, at the Campus Restaurant in New York City, whose building on Third Avenue no longer exists. Swan had moved to New York after World War II to improve his chances of getting a job in the commercial art field. Herron had been a writer at DC before the war, and he and Curt had worked together on the Army's *Stars and Stripes* newspaper while serving their country. France suggested that Swan apply for an art job at DC. This led to a working relationship with the company that was to last almost non-stop for fifty-one years. Though Curt's first assignment was a Boy Commandos story in 1945, it was probably not published until 1946 (see Raul Wrona's Curt Swan index).

The great team of Joe Simon and Jack Kirby had originated the Boy Commandos feature, about a group of World War II-era kids, accompanied by an adult chaperone, who fought bad guys all over the world (and later beyond). Swan continued on that feature for approximately three years. The Boy Commandos not only appeared in their own title but also in *Detective* and *World's Finest Comics.*

A second early assignment for Curt was penciling the Newsboy Legion in *Star Spangled Comics.* His first published work on that title also appeared in 1946, a few months after he'd begun drawing Boy Commandos stories. The Newsboy Legion was another Simon and Kirby-created patriotic kid gang mentored by an adult. But this grownup wore a costume—Swan's first opportunity to draw a superhero, aptly named the Guardian.

Though Curt was instructed to draw like Kirby and Simon, he couldn't. His panels were less dynamic. However, his early style possessed a primitive charm and a pristine look all its own!

Virtually from the onset, Curt used a cinematic element of perspective as part of his story-telling arsenal. A character's head and upper body were

©DC Comics

MEANWHILE, ABOVE...

THEY'VE RUN INTO AN OCTOPUS!

THEN KISS 'EM GOODBYE!

sometimes shown in three-quarters view from behind. That caused the reader to peer over the two-dimensional figure's shoulders, nearly bringing him/her into the scene itself and making it appear to have depth.

Various artists have stated that the hands are the most difficult part of the anatomy to portray in a naturalistic manner. Yet, Curt could do it whether characters were in action or repose. Unlike the work done by many in the industry, the digits were not hyperextended when they should have been slightly flexed. He never avoided drawing them by placing them in shadow or behind a chair arm. There were full lines on the backs of the hands, clearly accentuating the tendons and the underlying metacarpal bones. And

dainty or masculine, they looked right. Swan's hands became an effective and essential part of his characters' body language and of the story being conveyed. They were among the best ever pictured, in or out of the comics.

Interestingly, a few times per story, different figures' fingers

were positioned in a particular fashion, helping the reader identify Curt's early work. He would occasionally pencil the long and ring fingers straight and together, the others well apart. The practice continued, though less frequently, throughout his career. It's possible, though not likely, that Swan did this consciously to "sign" his art in the days before story credits. Many other artists, such as Nick Cardy, for example, used the same technique to give the hands expression. But no matter his reason, Curt Swan's "hands" were one of the things that brought personality to the work.

His illustrations involved a copious amount of detail, giving the art another signature touch. For example, rivets on metal ship hulls were round and finely shadowed, not just black dots. If there were a tropical setting, the fronds on the palm trees were fully drawn, not outlined. Intricate machinery that he was occasionally asked to portray was outstanding and remained a source of wonderment for the fans throughout his career.

*Left: While Swan's earliest efforts in comics are missing some of the distinctive style that makes his later art so easy to identify, one tell-tale trait of Swan's early work was his habit of drawing hands with the middle fingers together.*

*Dramatic composition and realistic detail in the service of descriptive storytelling — a splash panel from Gangbusters #38, Feb.-Mar., 1954.*

IN PRISON, EVERY CONVICT IS GIVEN THE CHANCE TO LEARN A TRADE! HE IS TAUGHT HOW TO HANDLE TOOLS WHICH WILL ENABLE HIM TO START LIFE ANEW IN A DECENT, STEADY JOB WHEN HE GETS OUT! THIS SYSTEM WORKS MOST OF THE TIME! BUT, SOMETIMES, ALL IT DOES IS TURN A HOOD INTO...

The JACK OF ALL CRIMES!

*A prelude to a jailbreak from the cover of* Gangbusters #38. *The face in the foreground illustrates other early identifying traits of Swan's work: thin lips and pronounced folds coming down from the sides of the nose.*

*An early Swan villain from a Boy Commandos story in* World's Finest #23.

Regarding this painstaking attention to detail, Curt enjoyed telling the story of his early inker, Steve Brody, taking him aside to tell him that he was breaking his arm inking Swan's pencils.

He also related a story about his early career as a comic book artist when he thought it had come to an abrupt end. Curt and his young wife were living in a hotel at the time. He was working sixteen hour workdays, having led the folks at DC to believe he was a faster penciler than he actually was. One Sunday morning while sitting on the edge of the bed, he offered to go buy a newspaper for his wife. While pushing off to come to standing, his drawing arm col-lapsed. But after visiting a doctor, Curt found that it was just a case of "nerves," and he was able to turn out tens of thousands of pages over the next few decades. Also, once Steve Brody showed him some shortcuts, he learned to insinuate rather than render every detail to pick up the pace, easing his workload. It wasn't long before he was penciling three to four pages a day.

Actually, Swan's rendering remained extremely detailed, but not in every panel. He learned to pick and choose which scenes would have extensive backgrounds and which would not. In fact, some had no background at all. Nevertheless, he became one of the best artists ever at making the reader imagine a richly portrayed world off-panel. Occasionally using close-ups also helped, so less full-figured people might be seen running around.

With the war over by the time Curt took on the Newsboy Legion and Boy Commandos, the two gangs no longer had the Axis to fight. Therefore, many of the tales began adopting a science fiction or high adventure bent. This was especially true of the latter kid group, who appeared in more titles and for which more story ideas were need-ed. From the bottom of the sea to outer space, Swan began to hone his illustrative skills. He drew the distinctly featured "commandos" and their adult mentor named Rip Carter; diverse looking villains with wonderful, multi-lined faces reminiscent of Shelly Moldoff's work; exotic locales; and high-tech gadgets. Two examples came from *Boy Commandos* #20, Mar.-Apr., 1947. In "Danger Below!" Rip Carter and the boys boarded a ship to recover sunken gold bullion and try to catch a murderer. Swan rendered a bearded sea captain, sophisticated diving equipment, an attacking manta ray and an octopus' probing tentacles. The third story in that issue, "First Stop—The Moon!," included little blue moon men, a huge tunnel filled with elaborate machinery, warring rocket ships, hand-held ray guns and a futuristic rifle dubbed an "atom freezer."

His editor(s) may have seen a forte in Curt's illustrative style that led to his next assignment, the science fiction feature *Tommy Tomorrow*. Swan's stint began with that character's first appearance as a backup feature in *Action Comics* #127, Dec., 1948. However,

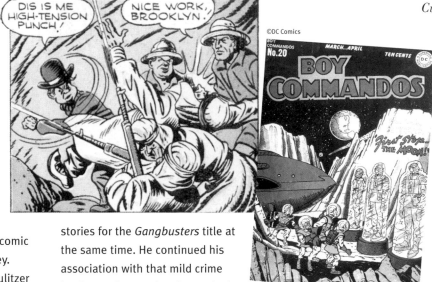

Tommy Tomorrow had appeared earlier, illustrated by others, in *Real Fact Comics*. Curt continued penciling the series until *Action* #172, when artist Jim Mooney took over. According to Swan, his inker on Tommy Tomorrow was John Fischetti, moonlighting in comic books to make extra money. Fischetti later became a Pulitzer Prize-winning editorial cartoonist.

It was on Tommy Tomorrow that the artist made another refinement, this time on peoples' faces. Since the beginning, he had effectively drawn the nasolabial folds, lines on both sides of the face that extend from just lateral to the nostrils to near the corners of the lips. But on this series, the lines grew sharper, especially on profiles, better defining the nose and mouth area. This feature, combined with Swan's thinly drawn lips on males, was another way to identify his early art.

Though best remembered for the above series in the late '40s and early '50s, Curt began illustrating

stories for the *Gangbusters* title at the same time. He continued his association with that mild crime book even longer than he worked on Tommy Tomorrow. *Gangbusters* was based on a radio, and later an early television, program.

It wasn't long before Swan also began to regularly pencil the DC character that was to be his greatest legacy to comics fans... sort of. In terms of continuity, the early Superboy had little to do with his grownup counterpart; there was almost no reference to this phase of the Caped Kryptonian's life in the pages of *Superman*, *World's Finest*, or *Action Comics*. Such inauspicious beginnings probably occurred within the pages of *Superboy* #5, Nov.- Dec., 1949.

This may be why Curt has often stated that he first began working on Superman with the one-shot *Three-Dimension Adventures Of Superman* in 1953. That assignment, more than his work on *Superboy*, stood out to him as a meaningful first step in eventually becoming the primary Superman artist.

Five years prior to *Three-Dimension Adventures Of Superman*, Curt was the likely penciler of the adult hero for one story in *Superman* #51, Mar.-Apr., 1948. It was a transitional period for Superman, occurring shortly after co-creators

*The Boy Commandos in 1947: the Nazi-bashing, juvenile WWII veterans turned to more fantastic pursuits during Swan's tenure on the feature. The panel at left is from* World's Finest *#23, Jul.-Aug. 1946.*

*Swan's depiction of the world of Tommy Tomorrow reflected the optimistic mood and deco-influenced architecture so common to comics' view of the future in the post-war era.*

*Swan depicts the Caped Crusader in the panel from Batman #70, Apr.-May, 1952.*

Jerry Siegel and Joe Shuster left the title in dispute, and just before Wayne Boring would be allowed to fully dominate the look of the character for the next several years. Ironically, it appears that Curt was asked to subjugate the style that would evolve into his own eventual signature look for The Man of Tomorrow. Some of the panels, especially those picturing

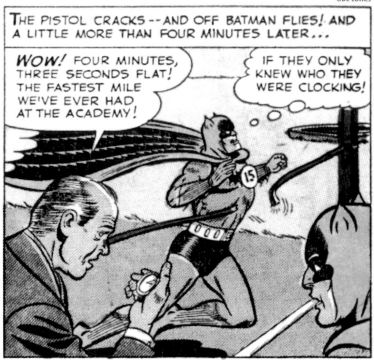

*Above: Swan exhibits good, old-fashioned storytelling clarity in this scene from Gangbusters #38.*

*At right: One of Swan's earliest takes on The Boy of Steel from Superboy #14 (1951).*

Clark Kent, may have even been inked by another early Superman renderer, John Sikela. This fill-in job might also have led directly to Curt's tenure on *Superboy*, beginning the following year.

In the early '50s, Swan did work for DC on a number of titles. Besides stories appearing in *Superboy*, he was also illustrating The Boy of Steel for *Adventure Comics*, beginning in Sept., 1950 with issue #156.

He would not return to drawing for the pages of *Superman* until #73, Nov.-Dec., 1951. Three issues later, in *Superman #76*, May-June, 1952, Curt illustrated the historic initial meeting of Superman and Batman in the comics. "Batman—Double For Superman!" again featured his inker from Tommy Tomorrow, John Fischetti.

*Batman #70*, Apr.-May, 1952, contained an early Swan-penciled tale titled "The Masterminds Of Crime!" His was an olympic looking Cowled Crimefighter, tall and lithe; more realistic than, say, Dick Sprang's Batman, but the latter artist had a wonderful, rollicking style all his own.

Going back even earlier, "a poll of experts in art styles" were of the opinion that a story from *Batman #42*, Aug.-Sept., 1947 (reprinted in *Batman 3D*,

1990) was penciled by Swan. Looking at the art, it's possible that information is accurate.

Some interesting parallels can be seen regarding the early years when Curt was first called upon to illustrate the two flagship heroes of the DC line. Whitney Ellsworth was listed as editor of both the Batman and Superman titles, though he may have held more of an emeritus position by the early '50s. Ironically, had things unfolded a bit differently, Swan might just as easily have slipped into the role of the definitive Batman rather than Superman artist. The fact that he capably rendered them both probably led to him penciling the first several teamups in *World's Finest Comics*, beginning with issue #71, July-Aug., 1954. That's when the page count decreased and the Darknight Detective and Man of Steel were paired in one story to avoid dropping either hero from the book.

The first great DC title devoted entirely to science fiction was *Strange Adventures*, which began in Aug.-Sept., 1950. Curt penciled stories in several of the early issues, including a movie adaptation called "Destination Moon" in issue #1. Again, the artist demon-

strated a penchant for portraying the futuristic, which would best serve him during the Silver Age of comics. That's when Superman's adventures spanned the furthest reaches of time and space.

He was assigned a war comic as well... when the words "War" and "Stories" were incorporated into the title of the revamped *Star Spangled Comics*. With issue #131, Aug., 1952, Curt penciled the first cover and an interior story for *Star Spangled War Stories*, the new addition to DC's early '50s lineup. He contributed in a similar vein on several more issues before leaving that long-running title.

In late 1952, early '53, there were a couple of Swan-penciled

stories for a police series called Manhunters Around The World appearing in *World's Finest Comics*. DC made an attempt to resurrect this theme in *Showcase* #5, Nov.-Dec., 1956. That issue was a three-tale affair, featuring Curt's only work for *Showcase* on one of the stories.

In the late 1940s, Swan appears to have done some work for *Real Fact Comics*. He drew for *House of Mystery* over a period ranging from the first issue (Dec. '51-Jan. '52) to mid-1954. There were two *Tomahawk* covers attributed to Curt, also done in 1954.

*Panels from the comic-book adaptation of the SF movie classic* Destination Moon *appearing in* Strange Adventures #1, 1950.

*Two icons for the price of one— scenes from the early days of comic's greatest team. At left, from the duo's first pairing in* Superman #76, *May-June, 1952. Below, from* World's Finest #73, *Nov.-Dec., 1954.*

*Swan's skill for expressive faces and subtle body language made him the perfect artist for the charming goofiness of* Superman's Pal, Jimmy Olsen.

It was in that same year when DC took a big chance by giving one of the Superman supporting characters a chance to carry his own book. *Jimmy Olsen* #1 appeared on the stands with a cover date of Sept.-Oct., 1954. This endeavor cemented Curt Swan's forty-eight year relationship with the Superman family of characters!

The inker on Jimmy Olsen and many other Swan-illustrated stories around this time was Ray Burnley, noted comic artist Jack Burnley's brother. Ray's inks were not well suited to the smooth pencils of Curt Swan, giving the lines a harshness that made them less appealing than normal. Jack Burnley wrote in May, 1999: "My brother Ray (whose real name was

Dupree) inked backgrounds for me in the early years (1939-43) but when he returned from army service in 1944 he worked in the DC bullpen as an inker and I lost touch with his work... He died in 1964."

Curt took from one to six months (depending on the source) off from DC around 1951 to try his hand at advertising art. This was after experiencing migraine headaches, largely due to his relationship with editor Mort Weisinger. Soon, however, Swan realized that he could not make a comfortable living for his family in advertising and returned to comics.

The headaches went away after he gained Weisinger's respect by standing up to him.

For the remainder of the 1950s, Curt sharpened his storytelling and artistic skills. His art became more beautiful, more illustrative. Different inkers came and went, including some who were themselves fine comic-book artists. One possible Swan inker on the early Superboy stories was Golden Age great Creig Flessel, best known as a pre-hero DC cover artist and illustrator of the original Sandman. Mr. Flessel said in June, 2000 that he did not remember ever having inked Curt, though later he thought he may have done so (and he's been credited in a few reprint anthologies). But whomever this long-ago Swan embellisher was, he helped make Superboy memorable by giving him a pompadour look.

GREETINGS! DO NOT CALL ME JIMMY NOW, FOR I AM THE *COSMIC BRAIN* OF THE FUTURE!

©DC Comics

That Curt was largely self-taught was remarkable in light of his technical superiority to many of the comic artists of the time. For example, if he drew a stone propylon (gateway) to a temple, each block was appropriately rendered when viewed from the combined perspectives of in front and beneath. Always interested in improving his craft, in the early 1950s Swan had the opportunity to enroll in formal art training under the G.I. Bill. He took some night classes at Pratt Institute in Brooklyn. After only a few months, however, he quit making the long commute from his home (in New Jersey by then) because he already knew the things being taught.

In the late '50s extending into the early '60s, Curt drew the daily Superman newspaper strip for a few years. Stan Kaye was his inker on the strip, as he had been on numerous comic book stories prior to this. Around this time, Swan was also given the choice assignment of cover artist for the entire Superman family of comics. That included *Superman*, *Action*, *Adventure*, *Jimmy Olsen*, *Lois Lane*, *Superboy* and *World's Finest Comics*. Kaye (also known as an excellent inker for early Superman artist Wayne Boring) became Swan's major embellisher at a time when Curt was developing a more defining look for his adopted characters. For awhile, the team of Swan and Kaye were even the cover artists for *Batman* and *Detective Comics*. Again, there was that Batman connection...

The Silver Age of Comics had arrived in 1956 with the "new" Flash's first appearance in *Showcase* #4, but it took awhile for Superman to be affected. Finally, by the late '50s, his mythos was expanding, and writer Otto Binder's grandiose ideas were a big reason. Things continued to percolate as the '60s unfolded. It wouldn't be long before the caliber and complexity of the lengthening storylines by Binder and others would inspire Curt to artistic greatness. With the arrival of a big gun named George Klein to ink his pencils, things got even better.

*Swan's Man of Steel in 1954, taken from the cover of* Superman #89 (May, 1954).

©DC Comics

# Swan's Silver Age Zenith

There were four zeniths in Curt Swan's comic art career. The first was in the period from 1962 through 1964, when the great two and three-part novels gave everyone involved the opportunity to shine. This was the era when the Weisinger-edited stories and George Klein's inking were at their peak. Of course, it was obvious that Curt himself was moved by the series' direction. He was inspired by the greater use of science fiction combined with the character-driven nobility of the grand stories he was asked to

*Above: Swan's rich feel for characterization lends credibility to a gangster and his moll from* Superman *#137.*

*Right: Swan and inker Stan Kaye generate a sinister mood in this scene from* Superman *#147, August, 1961.*

depict. Superman, his friends, and even some of his foes were reaching new heights of adventure and heroism, and Swan had the opportunity to create new worlds.

## FOREWARNINGS OF GREATNESS

There was a forewarning of greatness as early as May, 1960 when Curt was inked by John Forte on *Superman* #137 (cover by Swan and Kaye, story by Jerry Siegel). Titled "The Two Faces of Superman," this was the famous story of an energy being that was created in Kal-El's image. When Superbaby's ship, on its way to Earth from the exploding planet Krypton, accidentally careened off a giant space ship from another dimension, the impact triggered an onboard duplicating device. The Babe of Steel and his rocket were reproduced, except the duplicate infant was pure energy and

not flesh and blood. This creature landed on Earth as did Superbaby and was found and raised by a criminal couple. Swan was brilliantly able to portray the diverging emotional makeup of Super-Menace from Superman, in the forms of innocent but warped childhood, smirking teenager, and angry adult. And he drew up a storm when the two super-beings finally met in a titanic battle.

Comic book and graphic artist Jeff Weigel wrote the following comments about *Superman* #137: "What a great team Swan and Forte made together! I think this early '60s era must have been Swan's peak — his characters are so real and well defined! I'm thinking specifically of the evil foster parents in the story. Roles that were written as standard gangster-and-gun-moll types are really given an extra dimension by Swan's precise draftsmanship and

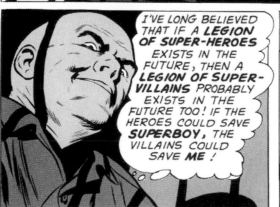

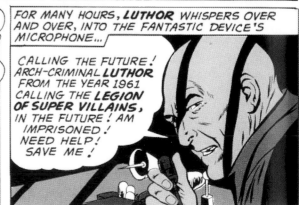

©DC Comics

the gestures and expressions these figures employ. The 'father' becomes a once-dapper 'middle-management' mobster now grown fat and complacent resting on the success of his salad days, and the 'mother' an aging flapper who fulfilled the only ambition she ever had in life, finding a sugar-daddy. This book really shows what Swan brought to the table on the stories he drew — the ability to add realism to stock characters and credibility to outrageous stories and situations! Curt could sell the patented Mort Weisinger pathos of stories like this better than any of his 'super-peers' (Win Mortimer, Wayne Boring, George Papp, et al.). What would be a laughable conclusion to the story in lesser hands wrings real sympathy from the situation when drawn by Swan. This kind of story always moved me as an eight-year old. Thanks to Swan, I could still remember some of what that emotion felt like at the distant age of 41!"

The June, 1960 issue of *Action Comics*, #265, scripted by Otto Binder, had another Superman double, this one a living, breathing hero named Hyper-

Man. Curt got to illustrate more rockets as well as a few panels of Hyper-Man's home world of Oceania. The science fiction components of the Superman saga were accelerating. There were several added bonuses in this thirteen page story inked by Forte. Swan created a handsome new uniform for Superman's equally powerful friend. Readers got two well-rendered heroes for the price of one. Another bonus was that the artist was asked to portray a bittersweet ending in which the Man of Steel recounted to Supergirl how he had pretended to disgrace himself. He did so in order to perform a selfless act for his now-dying buddy. And finally, Curt perfectly captured the peaceful passing of Hyper-Man with his wife (who "amazingly" looked just like Lois Lane) kneeling over him in a loving, bedside vigil.

Mention must be made of another story that appeared around this time. *Superman* #141, Nov., 1960 had a cover penciled by Swan, but the interior was penciled by Wayne Boring and inked by Stan Kaye. Superman co-creator Jerry Siegel scripted one of the all-time comic book classics: Kal-El traveled back in time to Krypton

before it exploded, attended his real parents' wedding, and double-dated with them while falling in love with that planet's most famous "emotion-movie actress." Prior to this issue, the chapters in the rare *Superman* three-part novels (beginning with issue #113, May, 1957) were sometimes like loosely linked vignettes. By the time of *Superman* #141, there was an evolving, sophisticated cohesiveness to the longer stories. And while that tale's wonderfully illustrated contents were not by Curt, it could be seen as a symbolic passing of the guard. Wayne Boring's Kryptonian architecture was filled with Eastern European style minarets. His futuristic perspective actually represented the past. Swan's expanding vision of Krypton, usually portrayed by him in tales of The

*Clarity takes priority over pyrotechnics in this battle sequence from* Superman #158, Jan., 1963.

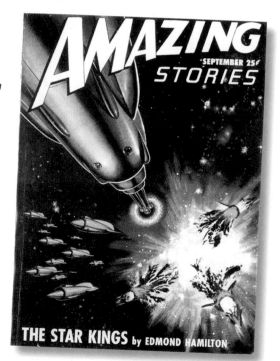

*Noted science fiction author Edmond Hamilton, a veteran of the pulp magazines from the '20s into the '50s and of the digest magazines from the '60s and '70s, was one of the most prominent of Superman's writers by the early 1960s. (*Amazing Stories, *Vol. 21, No. 9, September, 1947.)*

Bottle City of Kandor, was a more modern science fiction interpretation. Curt's buildings looked like castles might appear if built in the future, with curving skyways connecting one to the other and different geometric forms plopped on top of each; castles atop which commonfolk could perch to look up and point as they spotted Superman, or his Kandorian alter-ego Nightwing, flying overhead.

Another transition from one generation to another was just beginning to occur in the adult Man of Steel. In earlier years, Swan adhered to the thick-waisted, circus strongman look as portrayed by artists Wayne Boring and

Al Plastino. But gradually, the abdomen was thinning, Curt's Superman at times looking rather like a svelte bodybuilder.

*Superman* #149, an "imaginary story" titled "The Death of Superman," was a portent of things to come. ("Imaginary stories" in comics occur outside of the normal continuity, often dealing with events such as the marriages or even the deaths of major characters.) Though sometimes credited to George Klein, either Stan Kaye or Sheldon Moldoff inked the beautiful pink cover and Moldoff inked the interior of

another Jerry Siegel-scripted epic. Cover dated November, 1961, this imaginary tale was bathed in pathos. A sneering Luthor planned to be King of Earth after eliminating the Man of Steel. But before his plan was thwarted by Supergirl, Curt got to illustrate three pages of mourners as they passed in front of the late Superman's (Snow White-type) glass covered coffin. Swan penciled the remaining Justice League members, along with: Lana Lang, Lori Lemaris, Linda Lee Danvers,

*The pose every kid has struck — as depicted by the team of Swan and George Klein in* Action Comics *#325, Jun., 1965. (From the collection of Karl Mattson.)*

©DC Comics

the Daily Planet staff, "weird alien beings from other worlds," the three founding members of the Legion of Super-Heroes, the people of Kandor, and regular Earth mourners of varied races and dress as they all came to pay their last respects.

## THE FIRST ZENITH

Soon after this, the first zenith in Curt Swan's art was attained. George Klein came on board in early 1962. Weisinger and his writers, especially Edmond Hamilton, added more science fiction aspects as the stories became more grand; and nearly everyone became more emotional, more noble. The female faces became more beautiful, the male faces more lined and mature. The heroes and heroines were virtually selfless as they strove to save the world. This was especially true of Superman, as he had to protect not only Earth but the fragile city in a bottle perched above a solid rock floor in his Fortress of Solitude. The villains became more cunning, more smug. They also matured, with personalities so complicated that at times they were heroic themselves. Swan was a master at portraying all of "his" characters' qualities, quirks and traits. By this time, he had developed the definitive look of the Superman family of primary and supporting players.

The first zenith lasted approximately three years, due in large part to the epics which Curt Swan and George Klein depicted in the flagship title. *Superman* #156,

©DC Comics

*Two members of Superman's elaborate extended family in the Silver Age: the Cousin of Steel (Supergirl) and the Pet of Tomorrow (Krypto). (From Superman #156, Oct., 1962.)*

October, 1962, contained the earliest of the great Swan and Klein three-part novels. Virtually the entire cast of characters was found therein with larger roles than before. Supergirl, an expanded roster of Legionnaires, the Superman Emergency Squad from Kandor, and Superman's robots all fulfilled the "dying" Man of Steel's wish list of super-chores. It was his final desire to make the Earth a safer and better place. "The Last Days of Superman" had everything except a great fight scene, including the famous inscription burned into the moon by a weak-

ening Kal-El's heat vision: "Do Good to Others and Every Man Can Be a Superman..."

Before this tale, a similar saying was inscribed on the lunar surface in an earlier version of the same story from *Superman* #66, Sept.-Oct., 1950. The Caped Kryptonian merely appeared woozy in the prior tale drawn by Al Plastino. Curt drew him as a much more tragic figure, clearly in agony as he lay dying in *Superman* #156.

*This depiction of Lana Lang and Lois Lane demonstrates Swan's respect for female characters. Swan's females were beautiful, friendly and — most importantly — human. He avoided the sexpot characterizations so common throughout comics history.*

©DC Comics

©DC Comics

*Swan's facility with facial expressions puts across the agony of kryptonite exposure.*

*One of the Silver Age's classic moments: Superman and Luthor slug it out under a red sun in* Superman #164, *Oct., 1963.*

Weisinger and his writers' greatly expanded mythos challenged Swan in the latter adventure to also portray: Brainiac 5 in despair when he failed to find a cure for Virus X; the looks of concern on Lois', Lana's, and Jimmy's faces; Saturn Girl concentrating to pick up Mon-El's thoughts telepathically from the Phantom Zone, as he told her it was a hidden chunk of kryptonite rather than Virus X that was killing their friend; and a final reunion of the World's Finest team, as the Man of Steel told Batman and Robin goodbye for the supposed last time. Supergirl showed up everywhere as she assumed a leading role in guiding the others to complete their tasks. She even flew back in time to Krypton before it exploded to try to save her cousin. It was all colorfully and brilliantly rendered by Curt. Many of these images are still vivid more than thirty-five years later.

A tour-de-force arrived in January, 1963 with *Superman* #158, "Superman in Kandor." This three-part novel had non-stop action and was perhaps the best-plotted story during Curt's first zenith. Oddly, the issue began with a static but ominous cover which showed Superman trapped in the Phantom Zone. Cover and contents were penciled by Swan and inked by George Klein. From telepathic hounds to the weird vegetation on the outskirts of the city of Kandor, from shrinking rays to enlarging rays with the terrible consequence of disintegrating what was returned to full size, the science fiction aspect of Swan's storytelling ability was allowed to shine.

In this same story an elderly scientist, and friend of Jor-El and Lara when they were alive, was introduced. Nor Kann befriended his departed comrades once again by giving their son, Kal-El, and Jimmy Olsen a hideout as the two became hunted fugitives in the Bottle City. Because they needed secret identities to operate openly, Swan tailored new costumes for "Nightwing and Flamebird" on his Bristol Board. The result was a sleek, dark look for Superman, with his foil, Jimmy, donning colorful apparel that would have looked at home in the Legion of Super-Heroes. And those pivoting jet-belts that Curt drew on both costumes...Wow!

Swan and Klein continued to illustrate other wonderfully imaginative epics during this time. Though *Superman* #159 was a weak link in terms of the storytelling, the artwork was gorgeous. The story, titled "Lois Lane, the Supermaid from Earth," gave Curt the opportunity to have Lois don a pink, miniskirted costume with a map-of-Earth chest insignia. She gained super powers to help her fight for justice on a Krypton that hadn't exploded in this imaginary three-parter. In fact, parts of this story, including a pink, slightly different version of the costume, appeared to be the inspiration for a 1996 television episode of "Lois and Clark: The New Adventures of Superman," in which Lois also acquired powers.

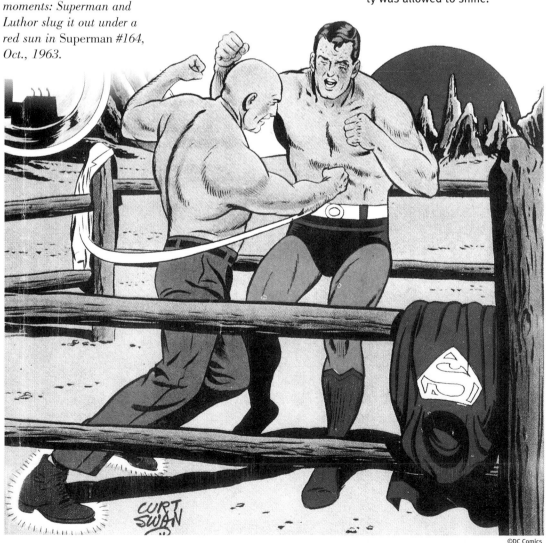

CURT SWAN

©DC Comics

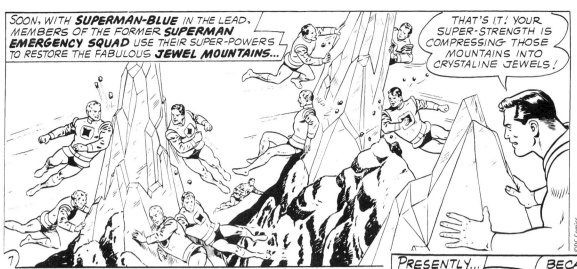

SOON, WITH **SUPERMAN-BLUE** IN THE LEAD, MEMBERS OF THE FORMER **SUPERMAN EMERGENCY SQUAD** USE THEIR SUPER-POWERS TO RESTORE THE FABULOUS **JEWEL MOUNTAINS**...

THAT'S IT! YOUR SUPER-STRENGTH IS COMPRESSING THOSE MOUNTAINS INTO CRYSTALINE JEWELS!

©DC Comics

*The team of Swan and George Klein brought dignity and realism to their characters during their collaboration in the early 1960s. Nowhere was this more clearly on display than in the classic tale of Superman-Red and Superman-Blue. (Superman #162, July, 1963)*

The next full-length novel appeared in *Superman* #162. Also imaginary, "The Amazing Story of Superman-Red and Superman-Blue" was a beautifully happy tale written by Leo Dorfman. Curt was asked to portray the original Man of Tomorrow being split into identical twins. The new Supermen possessed enough brain power to make the world a utopia by alleviating crime and disease. Other super feats were accomplished. For example, Swan showed Lori the Mermaid and her people being transported through a vortex to a new waterworld so they could have a planet of their own. Also, Supergirl never looked more lovely, as she continued to be a major supporting character during this era. Even the Phantom Zone villains were colorfully portrayed

after being freed from their ethereal state, and Lex Luthor's lost hair was regrown as he became a benevolent soul. Nikita Khruschev and Fidel Castro saw the error of their ways and conformed to the "American Way." This was 1963, after all! Oddly, though the interior was primarily by Swan and Klein, editor Mort Weisinger had Kurt Schaffenberger draw the faces of Lois and Lana throughout. Schaffenberger also did the cover, as he had on *Superman* #160. This was a rarity, as Curt had illustrated all of the other *Superman* covers since #117.

*Superman* #164 was a two-parter that still felt like an epic. Probably the best plotted issue after #158, Swan perfectly portrayed the nobility of

PRESENTLY...

THANKS, **SUPERMAN-RED** AND **SUPERMAN-BLUE**! YOU'VE KEPT YOUR VOW!

BECAUSE OF YOUR DEVOTION TO DUTY, **KANDOR** IS NORMAL AGAIN! AND OUR MOTHER PLANET IS RESTORED! WE'LL CALL IT **NEW KRYPTON**!

a Superman who had lost his powers but was able to cope when faced with isolation on a desert world. Complications encountered by the Man of Tomorrow included a huge sandstorm and hallucinations brought on by great thirst.

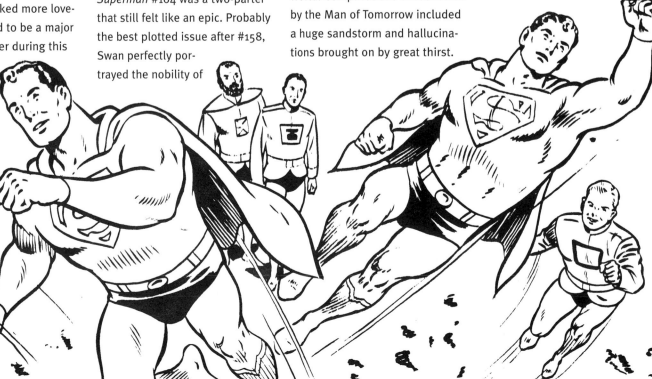

©DC Comics

Issue #164 also showed how well Curt could illustrate a great fight scene, rare between Superman and one of his legendary foes because of The Man of Steel's usually superior physical powers. But this time, Superman and Luthor agreed to duke it out on a red sun world. The fistfight portion of their battle was even more unique because they fought with no

*Some staples of Superman in the early Sixties: Luthor, Brainiac and the Bottle City of Kandor (Superman #167, Feb., 1964).*

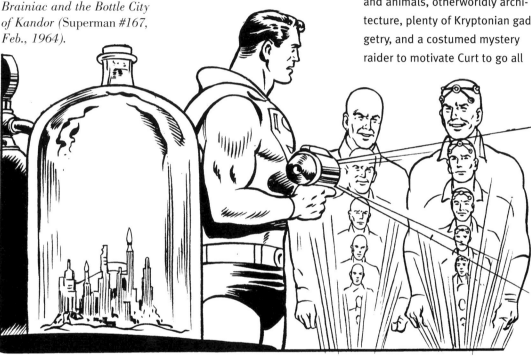

©DC Comics

*At right, Swan's design for a sculpture commemorating a distant world's overthrow of its computer tyrants (from Superman #167) demonstrates the artist's skill for depicting machinery and futuristic cityscapes.*

onlookers, in a ring built of petrified logs on the dried-up landscape. To see an in-shape Luthor and The Man of Steel evenly matched, Superman's cape draped over a rock hard timber, was unforgettable. And both protagonists' physiques looked very strong without need for the exaggerated, grotesque muscle drawings utilized by many comics artists in the 1980s and '90s. By the way, after suffering a black eye and listening to Luthor gloat, Superman kicked his butt.

The imaginary saga "The Sons of Superman" from *Superman* #166 was a bit formulaic, dealing with an inferiority complex suffered by

one of Kal-El's two sons, the one not blessed with super powers. However, this January, 1964 issue ushered in the last year of Curt Swan's first zenith with no letdown in the art. Weird creatures were penciled in force, including ocean life left over from the planet Krypton's existence, displayed under glass within the City of Kandor. There were atavistic birds and animals, otherworldly architecture, plenty of Kryptonian gadgetry, and a costumed mystery raider to motivate Curt to go all out. And as usual, he shone in the handling of emotional situations, such as a boy (Kal-El's non-super powered son) crying while running away from home, not wishing to be a security risk to his parents.

One of the most famous epics from the Silver Age

appeared in *Superman* #167. The primary reason is that this three-part novel contained the retro-origin of the space villain Brainiac. Titled "The Team of Luthor and Brainiac," Swan and Klein penciled and inked the cover and interior. Another tight plot with characterization that expanded upon the nature of the evil duo's personalities, this time Superman was soundly defeated by his nemeses. Only the Superman Emergency Squad, super-powered small fry who let themselves out of the Bottle City, prevented the death of The Man of Steel. And the entire city of Kandorians showed their nobility when they voted collectively to allow Brainiac, the one who had miniaturized them a couple of decades before, to go free in exchange for bringing Superman out of a coma. Though this story didn't allow Curt to illustrate much that he had not drawn before, the artist showed his penchant for drawing machines in a sculpture memorializing the overthrow of computer tyrants on Brainiac's home world. Curt also dreamed up a compelling image of alien beings who had evolved into living ships on their ocean planet. Luthor and Brainiac encountered these bizarre

©DC Comics

©DC Comics

THIS TIME I'M GOING TO GET RID OF MY NEMESIS ONCE AND FOR ALL...I'M GOING TO **DESTROY** SUPERMAN!

creatures while searching the cosmos for certain chemicals. And the bottom of page 3 found Swan posing Luthor with his fist clenched in rage, worthy of a scene from a Shakespearean play.

The next *Superman* was an all-Luthor issue, with Swan showing his great versatility. Scenes ranged from the now-futuristic world of Lexor, named after Luthor for being that planet's hero, to a time in our country's past. Curt drew the costumes, props and architecture from the 1906 great San Francisco Earthquake with a credibility that made readers feel they were there.

At this same time, a fantastic twenty-seven page story was unfolding in the pages of *Action Comics*. Requiring two issues, "Superman, King of Earth" and "King Superman Versus Clark Kent, Metallo" appeared in *Action* #'s 311 and 312, in April and May, 1964. A gimmick that had been implemented before by editor Mort Weisinger was to make Superman and Clark separate entities, usually by exposure to Red Kryptonite. In this novel, both were heroes, but the former pretended to be interested in domi-

nating Earth to divert attention from an alien invasion, thus avoiding worldwide panic. Clark became bold and angry, as opposed to meek and mild mannered, as he strove to overthrow his super-powered twin, whom he thought was now evil. Some of the saga was hokey, but there were unique moments that had a lasting impact. Clark was seldom featured

in the longer stories during this time period, but Curt was the perfect artist to portray him as the major player in this tale. And he was brilliant at illustrating a Superman who appeared supremely arrogant as he crowned himself planetwide monarch. One particularly poignant sequence occurred when Clark, now a normal man, was shot in the stomach while masquerading as The Man of Steel. His pain was palpable as he staggered away from the scene and fell headfirst into a river.

*World's Finest Comics* assumed new editorial guidance and sweeping changes when Mort Weisinger took control with issue #141, May, 1964. He reassigned writer Edmond Hamilton and artist Curt Swan to the title. The trio immediate-

*At left: Swan's skill with subtle facial expressions and camera angles were used to illuminate character and propel the drama of the story.*

*This battle from the cover of World's Finest #159 (1966) shows Swan's flair for figure balance and his knack for drawing the viewer's eye into a composition.*

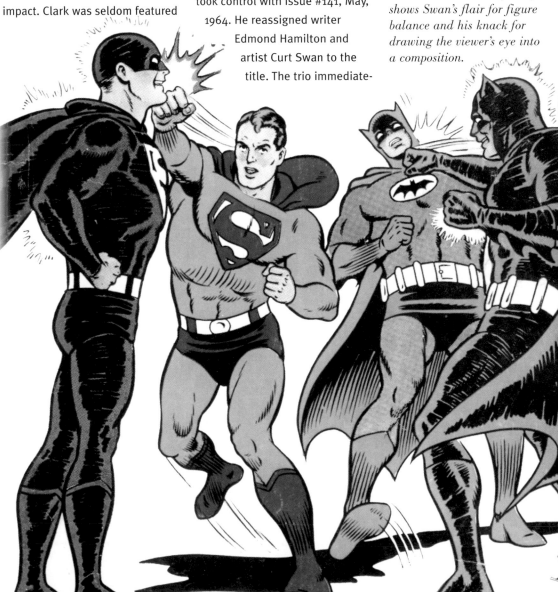

©DC Comics

ly utilized more science fiction aspects and characterization within their stories. Jimmy Olsen often became a fourth team member, aiding his pal Superman to counterbalance Robin The Boy Wonder at Batman's side. Another editorial change was that Batman and Robin were introduced to Kryptonian lore. For example, they saw their friends assume the identities of Nightwing and Flamebird as Kandor became the backdrop for adventure in issue #143, "The Feud Between Superman and Batman!" Other classic examples of the new direction for the title include issues #142 and #146. The former held "The Origin of the Composite Superman!" Swan pulled out all the stops as the villain assumed the complete powers of The Legion of Super-Heroes and soundly defeated Superman and Batman. *World's Finest Comics* #146, December, 1964 was ahead of its time, containing one of the first tales in which Superman really appeared to be an outsider on this planet, capable of super vengeance. It was obvious in "Batman, Son of Krypton" that The Man of Steel's first loyalty was to his people and the planet upon

*Detailed backgrounds can be the bane of a comic book artist's existence, but Swan never balked at making sure a reader always had a strong sense of where a story was taking place. From sewers to futuristic cityscapes, Swan made story settings imaginative and believable.*

which he'd been born. Curt portrayed a furious Kal-El whose actions could not be predicted if he were to find out the identity of an earthling (an aged scientist) who may have inadvertently destroyed Krypton. And The Caped Crusader, while not exactly afraid of his superpowered friend, was wont to tell him who the older man was and went to great lengths to protect him. Swan successfully wrinkled the mentalis muscle on the front of the scien-

tist's chin to show age and on Superman's face to depict rage.

There was so much beautiful art produced by Curt for the Superman family titles during this three-year period of 1962 through 1964 that most of it must preclude mention. However, to list a couple more: the penciling, especially of the female members of the Legion of Super-Heroes, soared in *Adventure Comics* #313, October,1963 when the art team of Swan and Klein substituted for regular artist John Forte; Curt also brilliantly depicted three different periods in world history in a full-length tale from *Superboy* #103, March, 1963.

Another facet of Curt Swan's career included his cover pencils for the *Superman* Annuals and Eighty-Page Giants. They spanned the ink runs of Kaye, Klein and later embellishers. Whom more than Swan defined the look of the reprint genre? His multi-scene series of covers deserved to be richly colored, and they were.

## MORE ON CURT'S FIRST ZENITH: THE OCTOBER ISSUES

For three glorious years (1962-1964) the Swan/Klein art team was at its peak with sagas of bravery and self-sacrifice in the October issues. Two, 1962's *Superman* #156 and 1963's #164, have already been mentioned. Finally, to close out this zenith came *Superman* #172 in October, 1964. This was "The Tyrant Superman" three-part novel. Kal-El actually lost his super powers permanently while diverting an energy-draining comet that was heading for Earth impact. Always thinking of others, he had first chosen a successor from Kandor to replace him as this planet's protector. But

the new Superman, Ar-Val, was interested only in proving to the people of Metropolis that he was better than the former Superman. He was more concerned about preening in front of a statue erected in his image atop City Hall than in saving a kidnapped Lois and Lana. Jimmy Olsen had to blackmail the new Superman into coming to their rescue. He did so by threatening to expose Ar-Val for creating phony emergencies in order to build himself up in peoples' eyes. When Ar-Val and Jimmy arrived at the scene of the kidnap-

pings, the powerless former Superman was already there and proved himself once again to be the greatest hero of all. He leaped in front of a Kryptonite spear meant for the new Superman and took it in the back. Seeing this act of selflessness awoke the latent hero in a repentant Ar-Val. At a terrible cost, he gave his life in order to transfer his own super powers into Kal-El so that the rightful Superman could resume his career. Curt ran the gamut of emotions with this saga; from arrogance to agony, from callousness to concern. Swan and Klein did the cover and two of the three interior

chapters. Chapter 2 had Curt's pencils inked by Sheldon Moldoff.

*Superman* #175's "Lex Luthor Kent as 'Clark Kent's Brother'" was almost included as part of the zenith, bringing this wondrous period for Swan and Klein's published work into 1965 (though this story with a February, '65 cover

*Swan's fantasy machinery always looked like it could really work, like this robot dog from* Superman *#164.*

©DC Comics

date was actually on newsstands in late '64). Though it seems that the art was beginning to loosen up a bit, some panels were as beautiful as ever. Two wordless scenes showed Lana Lang crying, displaying her vulnerability and loveliness as well as anything that Swan had penciled before.

Another reason that Curt's first zenith came to an end was that Edmond Hamilton's run as a writer was nearly complete. He was the author of nearly every great story mentioned above that was not credited to Siegel, Dorfman or Binder. His novels were the most star-spanning, his larger than life

characters the most grand. Under Hamilton's tutelage and Swan's pencils, even the Bottle City of Kandor achieved an exotic personality all its own. It should be acknowledged that neither scripter nor penciler would have achieved the heights they did without the other's complement. Hamilton's stories looked more pedestrian when illustrated by someone other than Curt. And Curt would not have been as challenged to surpass what he had done before were it not for the fantastic locales and depths of emotion asked for by Hamilton's scripts. They were comics done by committee, but they worked.

Hopefully, the reader will appreciate the diverse storytelling from this wondrous period in the history of the Superman family. Though some of the plots (especially after 1964 when Curt's first zenith ended) were rehashed with only slight variations to make them appear fresh, the optimism and imaginations of children buying these bright and colorful comics could be sparked for a lifetime. But perhaps more important were the lessons of selflessness and courage which these tales fostered by virtue of the plots, characterization, and by Curt's emotional, heroic art.

Additionally, it would be overly simplistic to depict these comic books as merely luminous, optimistic and full of wonder. They were more than that; there was a dark side too. Kids were educated a little about death, tragedy, struggle, and failure. Heroes died, as in "The Hero Who Was Greater Than Superman," from *Superman* #163, August, 1963. Heroes failed, as when Superman was unable to enlarge Kandor after repeated attempts (until finally succeeding, long after the Silver Age ended, in *Superman* #338, August, 1979). But the dark side was presented in a gentle, sensitive way that did not overpower child readers. One of the things that kept the sadness manageable was the humanity and the beauty that flowed from Curt's pencils.

Finally, a debt of gratitude is owed to Mort Weisinger, editor of these and so many other enjoyable stories. His guidance made for a universe as complicated, yet as accessible to new readers, as any every portrayed in the comics.

## FROM THE SUBLIME TO THE RIDICULOUS

There was a flip side to Weisinger's editorial vision. For every terrific tale like the great two- and three-part novels, there were at least three or four stories that were downright silly. Even in those more innocent times, they wouldn't have been nearly as palatable without Curt's help. Whereas an artist like Kurt Schaffenberger would play them more cartoony with a slapsticky feel, Curt would play them straight. That approach worked for him because the work was clean and bright with a glint of humor—a nodding wink to the reader. The realism he brought to

*Swan had the ability to depict Superman's distinctive character in an almost unlimited variety of expressions and viewing angles, all with complete consistency. This model sheet demonstrates why Swan defined The Man of Steel for over thirty years.*

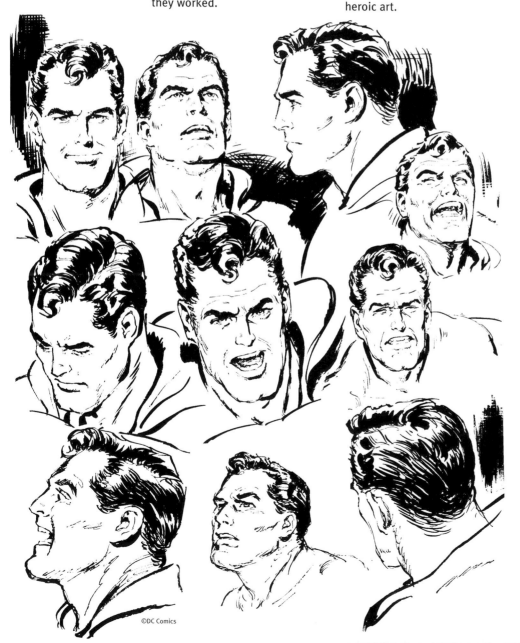

©DC Comics

each page made the absurd acceptable, the ridiculous fun! Whether penciling a space alien with a flower-petal head, a "Simpleton of Steel," or Jimmy Olsen dressed as a woman and becoming a gun moll, he did it with panache. Swan made it easy for us "kids" to suspend disbelief, although it didn't hurt that we were kids with imagination.

One intentionally silly story deserves special mention. When DC held what became known as "The Great Boo Boo Contest" in *Superman* #145, May, 1961, Curt was the best man for the job. This short tale, titled "The Night of March 31st!", was for continuity buffs and casual readers to catch as many mistakes as possible. Prizes which included original art were awarded for the most errors found. Swan even got to draw himself and buddy Stan Kaye in one panel, watching Clark Kent change into his not-so-secret identity.

©DC Comics

*Swan's gift for realism strangely complimented some of the more tongue-in-cheek situations he was called upon to depict. When the stories got weird, comic or campy, Swan's artwork lent believability to an otherwise ludicrous situation.*

©DC Comics

©DC Comics

# Swanderson and Beyond

There were likely two reasons that the art gradually became slightly less appealing from 1965 through the end of George Klein's run as Curt's inker in 1968. The first reason appeared to be due to a decline in Klein's inks. Facial details were slightly less distinct, characters' expressions less consistent; chins became a bit too round, ears a little cauliflowery. Eventually, male hairlines began to recede a little too much, even on the Man of Steel himself. The latter reason, however, may have been due to the penciler's subconscious efforts to naturally age Superman after working on him for so many years, and as Curt himself hit middle age.

The second reason for a slight decline in Swan's art was because he started to design more of his comic-book panels with less detail. In the pages of Superman, he drew larger, simplified figures that took up more space, allowing less room for additional characters and backgrounds. This became more prevalent after he also became the regular series artist for the Legion of Super-Heroes, beginning with *Adventure Comics* #340 in January, 1966. While still

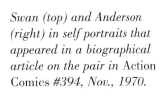

*Swan (top) and Anderson (right) in self portraits that appeared in a biographical article on the pair in* Action Comics #394, Nov., 1970.

doing beautiful work, he grew to detest the Legion assignment because of the multitude of characters he had to portray therein. His problem was the opposite from the one faced in Superman. In the latter title, he rendered The Man of Steel larger in order to save time. In *Adventure Comics*, Swan was forced to pencil the heroes smaller and sometimes with less clarity, so that more of them could fit in each panel per script requirements. He had a limited duration each month to illustrate the many pages for that time-consuming series, for *World's Finest Comics*, for *Superman*, and occasionally for other books in the Superman family. Curt may have been simply overworked.

The above statements might appear blasphemous to the thousands of fans whose favorite issues involving the Legion of Super-Heroes were the stories penciled by Curt and written by Jim Shooter. But they were not meant to be. Even a slightly looser Swan was still the perfect choice to draw the many colorful costumes and personalities of the Legionnaires. He was the artist whose work on such chromatic characters in a brightly portrayed future would be the most diminished were it not in color. And who better to render the hormonally rampant emotions on these super-teenagers' faces, as scripted by the young Shooter? Besides, things soon changed and Curt's art became more exciting!

One factor was that the page size for the original art was reduced not long after Swan began working on the Legion's monthly adventures. The smaller overall dimen-

sions made it harder to put as much detail into each panel. Much later, Curt told his friend Raul Wrona that he liked the new page size precisely because it matched his needs, allowing him to be more productive while working a little less hard. There was another benefit; it was easier to see the entire page to better envision its overall design. That, combined with the fact that Swan eventually asked Shooter to put fewer characters in the stories so he wouldn't have to keep up with so many heroes' costumes, etc., perhaps freed him to experiment more. Not only did he begin to alter his panel arrangement, but he tried new perspectives and unique figure positioning.

While under tremendous deadline pressure, Curt was a creative force and an innovator in other ways. For example, in *Adventure Comics* #'s 359 and 360, almost as an aside, Swan was asked to come up with new uniforms for eleven Legionnaires which still symbol-

ized their individual powers. He made it look easy, and this was only a small part of the demanding storyline in those two issues.

Meanwhile, the writing of the stories that Swan penciled in *World's Finest Comics* was becoming increasingly trite. After several well-written novellas, there were eventually too many imaginary stories. These were often contrivances to pit Superman against Batman, "clash(es) of cape and cowl," to borrow the title from *World's Finest* #153.

Sheldon Moldoff, an excellent illustrator whose contributions to comics are legendary, was inking more Swan stories. Eventually, George Klein left DC (in 1968) for a short but brilliant run as an inker at Marvel, and Jack Abel was assigned as a replacement inker in addition to Moldoff. Swan was averaging two pages per day by now if they were difficult, occasionally three or four if they were not. His drawings looked less luminous with the heavier line of Abel, the beauty of his penciling more obscured. On the other hand, the different look afforded by these and other inkers over the years, when seen infrequently, was a nice change.

Ross Andru's longtime partner Mike Esposito even had a fling working over Curt's illustrations around this time, mostly in the pages of *Superman* and *Lois Lane*. By phone on July 31, 2000 Mike explained that previous teamings with Ross on features such as *Wonder Woman* and the *Metal Men* had come to an end. Besides being reassigned to *The Flash* and some Superman stories with Andru, Esposito wanted to "do other guys if I could." The opportunity first arose to ink Swan when for some reason, a story which Curt had penciled would have been late to the printer had he not stepped in. Mike described artists such as Ross Andru, Jack Kirby and Joe Kubert as being very con-

cerned with shapes and designs. Kirby, especially, was "very decorative," but "Curt, he never designed; he really drew!" Esposito was always impressed with the realism "this handsome guy" brought to the page.

Though perhaps less decorative than some of his peers, Swan did begin employing a greater diversity of panel design as he headed for the next zenith of his career. *Action Comics* #370, "100 Years... Lost, Strayed or Stolen!" from December, 1968 was an early tale for writer Cary Bates. Curt, with

*Bottom left: Jack Abel's casual, spontaneous inking style stood in sharp contrast to George Klein's precision. This example of the Swan/Abel team's artwork is from* Action Comics #372, Feb., 1969.

*Below: A 1970 teaming of Swan with another loose inker — George Roussos, from* Action Comics #386, Mar., 1970.

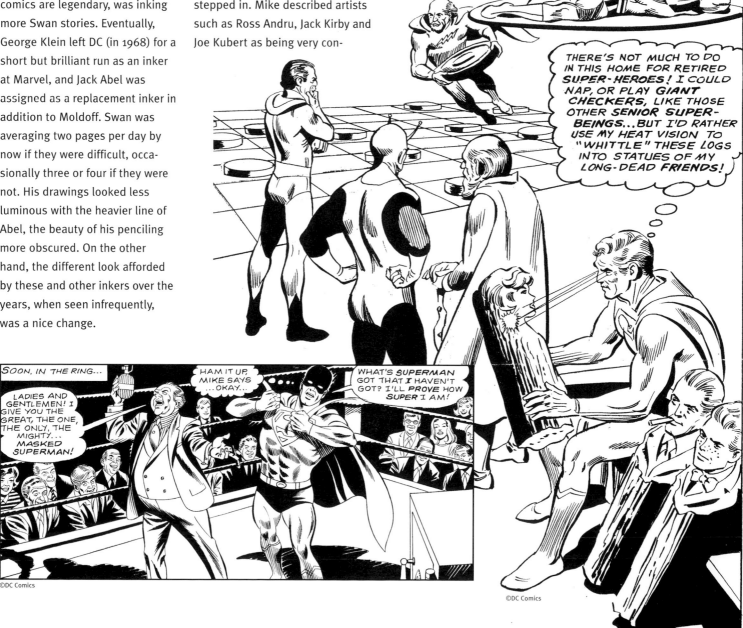

©DC Comics

©DC Comics

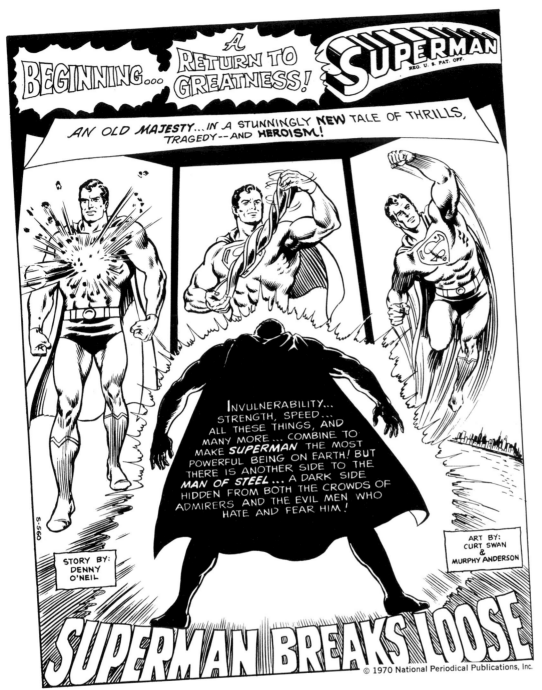

© 1970 National Periodical Publications, Inc.

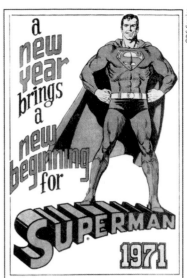

©DC Comics

*Above: With this splash page, a new era for Superman was ushered in under the guidance of Julius Schwartz, and fans were treated to one of comics' most admired art teams — Swan and Murphy Anderson.*

*Above right: The DC house ad announcing the changes coming to The Man of Steel (Both from* Superman *#233, Jan., 1971.)*

inks by Abel, aptly gave the thirteen-pager an epic feel. Kal-El's journey from doomed Krypton to Earth was interrupted as he moved from infancy through his entire lifespan on an alien world before being de-aged and sent here to be found by the Kents. Gone was the stodginess of six square panels per page, replaced by angling and flow. Curt was now designing his layouts with dynamic progression from one drawing to the next.

It should be noted that he had been doing panel experimentation for some time, but this was a standout example. Carmine Infantino was now editorial director of DC Comics. Curt has acknowledged the debt he owed Carmine for helping him mature as a comic-book artist and panelologist/designer.

Mention should be made of the final new story supposedly under the aegis of Mort Weisinger, but probably edited, in actuality, by E.

Nelson Bridwell. It spanned two issues of *Superman*, #'s 230 and 231 in Oct. and Nov., 1970. The story was another imaginary tale, whose ilk had grown tired. But as a tribute to past glories, it was a fitting sendoff to the Weisinger years. It was also the first time artist Dan Adkins inked Swan's pencils. There was a feeling of dejá vu, Adkins' work being somewhat reminiscent of George Klein's.

During all his years in comics, Curt inked only a few of his own pages. Two of them appeared in early 1971, introducing Superman's "...new beginning..." This ad, which included a full page pin-up of The Man of Steel astride his own logo, has stood out to fans and those in the business for years. The inking was fine-lined, precise, and one could finally see how the master fully interpreted DC's signature character.

## THE SECOND ZENITH

The three-parter spanning *Action Comics* # 385 through #387, scribed by Cary Bates, ran from February through April, 1970. This story incorporated the science fiction concept of time curving back upon itself so that the end of time eventually merged with the begin-

ning. Kal-El aged a million-plus years as he propelled himself into the future before finally being reborn at the proper time in history.

The three covers of a weatherbeaten hero were an early showcase for what became known as the Swanderson team. The term "Swanderson" aptly described the seamless melding of Curt's pencils with Murphy Anderson's inks.

The two artists actually began working together six months earlier, producing beautiful covers for all of the titles of the Superman family. Their first interior art appeared soon after in *Action Comics*, when the book was edited by Murray Boltinoff after Mort Weisinger retired. But it was not until the publication of *Superman* #233 in January 1971, when a different editor was assigned to the title, that the Swanderson pairing achieved legendary status.

## THE SCHWARTZ REIGN BEGINS

By this time, Swan had long since become adept at working on the reduced size of the blank pages supplied by DC for original art production. His storytelling was more streamlined, with less background

detail than at the time of his first zenith. But the larger figures in each panel were a pleasure awaiting the reader's focus. This issue, titled "Superman Breaks Loose," could as easily have been called, "You will believe a man can chew," as Curt realistically portrayed the Man of Tomorrow devouring a piece of Green Kryptonite, turned to harmless iron a few pages earlier.

Incidentally, *Superman* #233 marked the approximate halfway mark in Curt Swan's illustrious comics career.

Julius Schwartz, on board DC since 1944, was now the editor of *Superman*. He would also assume the helm of *Action Comics* the following year (1972). Schwartz brought in a youthful infusion of scripters to the Superman line. They included Denny O'Neil, Elliot S! Maggin and Len Wein. Cary Bates was utilized more than he had been under Weisinger.

Curt Swan was more than able to keep pace with these young men, beginning with writer Denny O'Neil as he wove the tapestry of a multi-issue saga running from *Superman* #233 through #242 (with time off on #239 for a giant reprint issue). This was the famous tale involving

the Sand-Being from Quarrm, in which, not only was all Kryptonite on Earth eradicated, but The Man of Steel's powers were halved in order to make him struggle more to overcome future obstacles. In an attempt to give his foes a fighting chance, Superman, who had become too powerful over the years, was taken down a notch.

Actually, the Sand-Being wasn't the featured antagonist in all of the issues listed above, but rather an ongoing thread loosely tying the stories together. Though sub-

*Superman snacks on inert kryptonite — the Swanderson team's eye for character and facial expression really sells this classic moment from the landmark* Superman *#233.*

*A cartoon that appeared next to Swan's entry in the 1972 National Cartoonists Society Directory.*

©DC Comics

*Art on these pages is from Swan's all-time favorite job: the collaboration of Swan, Carmine Infantino and Murphy Anderson for a Superman origin recap. (Amazing World of Superman, Official Metropolis Edition, 1973.)*

plots had been present since Lois first thought Clark was a wimp in *Action Comics* #1, June, 1938, Julius Schwartz, along with the new writers, introduced a more modern form of storytelling to the Superman cast of characters. They gave the stories a continuing serial/soap opera feel while still having each tale end in one issue as far as defeating the major foe of the month.

One of the more bizarre cliffhangers ever to be done in comics involved The Man of Tomorrow becoming psychically joined with a lynx and a boy named Billy Anders. The storyline by Denny O'Neil began in *Superman* #'s 253 and 254 in June and July, 1972. Swan, always wonderful at drawing children, now also had to occasionally portray The Man of Steel with the head of a lynx coming out of his noggin. In an attempt to promote characterization and make the hero's life more complicated

by further linking him to mere mortals, the point of absurdity had been embraced and surpassed. At the same time, there was a certain charm to having a kid help Kal-El now and again, and Curt's penciling was one of the primary reasons for that charm. This was O'Neil's swan song on Superman and, mercifully, Cary Bates

wrapped up this plotline in the only followup "Lynx" issue, *Superman* #259.

Some of the other subplots from this era included turning Clark into a television news reporter in order to make it harder to change to Superman while on the air. There were the introductions of new media mogul boss Morgan Edge and T.V. sportscaster Steve Lombard. The latter always attempted to make Clark look like a fool while ultimately achieving that goal himself. Curt adeptly portrayed the subtleties of everyday events involving all of these characters.

Though a little more Earthbound than he had been in the '60s, probably an editorial decision to increase realism, Superman still occasionally traveled in outer space. It would have been a shame had he not, as Murphy Anderson did some of the best-ever inking of stars and nebulae. He was also using wash techniques to stunning effect on interior panels.

One of the all-time best stories to meld the cosmos-spanning with relevant social issues occurred in *Superman* #247. It was a credit to editor Schwartz that he allowed heroes with such great powers as Superman to address problems without pat answers. In that issue, he grappled with the matter of human rights for poorly paid migrant farm workers. As written by Elliot Maggin, the tale began when Green Lantern's Guardians of the Universe planted a seed whereby Kal began to realize that if he always charged in to solve others' problems, they grew needy and less self-sufficient. This example stood out as a showcase for Curt Swan's artistic versatility. He switched seamlessly from Superman saving our galaxy by diverting a pod full of deadly spores, to the world of Oa with its giant power battery, to central California with a fruit-picking populace attempting to strike for better pay.

as when Superman was in flight. One might see just The Man of Steel's torso as he flew toward the reader, obscuring the lower extremities. Or the reader might have a unique view from underneath, glimpsing the soles of his boots, or the bottom of his chin as Superman quickly exited a panel.

At times, Kal-El looked more introspective, his brow furrowed with Murphy Anderson's smooth lines, as he thought of a way to solve the latest dilemma. He was a more mature looking hero during the time of this zenith. Also, those trademark Anderson abdominal muscles were prominently displayed.

By this time, Curt had also become a master of anatomy. Gone were the days when, occasionally, Superman's arms were a little too short, as on the cover of *Action Comics* #300, May, 1963 (it did increase the dramatic effect on that earlier cover, however).

Swan also began to experiment more with different perspectives,

By mid-1972, Swan's second zenith was coming to an end, though Murphy Anderson would continue as his regular inker in Superman and Action Comics through the end of 1973. There was a line or two less of wisdom and expression on Superman's face. Perhaps by that time, editor Julius Schwartz had insisted that The Man of Tomorrow look no older than age twenty-nine. Also, Swan's layouts had once again become a bit more conventional, with generally more panels to a page than a year or two earlier. Consequently, figures were drawn smaller and were a little less stunningly beautiful. Also, the quality of the comic book printing itself had taken a nosedive. It was a bit harder to imagine that Anderson had inked every hair drawn on Superman's head.

*The Swanderson team's Man of Tomorrow side-by-side with pop artist Andy Warhol's 1981 screenprint on Lenox Museum board. Warhol brought Superman into the world of Fine Art while at the same time poking fun at the character's overexposed image and his commonality with other well known trademarks.*

© 1981 Andy Warhol Foundation for the Visual Arts

In succeeding years, there were occasional jobs in which Murphy Anderson served as a guest inker over Curt's pencils (some are discussed later). Those Swanderson teamups were always a welcome return to greatness. One of their final pairings was a limited edition lithograph produced for sale in Warner Bros. Studio Stores around the country in the mid '90s.

Nearing the end of the first thirty years of Curt Swan's comics

*Swan's skill with figure balance and expressive posture are used to ominous effect in a scene from* Superman *#233.*

freshen his storytelling approach and so asked Carmine to lay out a story for him. Infantino saw this as the perfect excuse to do something special. Originally done in black and white using wash techniques in some panels, "The Origin of Superman!" has since been reprinted in color a couple of times.

By the mid '70s, a new fellow had established himself as Curt's chief inker. Previously known in large part for his work on several DC

America membership status was eventually restored. It was one of the few times Swan would come close to illustrating that august group, as he got to draw several members aboard the JLA satellite discussing Wonder Woman's plight. He would also contribute a couple more issues to this ongoing storyline, which ended in early '76.

## WHO TOOK THE SUPER OUT OF SUPERMAN?

One of the happier aspects of Julie Schwartz' serial feel to the stories appearing in the Superman titles was a deepening relationship between Lois Lane and Clark Kent. As a couple, the pair was no longer stagnant like they'd been to this point in their history. Though there would be down times along the way, Schwartz and his writers allowed the two to develop a mature, loving relationship that would eventually lead to marriage (though it would take another twenty years, with Schwartz no longer at the helm). A real turning point occurred in the four-part story written by Cary Bates and Elliot S! Maggin that took place in *Superman* #'s 296-299, February through May, 1976. That saga is remembered by most from the title of the initial entry, "Who Took the Super Out of Superman?" Swan penciled and Oksner inked the tale of Mr. X, or Xviar (alias Xavier), an alien who took away The Man of Steel's powers whenever he wasn't wearing his super-suit. This plot device meant that Clark once again became a dominant character in his own right. Curt drew him with a subtle change in his expressions and body language. Kent appeared a little threatening when provoked, a bit more interested

IT IS A *THING* CREATED FROM SOIL AND ROCK AND A BURST OF RAW ENERGY...CAST IN THE MOLD OF *SUPERMAN*...

...AND IT *LIVES!* LIKE SOME NIGHTMARE CREATURE, IT PLODS TOWARD THE DISTANT MOUNTAINS...

...AND TOWARD THE VILLAGES AND TOWNS AND CITIES BEYOND...

...MOVING SLOWLY, RELENTLESSLY TO A TERRIBLE DESTINY...

END

©DC Comics

career, it would be remiss not to mention perhaps the artist's favorite assignment. *Amazing World Of Superman, Official Metropolis Edition*, was an oversized cardboard cover affair released in 1973. Three of the finest comic-book artists ever to grace the medium worked together on The Kid from Krypton's beginnings. Swan penciled from Carmine Infantino's layouts, and Anderson inked. On October 14, 2000, Infantino explained that during that period in the early '70s, Curt had come to the office to make a request. He wanted to

humor titles, Bob Oksner provided a solid line that evolved into a slightly more rounded, more muscular Man of Steel. The torso, biceps and forearm muscles became a bit more exaggerated. Oksner's first inking over Swan on Superman began in the Oct., 1973 issue, #268.

At the time of *Wonder Woman* #212, July, 1974, Julius Schwartz had also assumed editorship of that title. He assigned Curt (inked by Tex Blaisdell) to the interior art for a story titled, "The Man Who Mastered Women!" This was part of a multi-issue saga in which The Amazon Princess' Justice League of

and content when with Lois. Incidentally, issue #297 drew media comments asking if Clark and Lois spent the night together when they were seen from the rear entering his apartment on the last story page. In the second-to-last panel, the door was now closed with Lois saying, "All right, Clark...no more shop talk tonight!" Clark answered, "Want to see something, Lois? I've got this great romantic view of the apartment across the street..."

Earlier, *Superman* #338, August, 1979 was noted as the comic book wherein Kandor was finally enlarged. The inspired art and storytelling matched the event as Frank Chiaramonte inked Curt's pencils on an extra-length tale (for that time) of twenty-three pages.

The opening scenes were dramatic as Superman had to don a specially-insulated spacesuit, rare before there were toy lines requiring extra gadgets and costumes designed to sell more product. The protective suit was to survive flying into a supernova in order to harness the expanding energy necessary to enlarge the Bottle City. This tale packed more elements into a single story than any in years, including a shrinking battle with the space villain Brainiac, a major guest-starring part for cousin Kara (Supergirl), and the return of Kal-El's cousin Van-Zee in a pivotal role for the first time since the Silver Age. The writer was Len Wein, the editor Julius Schwartz.

It was nice to see Superman keep his longtime promise to restore

the Kandorians to full size, made under the previous editor's direction. Rarely has a sixteen-year storyline been allowed to reach fruition with everyone still in character. Having the same penciler that had depicted so many of Kandor's best remembered tales provided a valuable link.

*These panels from* Superman *#248 (Feb., 1972) show the combination of intelligent composition and the graceful rendering of space, form and shadow that made the Swan/ Anderson team one of comics' best.*

*Kandor is enlarged at long last in this scene from* Superman *#338 (1979).*

# New Glories in the '80s and '90s

While still the primary Superman artist, Curt had the occasional opportunity to pinch hit for others on different titles in the early 1980s. There was a wonderful outing on *The New Teen Titans* #5, March, 1981. One could see how that series' "inker extraordinaire" Romeo Tanghal embellished his pencils. And Swan departed from

*The animosity between Superman and his greatest foe reaches a new intensity in this scene from* Action Comics #544, June, 1983.

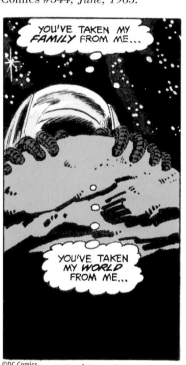
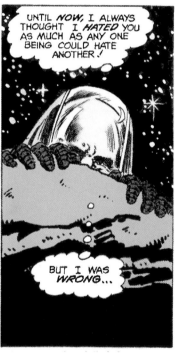
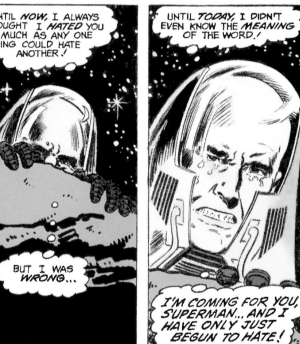

©DC Comics

YOU'VE TAKEN MY *FAMILY* FROM ME...

YOU'VE TAKEN MY *WORLD* FROM ME...

UNTIL *NOW,* I ALWAYS THOUGHT I *HATED* YOU AS MUCH AS ANY ONE BEING COULD HATE ANOTHER!

BUT I WAS *WRONG...*

UNTIL *TODAY,* I DIDN'T EVEN KNOW THE *MEANING* OF THE WORD!

I'M COMING FOR YOU, SUPERMAN... AND I HAVE ONLY JUST *BEGUN TO HATE!*

Swan's art as one of his primary inspirations. There were further guest shots for Curt on Titans-related series written by Marv Wolfman over the next ten years, extending into the early nineties.

Wolfman also challenged Curt to become a more exciting storyteller in the pages of *Action Comics* from 1980-'84. In these issues, more than the usual number of panels were often required to quicken the pace. At other times, the large scale action required one and two-page spreads. Villains would appear and then vanish, sometimes working their machinations offstage for several issues before returning to

his usual layouts to pace the story quicker with more images and panels per page, á la regular Titans artist George Pérez. He did a great job, and his attempt at "modern storytelling" was compatible with what had been done in the first four issues. But then, this should not be surprising considering that Pérez has listed

wrap up dangling plotlines. The opposite occurred in *Action* #514, Dec., 1980 when old foe Brainiac became benevolent. He spanned the cosmos for a year-and-a-half to undo past wrongs, finally returning in *Action* #'s 528-530, Feb.-Apr., 1982 to help Superman save the Earth. Swan was allowed to portray emotion on a walking com-

puter who had regrets, earning the right to be called "he" instead of "it" for awhile before being programmed again for evil.

The fiftieth issue of *DC Comics Presents*, October, 1982, had a special anniversary tale written by Dan Mishkin and Gary Cohn. It was yet another take on the "Superman and Clark Kent separating into distinct individuals" concept. However, there was an updated feel to the storytelling. From a letter by the author which saw print in issue #55 of that title: "Clark and Superman have been split many times in the past, but they never forgot they were the same person till now! This allowed for very interesting characterization. Clark truly received a distinct personality, and even found fault with his former alter ego for failing to remain close to the earthlings he sought to protect. Superman lost the 'humanness' that he could have developed only from following the role model provided by the Kents... A story of such strong characterization was fittingly illustrated by Curt Swan and Kurt Schaffenberger."

*Action Comics* #544, June, 1983 was an extra-long comic celebrating forty-five years since The Man of Tomorrow's debut in *Action Comics* #1. DC's chief Superman artists at that time, Curt Swan and Gil Kane, drew the first and second

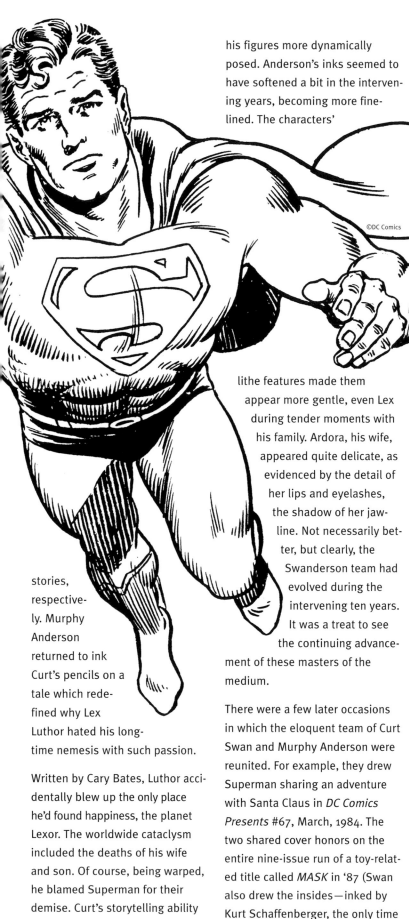

his figures more dynamically posed. Anderson's inks seemed to have softened a bit in the intervening years, becoming more fine-lined. The characters'

©DC Comics

lithe features made them appear more gentle, even Lex during tender moments with his family. Ardora, his wife, appeared quite delicate, as evidenced by the detail of her lips and eyelashes, the shadow of her jaw-line. Not necessarily better, but clearly, the Swanderson team had evolved during the intervening ten years. It was a treat to see the continuing advancement of these masters of the medium.

There were a few later occasions in which the eloquent team of Curt Swan and Murphy Anderson were reunited. For example, they drew Superman sharing an adventure with Santa Claus in *DC Comics Presents* #67, March, 1984. The two shared cover honors on the entire nine-issue run of a toy-related title called *MASK* in '87 (Swan also drew the insides—inked by Kurt Schaffenberger, the only time he penciled a regular monthly title for its entire run).

stories, respectively. Murphy Anderson returned to ink Curt's pencils on a tale which redefined why Lex Luthor hated his long-time nemesis with such passion.

Written by Cary Bates, Luthor accidentally blew up the only place he'd found happiness, the planet Lexor. The worldwide cataclysm included the deaths of his wife and son. Of course, being warped, he blamed Superman for their demise. Curt's storytelling ability had continued to evolve; his panel layouts were more contemporary,

Work on that series actually began for Curt in the spring of '86, just after he was no longer the primary artist on the Man of Steel. In a letter dated May 7, 1986 he wrote: "I've been assigned to the '*MASK*' feature and am at present mid-way through a story. I just hope that I can get the 'feel' of it ere long so that I'm comfortable with it. Needless to say it's going very slowly what with the number of characters and tricky vehicles involved. Maybe you're familiar with the Kenner toy line labeled "M.A.S.K." — It's a take-off on that. In any case, I shall survive."

*A troubled Man of Steel flies out from the cover of* Action Comics #583, *Sept., 1986. This issue ushered out the Silver Age incarnation of Superman and marked the end of Swan's dominance on the character.*

*Swanderson artwork for the first issue of one of DC's toy license comics,* MASK *(Feb., 1987).*

©DC Comics

"But know this, Eddy, I expect to keep penciling away so long as D.C. will have me..."

From another letter dated Oct. 9, '86: "...the *MASK* issues should be coming out soon, I think. I do believe the change has been good for me but more importantly I'm being kept as busy as I wish to be..."

Curt and Murphy were again paired for thirty interior pages of an unusual Batman project in 1992—a special Canadian-printed comic book written by Len Wein. Beautifully drawn in a way that matched the story's gentle tone and low-key message promoting literacy, it was titled, "A Word to the Wise...!" At the end, Batman got to hog-tie The Joker during a rodeo in Alberta.

*Pencils of the understated but moving reunion between Super-cousins from* Superman *#423, Sept., 1986.*

Nothing was more fun than when DC invited its readers to a surprise 70th birthday party for editor Julie Schwartz in the pages of *Superman* #411, Sept., '85. Unbeknownst to Julie, this comic book was released between two issues of a continued storyline. The lighthearted tale featured the Julie of our Earth and his doppelganger from a parallel dimension. Naturally they made his double a bum! The Swanderson team obviously had a great time with this one, as did writer Elliot S! Maggin. Dick Giordano did the cover honors, drawing a cake with candles and the whole shmear.

Besides the occasional inks of Anderson and others, Swan's chief embellisher during the late '70s, early '80s was Frank (Francisco) Chiaramonte. Next, Dave Hunt loaned his clean, distinctive inking style to the work. During the mid-1980s, comic book/strip legend Al Williamson delineated Curt's pencils on Superman. In the book *Superman at Fifty! The Persistence of a Legend*, Curt stated that, for the record, Williamson was his favorite inker. He wrote of his "flair." Indeed, Williamson's varied line did lend itself to excellent reproduction in the telling of a good story.

## THE THIRD ZENITH

The third zenith in Curt Swan's career showed a mature flowering of his talent as he tapered off more than two decades as the dominant Superman artist. This occurred around the time of the two-issue "last Superman story" in *Superman* #423 and *Action Comics* #583, Sept., 1986. Swan and editor Julie Schwartz were planning to leave the character to younger men. Perhaps because he realized it was the end of an era for both he and Superman, Curt's work seemed newly invigorated. In addition to the hint of more background detail, Swan gifted additional expression to The Caped Kryptonian's underlying visage. A raised eyebrow, a shoulder thrust toward an antagonist to invade his space, he gave Superman an edge, an extra sense of toughness. Though more formidable, however, Kal-El continued to be at his most tender as portrayed by Curt when the script required. And regarding the "last Superman" script, Swan said it drove him a little crazy because of its minutiae. He joked that by the time he finished reading each long panel description, he couldn't remember what the heck he was supposed to draw. But fans can only express their eternal thanks to writer Alan Moore. He challenged Curt to revisit many friends and foes from the Silver Age of Comics in what was one of the grandest imaginary tales of all! How fortunate that Julie Schwartz picked Moore after his first choice, Superman co-creator Jerry Siegel, couldn't write the story because there wasn't time to resolve some legal issues.

## THE FOURTH ZENITH

The first three zeniths gained something through the interactions and contributions of others. The last was a solo effort. Its onset more or less coincided with the third zenith in the mid-eighties but continued on until the end of Swan's life. As his published comic book output began to dwindle, he accepted more private commissions. It's a tribute to everything he stood for that Curt strove to improve his craft on these unpublished pieces, done for individual enjoyment and occurring out of the limelight. Murphy Anderson, when interviewed, mentioned that had life unfolded differently for his friend, he could have become a fine illustrator. Curt probably came closest to achieving that goal at this time.

His private commissions underwent three phases of evolution. First, Swan began inking his own pencils with increasing frequency. Next he also began coloring the works, and what an excellent colorist he was. Finally, Curt chose to return solely to penciling, but often with exquisite shading to add more lifelike detail. His mastery of the pencil provided a greater dimension of depth than any of his inkers could give him.

## A STINT ON THE KING OF THE SEAS

Some of the most beautiful Swan art released during the last decade of his life was produced not only for The Caped Kryptonian, but for a fellow Justice League member who did not have his own title at the time. The King of the Seas, Aquaman, was relaunched with a forty-four page special in

1989 followed by a five-part miniseries. Inks on both were laudable. For The *Legend Of Aquaman* one-shot, Eric Shanower embellished Curt's pencils; for the miniseries, Al Vey. Shanower's feathery, graceful style was a wonderful complement to Swan's delicate pencils. Though by this time, Swan had illustrated just about everything that could be depicted on a printed page, the opening scenes of *The Legend Of Aquaman* were a chance to renew a kinship with nature—the ocean's solitude.

*A spectacular sea battle from Swan's stint on* Aquaman *(1989).*

*At right, a true oddity from late in Swan's career — a cover for Spotlight Comics'* Mighty Mouse #2 *(1987). Inks by Frank McLaughlin.*

When he portrayed the underwater architecture of Atlantis, he gave it a seashell motif with a bit of scalloping. It was obviously good for Swan to stretch his artistic legs illustrating the exploits of a different superhero.

Al Vey grew as an inker during the course of the subsequent Aquaman miniseries. Two years later, when he again embellished Curt's pencils on *The New Titans* #81, December, 1991, one could see a melding of what had gone before, including elements of George Klein and Murphy Anderson. Without altering Swan's art, it was enhanced. It's fitting that Vey went on to collaborate so eloquently with George Pérez, Swan admirer and artist extraordinaire, on *The Avengers* for Marvel.

*This offbeat round-robin series featured disparate writer/artist teams that often tackled unfamiliar characters. But when the dust cleared Curt was still penciling Superman, here inked by the great Terry Austin. (Aug., 1986.)*

Interestingly, while responding to a critical review of the *Aquaman* miniseries, a letter Al Vey wrote to *Comics Buyer's Guide* newspaper in the March 31, 1989 issue included the following: "... I hope this improves your opinion of the Aquaman project. I am having a great deal of fun working on it. Inking Curt Swan is a dream come true for an oldtime fan like me and Curt's pencils are stunning. An aside to you readers — give it a look!"

## END OF AN ERA

It's been said that after all his years drawing Superman, it was unfair to take Swan off the monthly books in 1986. But Curt himself once stated he felt relieved to hand John Byrne (and soon others)

his pencil, having nothing left to say about the character with his art. Obviously, he changed his mind, because almost immediately after being "retired" from Superman, Swan could be seen drawing—Superman! It was both an odd and wonderful surprise to see him drawing his old friend again so soon.

The Dec., '86 issue of *Who's Who: The Definitive Directory of the DC Universe* #22 had the old guys enhanced by the new when Jerry Ordway inked the Golden Age and John Byrne inked the Silver Age Superman in two pin-ups penciled by Wayne Boring and Curt, respectively.

Other special projects on which he delineated Kal-El around this time included a *History of the DC Universe Portfolio* pin-up, 1986; *Superman IV — The Movie Adaptation*, 1987; and *The Earth Stealers* graphic novel, 1988. Also in May, '88, Curt drew a chapter for the 600th anniversary issue of *Action Comics*. This was followed immediately by him being given the assignment of drawing The Man of Steel not monthly but weekly for the comic book in which the hero had first appeared in 1938. More on that in the next chapter.

After Swan's last regular run on *Action* ended, the '80s were drawing to a close. While attending the International Superman Exposition in June, 1988, Curt was delighted to be asked his opinions about the direction Superman should take in his various books (see Roger Stern's and Jerry Ordway's interviews). That meeting was the first of what became known as the "Super-Summits." One result of these summits was that The Man of Tomorrow began to appear in an increasing number of extended storylines, sequences which ran through each of the titles that featured the lead character. Curt would occasionally be recalled to pencil portions of these multi-issue tales right up to the time of his death. Stories like "Krisis of the Krimson Kryptonite" and "Last Sun of Krypton" in '90 and '91, respectively, were good examples. There was even a "Curt Swan Month" in which he drew all of the related books with an Oct., 1990 publication date.

The last time that Swan would pencil a long sequence with the adult Man of Steel in all-out action

©DC Comics

*The Super-gladiator from* Action Comics Annual #2 *(1989).*

was for an eighteen-page chapter in *The Adventures of Superman Annual* #2, 1990. It was written by Dan Jurgens and beautifully inked by John Byrne. However, Curt's final major contribution to a true epic occurred in 1989 during the "Superman: Exile" saga. Now under the direction of editor Mike Carlin, some of the star-wandering wonderment that had long been a part of the Superman titles returned over the course of several months. Kal-El felt he'd become a threat to Earth and banished himself into space. His self-imposed exile was also punishment for breaking his code against killing, after executing three Kryptonian killers in the cosmos' best interest. A pivotal chapter occurred in *Action Comics Annual* #2, 1989. Curt, along with a great team of then-current writers and artists,

portrayed a captured Superman, forced into the role of gladiator on a prison planet for the villain Mongul's amusement.

Though he didn't illustrate any of the fight scenes, Curt's ability to render a bearded Kal-El, wearing nothing more than some leather straps and his strategically placed cape, was unsurpassed. Swan's crucial role in the book was to capture the look and mood of a displaced and weakened but defiant hero. His work integrated smoothly with the book's other pencilers, Mike Mignola and Jerry Ordway.

A letter by the author about *Action Comics Annual* #2 was printed in *Superman* #36, second series, October 1989. An excerpt: "By the way, I loved Superman's costume in the current storyline. Even the

artistic license taken to clothe The Man of Steel with his cape was great. By that, I mean there ain't no way Superman's cape is long enough to cover his frontside and his backside. And the line from [the] last panel on page 9, is priceless: 'Ma said to wear it... wherever I go.' If Ma Kent told her son to always wear his cape, you can bet your boots she must have said something to him about keeping his trunks on as well."

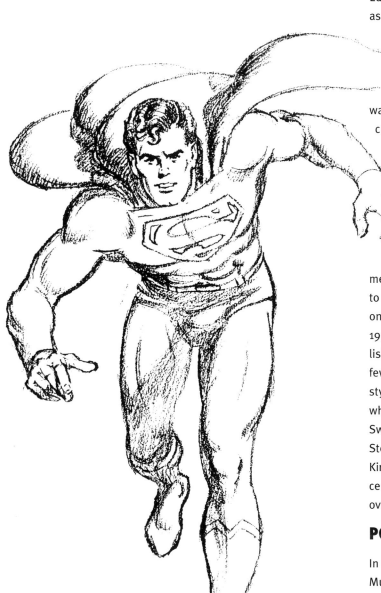

©DC Comics

Some of Swan's final work on The Man from Krypton appeared without a cover byline under the direction of another editor, KC Carlson. Fittingly, he was asked to pencil the space villain Brainiac for the umpteenth time in three of the related monthly titles dated July (and the fourth, dated Aug.), '96.

## THE LAST REGULAR SERIES

Editor Mike Carlin assigned Curt as the semi-regular penciler on *Superboy, The Comic Book* after the initial artist, Jim Mooney, went on hiatus. The comic was based on a successful, then-current television series. In July/Aug., 2000, Mr. Mooney wrote, "I had to leave it because of a cataract operation, and I wasn't able to draw for awhile afterwards. I knew Curt Swan but not well. We met only a few times. I found him to be a nice person." Curt's stint on that title lasted from 1990 to 1992. His pencils were embellished by Ty Templeton for the first few issues. Ty's clean, bold inking style had improved to the point where it beautifully enhanced Swan's classic look on The Boy of Steel. Later issues were inked by Kim DeMulder, a bit more reminiscent of Al Williamson's '80s work over Curt.

## POSTHUMOUS HONORS

In 1984, Curt Swan (along with Murphy Anderson) was presented with an Inkpot Award at the San Diego Con. A few years after the convention was renamed Comic-Con International, DC publisher Paul Levitz accepted an Eisner Hall of Fame Award posthumously on

Curt's behalf (in 1997). But it is perhaps the tributes paid in the comic books themselves after he died that would have meant the most to him.

One was a ten-page tale which he'd previously penciled, written by Dennis O'Neil, that appeared in *The Batman Chronicles* #6, Fall '96. It was about the macabre but humble beginnings of Gotham City. Curt stepped out of the superhero realm to set a mood of murder and mystery as he transported us back at least one hundred-fifty years with his art. The fact that O'Neil wrote one of the last stories which Swan illustrated was apropos, considering he was there at the start of the second half of Curt's career (*Superman* #233). Things had come full, or at least half, circle. Aptly, at the top of page one was a note from the editors: "This issue is dedicated to the memory of Curt Swan. Without him, growing up a comic book fan will never be the same."

December, '96 was the publication date of *Superman: The Wedding Album*. Many creators who'd figured in the Man of Steel's long-lived success provided words and pictures. In light of his past contributions, five previously unreleased pages penciled by Swan and inked by Jackson Guice were written into the story. Curt was drawn as a guest at the wedding ceremony of Clark and Lois. Other real-life persons, including co-creators Siegel and Shuster, were likewise portrayed as either guests or participants.

From intact memorials of Kal-El's forebears floating in space or residing in his Fortress, to museums dedicated to Superman and other heroes, to anniversary

government agents. During drawing class, he said, "... An artist's job is to see... not to dehumanize... Search any face, and you'll find some dignity, some strength, some tenderness, some intelligence." Another perceptive line captured one of Curt's character traits; "Fortunately, your Mr. Swan was here to transmit his liberality... and you were receptive." In real life, Swan had a dream of moving to Boca Raton in semi-retirement to teach his craft at the International Museum of Cartoon Art. This posthumous tribute comic book was as close as he came to the role of art instructor. The book's final message read, "In memory of—and gratitude to—Curt Swan: Honorary Legionnaire."

*As this scene from the early '90s* Superboy, the Comic Book *shows, Swan had lost none of his storytelling chops at the end of his career.*

*Legion of Super-Heroes #92 (May, 1997) paid tribute to the legacy Swan left current and future generations of comic book creators.*

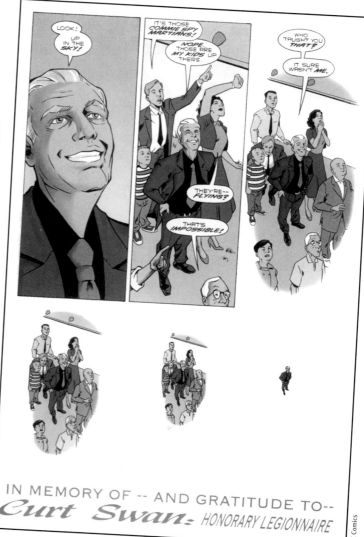

IN MEMORY OF -- AND GRATITUDE TO-- *Curt Swan:* HONORARY LEGIONNAIRE

issues, statues were a recurring motif in the stories that Swan illustrated throughout his long career. He possessed a remarkable ability to render them realistically, whether they were made of bronze, marble, granite, plaster, gold or silver. Perhaps this was due to the "instructions" he gave the inkers via his delicate pencil shading techniques. How fitting then, that DC memorialized the artist in some of its comics dated Oct., 1996. They reprinted one of his best-known statues from the cover of *Superman Annual #7* (1963) with the year Curt was born and the year he died inscribed in the base. Part of the copy on the

page read: "His life was reflected in everything he touched. What he touched, he defined. What he defined will endure forever."

*Legion of Super-Heroes* #92, May, 1997 contained a story titled, "Swan's Way." Some of the Legionnaires were transported back in time to the days shortly after the Communist witch hunts in the fifties. Forgetting their identities along the way, they enrolled as normal high school kids. Curt was cast as their art teacher. His words helped to rectify things when they became hunted and hated after their powers were inadvertently revealed not only to themselves, but to suspicious

# Swan and the Superman Newspaper Strip

### PARALLEL UNIVERSE IN THE REAL WORLD

In addition to his comic-book assignments, Swan drew the dailies for the long-running *Superman* newspaper strip from June 18, 1956 through November 12, 1960. At the end of that period, he gave up the additional income to have a bit of a personal life and a little more time for his family. To see this rarely found art is a treat. Some of the same tales were appearing nearly simultaneously in the comic books as drawn by other artists or by Curt himself and are there to contrast and compare.

Due to the limitations in the format of the daily strip, there was a need to create a different visual feel from the comic books to generate interest. The artist met this challenge and succeeded admirably. Perhaps Curt was inspired by the fact that he had wanted to draw for the newspapers for awhile (see the earlier unpublished Native American daily tryouts pictured in this book). Also, he never liked to copy his own or others' work directly, not wishing to repeat the same scene twice. Therefore, Swan's Silver Age art attained new vistas via the strip.

### A DREAM COME TRUE

Superman traveled as an adult back to his home planet Krypton before it exploded more than once, due to time paradoxes liberally borrowed from other science fiction sources. It first occurred in *Superman* #61 drawn by Al Plastino, next in *Superman* #123 with art by Dick Sprang. The first time an entire comic was devoted to this concept was in the classic three-part novel from *Superman* #141 with Wayne Boring's wonderful art. But few know that besides penciling the cover to the comic book, Swan drew "Superman's Return To Krypton" for the papers, with an assist from inker Stan Kaye.

As mentioned, the *Superman* daily strip had disadvantages when compared to the comic book. One disadvantage was the horizontal format, always with the same narrow vertical dimension. Due to this design, and because it was an adventure strip where things kept moving, Curt could rarely vary from three panels per day. Hence, there were no chapter headings, each with a splash page that gave

*Trouble with Lois — from the daily Superman strip.*

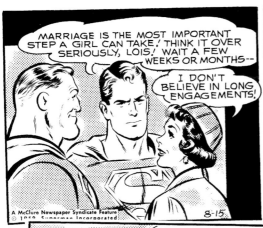

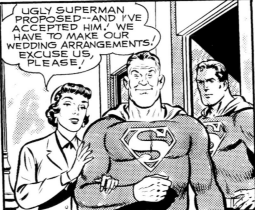

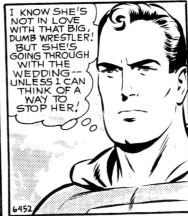

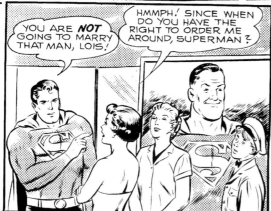

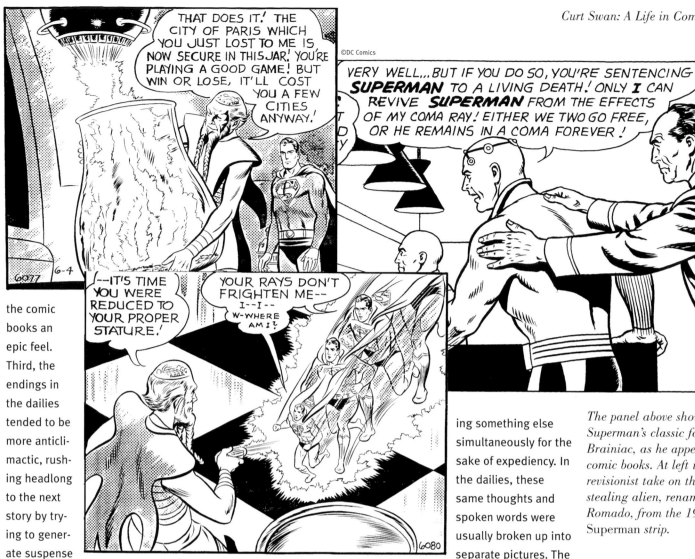

the comic books an epic feel. Third, the endings in the dailies tended to be more anticlimactic, rushing headlong to the next story by trying to generate suspense as a new crisis loomed. In the newspaper version of "Superman's Return To Krypton," on the last day of that continuity, The Man of Tomorrow reflected for two panels on his adventure as he flew back through the time barrier to then present-day Metropolis. But by the third panel, several days had already passed as he walked into the Daily Planet offices sporting the head of a lion (embarking on a new adventure likely based on the previously released *Action Comics*

#243). There was almost no time to dwell on the fact that he had actually returned home to his birth planet, reuniting with his long-dead parents and finding doomed romance.

There were, however, some terrific things about the "Return to Krypton" dailies. First, almost one hundred extra panels were used to tell the story and to enjoy Curt's art. In the comic book, characters had to think one thing while say-

ing something else simultaneously for the sake of expediency. In the dailies, these same thoughts and spoken words were usually broken up into separate pictures. The dialogue in the comic magazines and dailies was often identical and it's thought that Jerry Siegel himself wrote both (though other writers, such as Alvin Schwartz, also worked on the strip).

When Curt drew the Krypton continuity, he varied the planet's architecture a little from the comic books. Never wishing to be repetitious, otherworldly monsters and animals weren't exactly like those he drew elsewhere. He also put

*The panel above shows Superman's classic foe, Brainiac, as he appeared in comic books. At left is Swan's revisionist take on the city-stealing alien, renamed Romado, from the 1958 daily Superman strip.*

*Win Mortimer, Swan's predecessor on the Superman-related comic book covers and dailies, left DC for several years to work on David Crane, a soap opera strip about a Protestant minister. If not for the vacancy this left at DC, Swan might never have become a primary Superman artist. This example of Mortimer's work is from 1956.*

Jor-El in a few new outfits, depending on the occasion. Always a lovely illustrator of the female form, Swan had Kal-El's mother Lara and true love Lyla Lerrol looking radiant for the dailies in their Kryptonian garb.

Interestingly, there was some overlap in the publication of this storyline in the newspapers and in the comic book. The dailies ran from Aug. 13 through Nov. 12, 1960 while *Superman* #141, a Nov. issue, was likely released during September of that year.

By 1963, a flipflop had occurred. Curt Swan was now the main penciler of the *Superman* comic book while Wayne Boring was the primary newspaper artist. Instead of finding a comic book story illustrated by Boring and reinterpreted by Swan for the dailies, "The Showdown Between Luthor and Superman!" from *Superman* #164 (art by Swan and Klein) was also drawn by Boring for the Sunday news strip. It was strange to see Wayne's two-tiered interpretation

*Two of the Sunday strips Swan ghosted for Wayne Boring in 1961.*

of a barrel-chested Man of Steel and a barrel-bellied Lex Luthor fighting under a red sun, which ran from Sept. well into Dec., 1963. Though Swan had modernized Luthor by making him formidable physically as well as mentally, Boring had not. The emotion, excitement and power Wayne brought to the strip's various scenes did not compare to what was produced for the comic book, released during Curt's first zenith. Though to be fair, the Sundays, if a bit more open than the dailies, were still more restrictive than the comic magazines in terms of panel dimensions and layouts. Interestingly, some of the scientific gadgets used by the combatants toward the end of the story looked similar enough that the two artists might have shared some of their visuals.

## DIFFERENT FROM THE COMIC BOOKS

In the newspapers, though the first panel frequently recapped the ending of the previous day's strip,

Curt used very different opening scenes on succeeding days in order to avoid repetition and prevent boredom. And even though working on the strips was a bit claustrophobic as compared to the freedom to be found on the comic book page, Swan turned that negative into a positive. This was accomplished by working very hard to vary his layouts and perspectives. Also, Curt frequently alternated closeups and longshots but still managed to present a cohesive flow to each day's sequence.

Being one to pencil detailed backgrounds, he used this to advantage on the *Superman* strip. This was accomplished by presenting the illusion that there was much to be seen beyond the panel borders. Many items were partially presented at frames' edges, so we could expand the visuals in our minds. However, this was never done in a distracting way. Curt still drew the reader's primary focus toward the center of a scene.

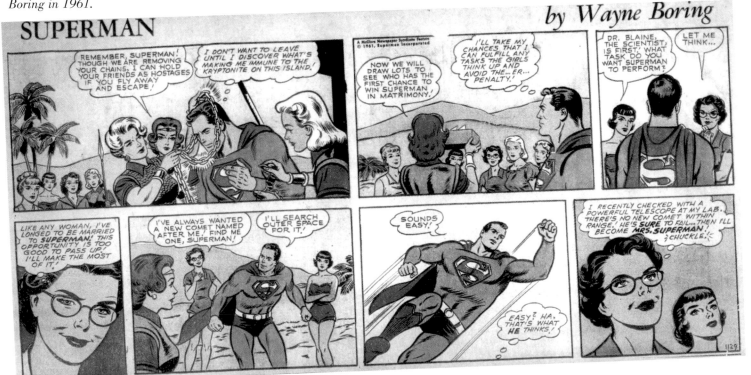

## OTHER DAILY STRIP CONTINUITIES

Sometimes the dailies allowed Curt to draw a few characters and plot variations which never made it to the comic mags. Though the space-villain Brainiac was shown in the "Return to Krypton" newspaper storyline in 1960, for some reason a character named Romado served in his stead two years earlier. Having a glass-domed, circuited head and a very long double-braided beard, this despot played a chesslike game with The Man of Steel; the objective being that each time he captured a playing piece representing a particular city on Earth, he shrunk that city and placed it in a bottle. In anger, Romado at one point made Superman a lilliputian and tweezered him into a jar for a side adventure in a stolen miniature "Kryptonian City."

Another variation on a theme was the story of Jena the Space Girl. In both the dailies and in *Action* #266, July, 1960, she was an Amazon from another planet trying to marry Superman by weakening him with Kryptonite and kidnaping him to her world. But there were many more differences than similarities. The longer newspaper continuity, which ran from October 30, 1959 to February 6, 1960 allowed the luxury of placing a story within a story. In both formats, Superman was eventually allowed to return to Earth. But in the dailies, the price that The Man of Tomorrow paid for turning down Jena's advances was that she had his superpowers removed. Curt had the opportunity of penciling a prehistoric lost valley in Mexico where a mortal Man of Steel used his wits to survive.

A list of other stories drawn by Swan and Kaye for the dailies included: The Courtship of Bizarro, The Menace of Metallo, The Ugly

Superman, The Black Knight, The Future Superman and a couple that never appeared in any form in the comic books. As noted, viewing these syndicated gems provides the opportunity to compare Swan's story interpretations to those done for the comic books as drawn by himself and others, such as Wayne Boring and Kurt Schaffenberger.

## SUBBING FOR WAYNE BORING AND THE PSEUDO-SUNDAYS

Besides doing the dailies for awhile, on two occasions, June 4

*This sampling of the real Wayne Boring's work on the Sunday* Superman *strip shows a clear contrast with Swan's more naturalistic approach to characters.*

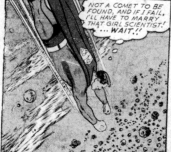

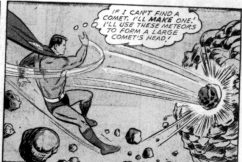
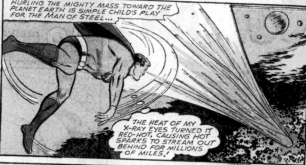

*One of the "pseudo-Sunday" strips from Action Comics Weekly.*

*Swan guest-penciled The Man of Steel, while Joe Giella illustrated The Dynamic Duo in this Batman daily from 1966.*

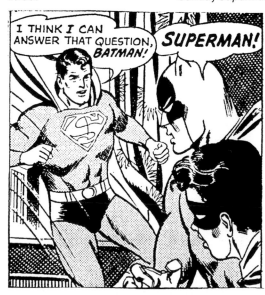

and June 11, 1961, Curt subbed for the regular *Superman* Sunday artist of that era, Wayne Boring. Pictured are two strips, the latter rife with full figures of The Man of Steel demonstrating his powers. The story looks to be a retelling of "The Super-Prisoner of Amazon Island" from *Action Comics* #235, Dec., 1957.

This is an appropriate time to mention how Swan illustrated DC's flagship character for a pseudo-Sunday *Superman* strip done some twenty-seven years later. In May, 1988, *Action Comics* added the word Weekly to the title, returned to anthology format and came out every seven days for ten months. After retiring from working on the Superman family in 1986, Curt was asked to return to the regular assignment of penciling two pages per issue. His charge: bring back the episodic flair of the old newspaper serials. Each three-tiered, double-page spread was written by Roger Stern and edited by Mike Carlin, with old friend Murphy Anderson returning to ink the majority. It was fun to see a latter day interpretation of how Swan would lay out a Sunday strip as if he was again working for the McClure Syndicate.

## REWRITING HISTORY

Just as it should be noted that Curt Swan actually began illustrating Superman in 1948, five years before *Three-Dimension Adventures of Superman* appeared in 1953, it can be argued that history also needs to be rewritten in terms of when he became a primary Superman artist. Due to his syndicated strip work, along with becoming the cover penciler for the Superman family of comic books the next year, Curt attained that status by 1957, not 1962, as is generally noted. The opportunity arose in part because former Man of Tomorrow daily strip and regular cover artist Winslow (Win) Mortimer had left DC not long before to work on his own newspaper comic titled *David Crane*.

The *Superman* dailies are a sidebar to the artist's career that adds to his massive creative output, being the equivalent in comic-book art of several hundred more pages tacked on to the total. They represent Swan's mastery of a related but separate medium from the comic books, worthy of reprinting in their entirety.

# Family, Friends, Admirers and Curt Himself

# Cecilia Swan Swift

*Cealie-bird is the nickname that Curt gave to his youngest daughter, Cecilia. That she loved her father very much is evident from our written and phone correspondence. Her generous nature is evidenced by the giving of her time to aid this project and in providing some of the photos used herein. This interview was conducted on November 10, 1998.*

Cecilia remembered cartoonist friends frequently visiting the house when she was a child, especially Dick Wingert, Roy Doty and John Fischetti. Fischetti's wife and Cecilia's mother remain good

quent inker George Klein's apartment. Klein's wife would give her petticoats to wear and play in.

When he was at home Swan tried to allow some flexibility in his demanding work schedule, letting especially nice weather draw him to the golf course. He would joke about his old editor Mort Weisinger sweating an impending deadline (which Curt never missed), calling his wife to track him down if there were several pretty days in a row. Swan also enjoyed bowling and shooting pool.

Curt was always available to help the kids with their homework, or whatever they needed. He never minded them coming into his studio. The price he paid for his fun-loving nature and open-door policy was frequently working through the night to complete an assign-

When she was young, Cecilia remembered a closetful of Superman comics, part of Curt's reference material. She loved reading them, but the downside was that when the neighborhood kids came by, "Everyone wanted to read comics instead of playing." She was a little embarrassed when it was her turn in school to tell the class what her father did for a living. For example, "One kid might say their dad was the president of Revlon, and I had to say, 'My father draws Superman.'" She added that, of course, the kids were all excited when they heard of his unusual occupation. Cealie-bird still has his reference file of magazines and clippings, drawing pencils, attaché case, and even a pack of cigarettes to remind her of not only what her dad did, but who he was.

*The Swan family at Christmas, 1995. From left: Helene, Curt, Cecilia, Karin and Chris.*

friends to this day. Doty was especially entertaining, with a great sense of humor. He drew and co-wrote the Laugh In (no hyphen in the newspapers) comic strip while the hit T.V. show was on.

When Cecilia went into New York City with her dad, they would fre-

ment in a timely fashion. Another reason Swan would sometimes work for long stretches in one sitting was because he believed in persistence at the drawing board when he was "on." This was because there were occasional dry periods when nothing would flow from his pencil.

Cecilia described her dad as "the life of the party." In the late seventies she knitted a "warmer" for a certain part of the male anatomy complete with tissue stuffing, as a gag gift for the men in her life. She sat the recipients together on the couch for a photo, and of course

Curt hung it on his nose. She also shared with him a love for dancing, and he took her out to cut a rug on several occasions.

We talked about Curt's generous nature. For as long as she could remember, "He always did charity work." When she saw his checkbook in later years, it was obvious that sometimes her father gave more financially to various causes than he could afford. He also gave of his time, donating many drawings over the years to be used in charity auctions, etc. In addition, he gave away sketches to countless fans, including some to Cecilia's friends and beaus. When she once dated a guy named Kent, Swan did a drawing for him with a pun alluding to his "namesake's" secret identity.

During our conversation, I mentioned that the only time I had seen her father on television was briefly during a television special about the success of the Garfield the cat newspaper strip in the early '90s. In a short segment, various cartoonists were present to draw characters for which they were famous during a charity fundraiser for a Florida hospital. Curt was in attendance to sketch The Man of Steel. Mort Walker later told me that a kidney stone prevented him from being there, but as a consolation, all the cartoonists drew a giant sketch for him which still hangs in his Florida studio. Cecilia recalled two other T.V. appearances. The first was sometime around the winter of 1976 or 1977 when he was a guest on *The Today Show*. She remembered watching him while she lived with four girls in her first San Francisco apartment. The second

*A mid-'90s penciled cover recreation of* Action Comics *#242, July, 1958. (From the collection of Hank Domzalski.)*

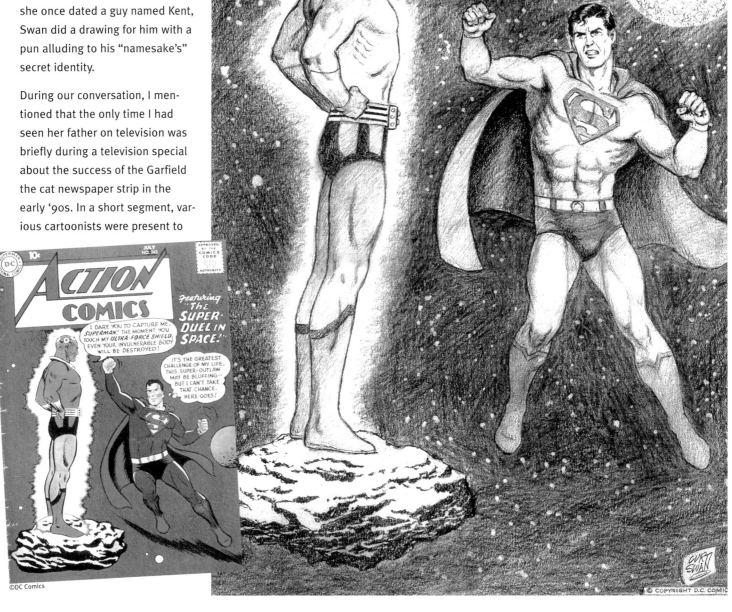

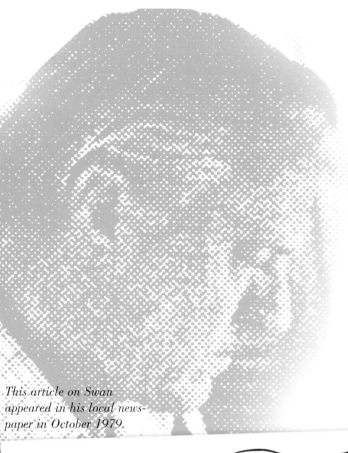

*This article on Swan appeared in his local news-paper in October 1979.*

was in 1994, when Curt appeared on cable television's QVC network to hawk autographed copies of *The Great Superman Comic Book Collection*. The host asked a lot of questions about past stories Swan had illustrated to fill the time. Never one to dwell on minutiae, he was unable to answer most of the queries, so Cecilia called her fidgeting dad on the air and simply said, "This is his daughter and I'd like to order a book." No doubt, Curt felt less awkward after this pleasant surprise.

Swan made a return appearance to *The Today Show* in 1988, during Superman's fiftieth anniversary, but the footage ended up on the cutting room floor.

Curt discouraged Cealie-bird from pursuing an art career, telling her it was too hard to make a living if she did not really love it. She and her husband currently own or co-own three restaurants, one of which she manages.

A letter to a fan from Curt dated November 20, 1995 states, "I've just started on your cover(s) recreation and should be finished this weekend. Didn't touch the piece over this past weekend because I had the great pleasure to watch my grandson [Chris' son] in a championship soccer playoff. His team won both games (Sat. and Sun.) to win their Division championship! Still hard for me to believe I have a grandson in college!! I am getting on in years." Cecilia has great memories of that weekend, having driven her mother and father to the out-of-town games.

From another letter dated Christmas night, 1995: "Survived another Christmas-I'm referring to the hoopla and materialism! My true pleasure is that my family all got together for a warm, giving evening." Though the best gift his youngest daughter ever gave Curt was her time, she had always wanted him to own a nice leather jacket. When finally old enough to afford to buy him one, she did—more than once. Cecilia laughed when she recounted her error in giving him a leather coat three Christmases in a row. She finally realized her mistake after spying one on someone else to whom her dad had passed along his good fortune.

# Westporter is 'alter ego' of Superman

**By GARY LIBOW**
Telegram correspondent

WESTPORT — First things first. Curt Swan is not faster than a speeding bullet. He's not more powerful than a locomotive. Nor can he leap tall buildings in a single bound.

While Swan lacks the familiar "S" across the chest, the Weston Road resident holds Superman at his fingertips. The pencil that mild mannered Swan uses to sketch the "Man of Steel" for D.C. Comics, in essence, is Superman's lifeblood.

This December marks Swan's 35th anniversary as a cartoonist. The 58-year-old artist said he chose to live here because the areas aesthetics are "conducive to creativity."

And create he must.

Swan is responsible for pencil sketching the intricacies of a 17-page comic every two weeks. Citing the tremendous demand for comics around the world, Swan explained, "Time is of the essence in this business. My main strength is staying up with the production schedule." He is currently working on the July 1980 issue.

Like clockwork, Swan, who works in a home studio, receives scripts from comic book writers based in Manhattan. A script includes a description of the plot, scenes, dialogue, action and the characters Swan is to portray.

Swan noted that his first chore is reading, then "digesting" the script. "I usually get a mental picture how the comic panel will look, when I read the description."

Swan said he is not one to indulge in preliminary thumbnail sketches. "I hit the page clean," he explained. "I start in the upper left hand corner and go through the page."

The artist tries to get at least two pages finished during each of his six work days per week. But as anyone in a creative position knows, there are good and bad days. "I have my dry days when I can't produce," admitted Swan.

The Westporter has the freedom to add

**Please turn to page 2**

or delete a panel, and lay out a page as he sees fit. "I usually cut a panel to give another more impact. Or I can add panel for the sake of continuity," said Swan. After Swan's sketching, the pages are returned to copy editors, who occasionally will make a marginal correction or two. Swan is rarely called to Manhattan to correct a major problem.

After editing, the pages are sent to a person solely responsible for lettering the dialogue. When that is completed, Swan's pencil drawings are traced by a person known as an inker.

Since Superman was created in 1939 in Ohio, the superhero has remained a constant in the eyes of comic lovers despite the passing of four decades and 12 Ameri-

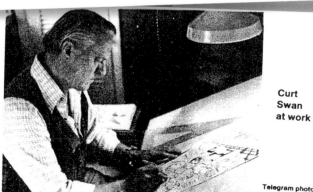

**Curt Swan at work**

Telegram photo by Gary Libow

lasted so long," laughed Swan. Like Orphan Annie, Superman never ages." The artist is at a loss when asked to describe the reasons behind Superman's popular-

have subtly changed during the years. Thanks to Swan, Superman grew longer hair and even sprouted a set of sideburns. Alter ego Clark Kent and

When asked to state her favorite comic story which her dad illustrated, Cecilia named, "I Flew With Superman!," from *Superman Annual* #9, 1983. In this ten page tale, the artist actually joined The Man of Steel to help solve a case, as plotted by Cary Bates, scripted by Elliot Maggin and penciled and inked by Swan himself. "He gave everyone in the family a page from the story," she recounted. It turned out that the last page pictured Curt awakening from a nap at his drawing board, not sure whether he had simply dreamed

that he and Superman really had an adventure together. But when he opened his hand, three bullets were revealed, confirming that the teamup had actually taken place. This was the page he had chosen for Cealie-bird. Later, when he passed away and was cremated, she received some of his ashes in a small brass, bullet-shaped container. She feels that these events were more than coincidental.

*Above: Some of the many items of merchandise that have utilized Swan's version of The Man of Steel over the years.*

*Below: one of Swan's cartoons for* Stars and Stripes, *the armed forces newspaper he worked on with Andy Rooney.*

# Andy Rooney

Thanks to Jerry Ordway, I learned that news correspondent, journalist and 60 Minutes editorialist Andy Rooney wrote briefly about Curt Swan after he died. Reportedly, they knew each other during World War II when both men worked on *The Stars and Stripes* army newspaper. I wrote duplicate letters, in care of Tribune Media Services and 60 Minutes, and upon arriving home from work February 17, 2000, there was a phone message from Mr. R. himself. He stated, "I don't know if I have a whole lot to say about Curtis Swan. He had some cartoons in *The Stars and Stripes,* but our principal cartoonist in London was Dick Wingert, who was a very good friend of Curt's."

I decided to call Mr. Rooney back the next day. About Curt he said, "He was a neat guy." He described him as a "minor figure" on *Stars and Stripes*. When I asked if that meant in terms of productivity, he said yes. We talked about Swan's and Rooney's mutual friends, Dick Wingert and John Fischetti. "He was good," was the response when asked about Fischetti. Andy covered the Nuremberg war trials and contributor David Applegate learned from Mrs. John Fischetti that her late husband was there too as a sketch artist. Surprised when I also mentioned France Herron's name in relation to Swan's, Mr. Rooney did not know that Herron had a career in comic books before and after the war. He'd known him as the writer of an insert for *The Stars and Stripes* called *War Week*. Though Andy continued his friendship with both Wingert and Fischetti after WW II, he did not keep up with Swan and was surprised to hear about his career drawing Superman in the comics. When we spoke again on March 6, Andy said, "I didn't really know him well and I'm not sure why. I knew him best in

*"Can't yer see I 'ave a flat tire?"*

London." He made the additional comment that Curt worked in an office "way down the hall."

To wrap things up, Mr. Rooney made a great comment because it seemed so in-character during our brief initial conversation. "Did you read my book? It would save me a lot of work." I chuckled to myself, knew it was good advice and proceeded to locate a copy of the one he recommended, titled *My War*. It's an excellent read and enhanced my perspective of that time. I also learned from Rooney's book, as well as from one of Curt's cartoons, that he and Andy shared something in common. They were both absolutely thrilled to be transferred from their units to their respective assignments with *The Stars and Stripes*!

The thing was this. He always kind of kept his work separate and he never wanted me to be involved. Consequently, I always used to just touch base and that was it.

**Zeno:** *Did you live in a hotel at first in New York?*

**Helene:** We lived in a hotel for about six months. It was out on Rockaway Beach, at the end of the subway line.

I think from time to time he'd get very tired of what he was doing.

**Zeno:** *Was that later on, or fairly early in his career?*

**Helene:** Oh, what he used to do was work three days and then be off four days. That was how he handled it.

**Zeno:** *Didn' t he quit one time in the early fifties to try his hand at commercial art?*

**Helene:** Actually, there were a number of times. He would just be completely fed up with the whole thing. But Mort Weisinger would call up and say, "Now you've had enough time; come back."

**Zeno:** *And he would always come back?*

**Helene:** Yes.

**Zeno:** *Did you know Mort at all?*

**Helene:** Not really. Curt never involved me with any of that. One time when Cealie was three years old, so that had to be 1957, we went to Long Island and had lunch with Mort Weisinger and his wife.

We took Cealie along and that's how I remember that.

**Zeno:** *What about some of his friends whom he worked with? For instance, did you know Stan Kaye?*

**Helene:** Yes. He had five kids. He used to live in Larchmont before moving back to the midwest. I had been to visit him in Larchmont. He had a nice place. His wife made his shirts.

**Zeno:** *What was he like?*

**Helene:** He was a real nice guy. I think he inked for Curt.

**Zeno:** *Yes, he even worked with him when Curt was on the newspaper strip.*

**Helene:** Curt would never allow me to get too involved with anything. He would always say, "Let's not even talk about it." Okay, fine.

**Zeno:** *He always seemed to be like that, even when I knew him; keeping the work part separate. Did you know George Klein?*

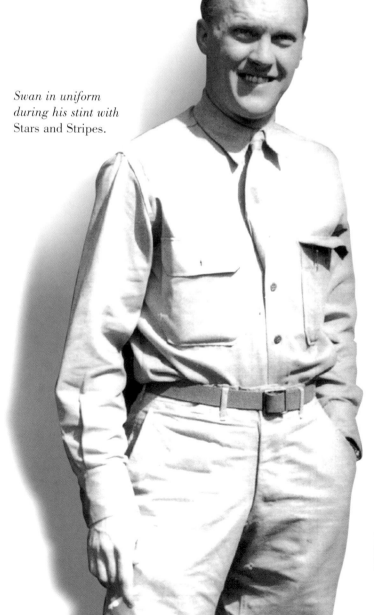

*Swan in uniform during his stint with Stars and Stripes.*

*"It seems the two American boys were lost!"*

**Helene:** George Klein and Lynn. They used to come and visit us when we lived in Westport [Connecticut].

**Zeno:** *Where did he live?*

**Helene:** George? George lived two or three blocks from the office [of DC], because we used to go and visit in his apartment when Curt would come down to the office.

**Zeno:** *Do you have any photos of people like Stan Kaye and George Klein, because it would be nice to know what they looked like?*

**Helene:** No, no photos. But George Klein had very blonde hair and a very straight nose, kind of Nordic looking. He was probably 5'11". He was not fat, and he was just a very, very, dear man.

**Zeno:** *And what did Stan Kaye look like?*

**Helene:** Stan Kaye had very blonde hair. I would say he was kind of Irish looking. He was not

terribly tall, maybe 5'8"...5'9". He wasn't skinny but he wasn't fat, just good-sized.

**Zeno:** *I was afraid you might not have any pictures of them, but it's great getting a description. What was John Fischetti like?*

**Helene:** John Fischetti was a very hot Italian. He had very dark hair, always wore glasses, very blue eyes. He was very funny; he was a riot.

**Zeno:** *Didn't he win a Pulitzer Prize?*

**Helene:** A Pulitzer Prize for his political cartoons.

**Zeno:** *Was that before or after he inked Curt's pencils? John inked Curt's work until about 1951.*

**Helene:** Oh, my goodness, he won the Pulitzer around 1974... '75; he died in '80.

**Zeno:** *Then it was long after inking Curt?*

*"Gad! I can hardly wait to see what's inside!"*

**Helene:** John, at one time... before World War II, had worked for Walt Disney in California (even though his home was Brooklyn), I think in 1939. When John came home from the Army, he worked on Long Island. Then Dick Wingert came, and Lee, his wife. At one point, we all had a house down there and John would come spend weekends with us. So John, till he really

*A war scene drawn by Swan for* Star Spangled War Stories *#8 (1953).*

Courtesy of the International Museum of Cartoon Art.

*"Oh Captain — meet my wife!"*

found what he did best, used to do inking on the side.

**Zeno:** *And you shared a house with the Wingerts?*

**Helene:** In fact, we shared a house with them for a whole year.

**Zeno:** *Did you know two of Curt's other early inkers, Steve Brody and Ray Burnley?*

**Helene:** No.

**Zeno:** *How about Murphy Anderson, who inked him later?*

**Helene:** Only by name.

**Zeno:** *When Curt would occasionally get fed up with work, did that have anything to do with Mort Weisinger?*

**Helene:** It would be too much of everything.

**Zeno:** *Was he a workaholic?*

**Helene:** We would all go to bed at

10 o'clock and he would work till 3 o'clock in the morning. I used to say to the kids in the morning, "Your father had to finish a story." So my kids were in a very quiet house.

**Zeno:** *And he stayed pretty much with the schedule of three days working and four days off?*

**Helene:** As much as possible. When he first did it, he used to stick with that, though sometimes he had to work five days. But he would always take time off between times.

**Zeno:** *What did you think of Curt's art?*

**Helene:** It certainly was very realistic, and that was the thing that I always liked about Curt's work. At one point when we had first come back from overseas, he always studied anatomy. The anatomy was always one of the biggest things about his work.

**Zeno:** *Do you mean he studied from books?*

**Helene:** Yes.

**Zeno:** *Tell me about his hobby of painting.*

**Helene:** He would have spells where he would do landscapes and seascapes and houses. And sometimes he wouldn't touch that for maybe six months.

**Zeno:** *Did he continue with this hobby throughout his working life?*

**Helene:** Actually, he would decide he was going to do something and he would do it. Then he wouldn't touch it again for a long while. And he finally got where he [only] worked and played golf.

**Zeno:** *Do you remember any of his cartoonist friends with whom he played golf?*

**Helene:** Mort Walker, Bill Yates, Jerry Dumas, Dik Browne. They

Courtesy of the International Museum of Cartoon Art.

*"Awright, awright — so I grind my teeth!"*

*"Captain! Please refrain from the 'Bang! Bang!'"*

could get a game together in no time flat.

**Zeno:** *I didn't know Curt was a good friend of Dik Browne's [creator of* Hagar the Horrible *and collaborator with Mort Walker on* Hi and Lois*].*

**Helene:** Ah, are you kidding? (Laughter) He was from Wilton, which is the next town from Westport. There was also John Cullen Murphy [who took over *Prince Valiant* from Hal Foster].

*"Smile, please!"*

# Charles Kiley

Charles Kiley was a writer and later an assistant editor for *The Stars and Stripes*. He knew Curt Swan while working out of the London office, from October, 1942 until D-Day, June 6, 1944. One of his assignments was to cover missions of the 8th Air Force's B-17 bombers. After that, Charles was in Normandy, Paris for a short time, then Belgium. He was assigned in early 1945 to Eisenhower's headquarters in Reims (northern France) where the Germans signed their surrender on May 7, 1945. After the war, Kiley worked for the *Herald Tribune* for twenty-one years. He became editor of *The New York Law Journal* in 1967 and retired in 1989. We spoke by phone on March 23, 2000.

Charles said that the three cartoonists at the London office of *The Stars and Stripes* during his tenure were Dave Breger, Dick Wingert and Curt, affectionately known as "Swaney." As Wingert continued his *Hubert* strip after the war, so did Breger. His was aptly called *Private Breger*, later *Mister Breger* after its creator became a civilian. He did not know if Curt ever met *Stars and Stripes*' most famous World War II cartoonist, Bill Mauldin, stationed in the Mediterranean (in Italy). Mauldin won a Pulitzer Prize in 1945 for one of his Willie and Joe cartoons.

Kiley remembered Curt as a very pleasant, extremely blonde-haired guy who was "good company." His close friend Dick Wingert was dark while Curt was light in appearance. The two of them would come in every day to work in the same office at their drawing boards, while Breger penned most of his cartoons elsewhere. One of Curt's jobs besides drawing gags was to pen maps illustrating Allied advances.

*The Stars and Stripes* office in London was in "The Times" of London building. In Paris, the office was in the *International Herald Tribune* building on Rue de Berri, just off the Champs Elysee. Living near the Eiffel tower, Swan once wrote of sitting "for hours sketching by the Seine" after he was transferred to Paris in January, 1945.

In the book *My War*, Andy Rooney talked about the large size of the London *Stars and Stripes* staff, consisting of some 110 people. Charles laughed when he heard that number, saying that was if you counted everyone including circulation people, etc. He said it was more like twenty writers, cartoonists and editors, tops, in the city room. Because they were a small group working together in another country with a war on, they got to know each other well and became very close.

# Bill Janocha

*This is a combination of two interviews which took place on January 25 and February 23, 1999. In many ways, Bill's comments expound upon the thoughts and feelings of the other interviewees. I am grateful not only for his spoken words, but for supplying the names and phone numbers of others from whom I obtained information, as well as for supplying the cartoons done by Curt Swan for Mort Walker.*

**Zeno:** *Please give us your job description.*

**Janocha:** I'm officially Mort Walker's studio assistant. I have a week of *Beetle Bailey* right in front of me. When I first started with him, I was his only assistant on his *Gamin and Patches* strip. Since then, I've been working on the *Beetle* strip, and a lot of the non-*Beetle Bailey* strip artwork; that's the licensing work that comes through. And there are numerous projects with the International Museum of Cartoon Art, and with the National Cartoonists Society [AUTHOR'S NOTE: Bill edited the most recent NCS Directory]. These are all things that came into my life through Mort Walker. So, right hand man, left hand man. But he has several [others] that are very loyal to him and put out very good products.

**Zeno:** *You mentioned a testimonial dinner for Curt in your letter. I didn't know he ever had one.*

**Janocha:** Well, yeah, it was after he had passed. Our local Connecticut chapter of the National Cartoonists Society meets twice a year and we have a dinner and whatnot. Each fall, we give out an award to a cartoonist that deserves to be called a "Connecticut Classic." We had wanted to commemorate him but he had just passed that summer, so we weren't able to do it while he was around. Eventually, we did have the members of his family and had Arlen Schumer, an accomplished artist who does have his own studio; he was dying to do this slide show to which we said, "Fine." We had [Curt's] family members speak and had some friends speak in his behalf. We presented this plaque to his family, so that was rather emotional. The funny thing is, knowing him, with all due love and respect, he wouldn't have... If he'd been at this dinner, he would have been more comfortable having a cigarette. (Laughter) At those dinners, he wouldn't touch much of his food. He'd rather just kinda hang around outside laughing and have a few drinks. He'd say, "What's all the big deal about? What's all this hoop-de-doo for me? I don't deserve this." He was that type of person. He was the least formal guy we had. He'd be honored, but... I don't know whether he would have even stood for it. So he's very fondly remembered and will continue to be so.

**Zeno:** *What family members came?*

*Far right: Swan's Superman is front and center on the cover of the 1996 NCS Album edited by Janocha.*

*Right: A Bill Janocha cartoon that recalls a boyhood made richer by exposure to Swan's work on Superman.*

©2002 Bill Janocha

EDITED BY BILL JANOCHA

©2002 National Cartoonist Society

**Janocha:** They were all present. Brian Walker [Mort Walker's son] knew them much more personally than I did. He helped set it up. I only met them at the dinner.

**Zeno:** *Was Curt always a member of the NCS?*

**Janocha:** No, in fact he wasn't a member at the end. He must have been a member way back. In the last NCS Directory I did, I just basically reprinted and axed out a lot of stuff, since he had divorced. And I whited out some of the other stuff that wasn't pertinent. He just basically said, "If you want to put me in, go ahead." It was a token entry but it was better than nothing. I was able to utilize a drawing of Superman on the cover and gave him a copy a couple of weeks before he died. That was nice the way it worked out.

**Zeno:** *By the way, please thank Mr. Walker for the photo he sent of himself standing in front of his bar with the large, color Superman drawing by Curt pictured behind him.*

**Janocha:** Yeah, that was a real nice, unusual piece that [Curt] gifted him, apparently, years ago. The standing figure of Superman is almost like it's on a cel. The background is actually xeroxes of his pencils, stories that are kind of pasted up like wallpaper behind. And it's just this very stark, beautiful image of him standing. Superman's actually cut out along the edge and pasted down. It took a lot of time.

There's also a real interesting piece which I don't believe he sent you. You know he's done some special drawings for Mort over the years, because they were, as I

said, real golfing buddies. There are images from the '60s to the '70s or early '80s. Mostly golf related, from a handful of really close buddies, like when [Mort] was forty years old, when he was fifty, sixty, that kind of thing. They show another side of Curt... caricature work and non-Superman.

**Zeno:** *Did you also play golf with him?*

**Janocha:** Yes. I started with Mort Walker; it will be twelve years ago in April. And the first couple of years is when I did most of my golfing. I think that's when they realized how bad a golfer I was. (Laughter) Early on they were foolish enough, or hopeful enough, to ask me to play with them. This goes back to the '87, probably '88 period. I mean I would regularly play, and still do play every year in the Connecticut Cartoonists Tournament in September. Curt would always play there. Anyway, on one or two occasions [Curt] was just very, very kind. The Silvermine golf course in Connecticut. I think this was the third hole; it was a long hole and you have to hit over a really high hill to get on the green. And it's still part of my game that I have not mastered. It's real important to be able to chip up, like out of a sand trap or up a hill. You don't want to go too far, but you want to hit it high, like a high loft. I remember, it was a tricky part where I was halfway or three-fourths down the hill. And I remember him being very kind, as they all were from early on. But Curt showing me just how to grip this particular club, how to chip up and things like that. In a fatherly or in a grandfatherly way, he was trying to be helpful. You know, most people just remember it and

*Swan did the pencils for this October, 1988 cover of* Keyboard *magazine.*

forget it. I remember it being a warm moment that he took time out to try to help me on this kind of thing. And it was kind of like, "If you don't make it, the heck with it." I think he was Mort's partner and I might have been playing with Greg or one of Mort's sons. [Curt] was a regular and a very good golfer and enjoyed it very much. He did enjoy the lunches beforehand, with a few drinks along the way (laughter) if I may mention that. Just a very jovial person. It was a good escape for him from the grind of the work that he had to do.

**Zeno:** *Did you ever see him other than during a golf game?*

**Janocha:** I really only saw him at lunches that we... that Mort would regularly have, as we'll probably have today. It used to be Tuesday, every other Tuesday. In fact, the

guys are assembling as we speak downstairs for one of the *Beetle Bailey* gag conferences. Though Curt was not part of the *Beetle Bailey* family, he was definitely part of Mort's golfing family and close to us. So it was a regular feature for us to gather at... We could be in various restaurants but usually later on in the Greenwich Country Club. We would have lunch, and usually, those guys would depart and have a beautiful round of golf in the afternoon... or not so beautiful. (Laughter) That's too lofty a word. It seemed that I would always situate myself next to him at one end of the table. I would just take time to chat particularly with him; what he was doing, what his work was like.

Later on, I remember he was beginning to attend more of the conventions. For years he didn't feel like it because, you know, he wasn't someone who really liked to boast about his work. He was very, very kind to fans, though. I just don't think that he... he didn't dislike meeting people. I think he just was more private. He didn't know what the big deal was. "It's a job I do." He knew he did it well, but he didn't care to brag about it that much. In fact, he never did. He was very likeable about that.

I know that he was very kind and did a special drawing for me at one point. I just asked him for

*A gallery of Swan's imaginative aliens from across the years.*

something very small, but it was very, very nice what he did. He did something a little bit different. At first I was perplexed about it and he kinda giggled. He did a drawing of Superman flying in the air with birds around. He said [Bill speaks in a funny voice], "I did it in a little bit of a fruity feel." I don't want to offend anybody but I'm quoting him. He was having fun kind of flying. You know, it wasn't the typical muscular fist flying in the air like, "I'm going to save you, Lois." It was sort of like [same humorous voice], "I'm soaring in the clouds with the birds" kind of a thing. It was a very light, airy, beautiful color piece. There was another person who was a friend at the time, who wanted a piece of art of himself actually getting hit by Superman. (Laughter) So that was something that he did also. And I remember when I went to Italy in 1992. I was invited to the Lucca festival. And I came across different artists and people, [including] someone that was very interested in Superman over there. I think he was one of the people that ran the festival. He was excited as heck that I knew Curt, and he wanted to get a drawing. That was something, again, that I arranged. And he ended up getting a very nice penciled sketch of him busting a chain. So it seemed like every few years I'd find someone who looked at me as a major contact to get some kind of drawing.

Even when I went down to Captain Blue Hen Comics in Newark, Delaware... There's actually the Fighting Blue Hens. (Laughter) That's the mascot for the University of Delaware. They had Curt down several years ago at Captain Blue Hen Comics and he did a signing. The proprietor of the shop is a great fan of his work, so there's a whole walled section of Superman with a very nice inked waist-up drawing of him, again maybe breaking a chain or doing something like that. You know, it's on permanent display there, definitely not a for-sale item. So when I go down there a few times a year to shop, I'm reminded of Curt and the people that he touched.

**Zeno:** *Do you remember the first time you met Curt?*

**Janocha:** It was Friday of the first week that I started with Mort. And he had a really nice lunch for the guys down at... I think at that time it was called the Showboat restaurant in Greenwich. This kind of old New Orleans-type showboat parked out front, I mean in the water. If memory serves, it was actually a dinner to celebrate the launch of the new feature. So he had a whole table filled with local cartoonists and that's where I first met [Curt]. And they were doing drawings on the placemats. It was really kind of a free-for-all and it was exciting. I remember [speaking with excited voice], "Oh, you're the guy who does Superman!" So I vividly remember that first meeting; it was a very exciting time.

And he was on a regular feature then. So my recollections are not really grandiose, but they're moments like with family.

I would have loved to have seen him other than sketching. I did see him sketch, but to have seen him actually at the board... but I don't know who really did.

**Zeno:** *What do you think of Curt's art now, as an adult?*

**Janocha:** There have been many people who have worked on the feature. As I learn more, there were so many who worked in the Siegel and Shuster camp. But as far as visionaries that dictated the feel of the strip, I consider Curt one of the top three. Obviously Shuster, Boring and in their order, Curt.

He is not only a great legend at DC but you just think of his name and you think of Superman. He was loyal to DC. He did not jump back and forth to Marvel. At that time, there weren't really too many independent companies like there are now; Image and Dark Horse and other ones. That's why he felt cast aside those last number of years that there was, you know, a new breed of artists coming in. He wasn't necessarily that bitter about it, but it definitely was something that he was aware of. He said, "Gee, this is how I've been treated after being loyal to them for about fifty years." Actually at the end, he did end up doing a little work for some other companies. It was just so inconsequential compared to the amount of work that he did for DC. So I think he just felt a frustration, that if the work isn't coming, you've got to get it somewhere.

I just would have loved to have known... At this point, had time continued for him, he obviously would have been saluted, especially with the sixtieth anniversary of Superman last year. I'm sure there would have been additional accolades, that he would have continued to go to conventions and continued to get special work. I'm sure that he would have gotten more work outside of the DC camp. It would have been interesting to see where he would have gone and what he would have done. Whether he would have been able to teach me to chip up on that green. (Laughter)

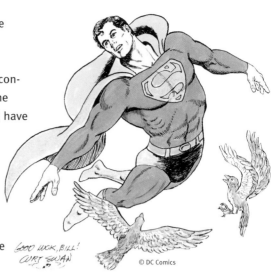

GOOD LUCK, BILL! CURT SWAN

© DC Comics

*Soaring with the birds — Swan had fun designing this lighthearted drawing for Bill Janocha.*

I CAN'T FIGGER IT. HE SAID THE SUN WOULD COME OUT. *AND BY GAWD, IT DID!* ON **HIM**!!

NEXT TIME, I'LL SAY 'NO'! - JUST PICK UP THE RECEIVER AND SAY 'NO'! *THAT'S ALL THERE IS TO IT. I'LL SAY 'NO'! WOT TH' HELL, IT'S NOT AS IF I'M ADDICTED TO THIS CRUMMY GAME. I SWEAR, I'LL SAY 'NO'! BY DAMNED I CAN SAY 'NO'! SO-WHAT IF MY NAME IS DROPPED TO THE BOTTOM OF THE LIST?! JUST A SIMPLE 'NO'! -- 'NO' --*

IF IT WEREN'T FOR THE AESTHETICS OF THIS GAME, I'D GO BACK TO BLOWIN' UP FROGS!

HEY, PARTNER, LOOKEE THERE! IT'S A SURE BIRDIE -- THAT'LL PUT US 8 UP WITH 10 TO GO! IT'S JUNE IN JANUARY--

SILVERMIN

HEY, MORT- HAPPY 51! CURT SWAN

©2002 Curt Swan Estate

*One of several cartoons done by Swan as birthday greetings for golfing buddy Mort Walker.*

# Mort Walker

*Legendary cartoonist Mort Walker is primarily known for two things, creating the comic strip* Beetle Bailey *for King Features Syndicate in 1950 and founding what is now known as the International Museum of Cartoon Art. Other strip creations include* Hi and Lois, Boner's Ark, Sam and Silo, *and* Gamin and Patches. *He is the author of several books. An avid golfer, he has sponsored tournaments in which he participated with his fellow cartoonists to raise money for worthy causes. I am extremely grateful to Mr. Walker for taking the time to candidly reminisce beginning on January 22, 1999, about his long friendship with Curt.*

Curt Swan's close friend Mort Walker displays a gift from his pal.

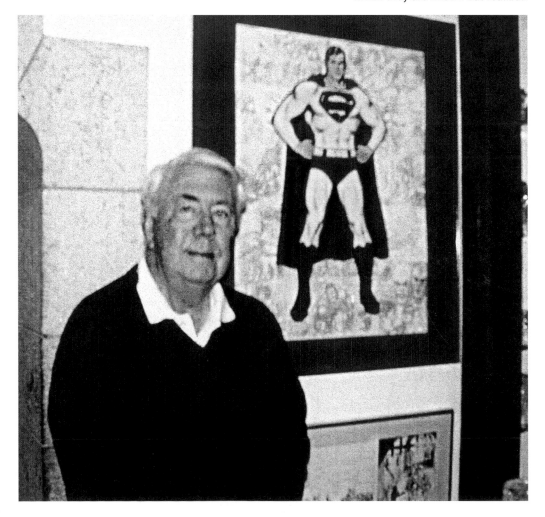

"He had other good friends, so did I. I wouldn't say we were just good friends; we were the best of friends. I once wanted him to do a picture of Superman; I'm looking at it now hanging behind my bar. It's very large; one of a kind, and he colored it also." When asked why he liked Swan's art, Mort answered, "His anatomy. His work is very clear, well done. He never used assistants, to my knowledge."

"Curt wasn't very articulate. He didn't like to talk about himself; he was shy. He didn't take good care of himself. Curt smoked too much. He tried to quit smoking several times, but I guess he didn't have the willpower."

Mort said both he and Curt dabbled in art other than that for which they are known but realized they couldn't make a living at it. "Curt did a few watercolors; they were good." Mort himself won a national contest for one of his oil paintings while in high school. He laughed, though, when he said a teacher asked him why he was painting "cartoony." Mort answered, "I'm not; this is fine art."

"Curt would always say he was burned out as a comic artist. He was burned out after twenty-five years, he was burned out after thirty years, after thirty-five years." Mort laughed, "But he always kept going, doing good work."

Once, in later years, Mort visited the DC offices to raise money for the International Museum of Cartoon Art. He asked one of the editors why his friend was no longer getting work. Walker was told that the comics were young peoples' magazines, and Curt's art was out of style. Mort said the problem was, "They wanted artists who drew cartoony muscles, not realistic anatomy."

The two knew each other for approximately forty years. "We met when I found out he was a fellow cartoonist living in the community." Mort called him to play golf with his group. "After some of the others died off (laughter), he became part of our foursome." He was an okay golfer, but Mort was better. When Walker arranged some cartoonist charity golf tournaments, including those in South Carolina and Sarasota, Florida, Curt also attended. "But we didn't just play golf together, we tried to meet at least once a week, even if just to eat lunch at a restaurant."

Describing his friend as "very ethical, hard working, affectionate," Mr. Walker once produced a stage musical and asked Curt to attend a

performance. Afterward, Swan asked, "Aren't you embarrassed by that?" He always appreciated his buddy's honesty.

*A follow-up interview took place on February 2, 1999.*

**Zeno:** *Do you remember the year you first met Curt?*

**Walker:** Oh, boy, I would say maybe in 1955. He was a good friend of one of my best friends, John Fischetti.

**Zeno:** *So you were also good friends with Mr. Fischetti?*

**Walker:** Oh, yeah. We played golf every week. He and Curt had worked on *Stars and Stripes* together. So John and I used to play golf, and John lived in Greenwich where I lived. Pretty soon, Curt began joining us.

**Zeno:** *I didn't realize there was that connection, because wasn't John Curt's best man at his wedding?*

**Walker:** Yeah.

**Zeno:** *Were there any other cartoonists that played golf with you on a regular basis?*

**Walker:** Everybody. (Laughter) Dik Browne; I sort of taught him how to play golf. And Bill Yates, Bob Gustafson... boy, there were a lot of them. Ten guys usually went to play every week. Bob Gustafson used to complain, "Mort, why do you have to ask everybody?" But it didn't bother me. "Bob, I don't want to leave anybody out."

(Laughter) I sort of organized the groups and I always belonged to the clubs and stuff like that.

**Zeno:** *Wasn't Curt also a good friend of Dik Browne's [Hagar the Horrible]?*

**Walker:** Yes, we all partied together, went out for lunch together. Sometimes we traveled together.

**Zeno:** *Anywhere in particular?*

**Walker:** Well, we did some articles for Golf Digest. We all went to, what do you call it, the World's Worst Golf Tournament. (Laughter) We competed in things that duffers usually do, like how far can you hit the ball into the woods without hitting a tree, how large a divot can you take, how many times can you lip the cup without the ball going in, all those things.

Then I took everybody down to Hilton Head and we competed in things. We golfed and partied.

**Zeno:** *Did you say Curt was also shy last time we spoke?*

**Walker:** Uh...

**Zeno:** *Or were you talking about being modest about his work?*

**Walker:** He was very modest about his work. I don't know if he was exactly shy, but when he got up to do public speaking, he was really nervous about it. Usually when he got up to tell a joke, it was a real bomb. (Laughter) He didn't have a real great sense of humor. He'd call himself a stupid Swede.

**Zeno:** *Speaking of his sense of humor, did you guys ever play any practical jokes?*

**Walker:** Not particularly with him, but the guys were always playing tricks on each other. Dik Browne was great at that, and Jerry Marcus [who draws a panel called *Trudy*]. He's one of my oldest friends. We were into magazine cartooning together, back in 1948. But Jerry was a real practical joker.

**Zeno:** *Did Jerry Marcus also play golf with you?*

**Walker:** He did for awhile, but he was such a terrible golfer... finally, he gave it up.

*The cast of Beetle Bailey — one of Mort Walker's many creations — as seen on Walker's personal stationery.*

*A gallery of Swan characters from the artist's listing in the 1965 National Cartoonists Society Directory.*

**Zeno:** *There are some photocopies of a daily strip that Curt submitted at one time dealing with Native-Americans raising a white child (Yellow Hair). Do you remember anything about that?*

**Walker:** No. I've got some of his other work, though. He did gag cartoons for awhile. I guess it was for *Stars and Stripes*.

**Zeno:** *You have some of those?*

*Another of Swan's birthday greeting cartoons for Mort Walker.*

**Walker:** We have a scrapbook of his, yeah. Twenty or twenty-five years ago, he gave them to me for the museum. [AUTHOR'S NOTE: This scrapbook was the source for Swan's WWII cartoons printed herein.]

**Zeno:** *What were Curt's work habits like? Did he try to stay on a regular schedule?*

**Walker:** He had his regular output. But he didn't seem to like his

work. He was always putting it down, and saying, "Ah, I'm sick of this. I've been doing it for twenty-five years." One time he quit and went into artwork. He did oils and watercolors. He didn't have much luck selling it, but they were good. That was about fifteen years ago [approximately 1984].

**Zeno:** *Did he sell any of the work?*

**Walker:** Yes, he sold some but not for very much.

**Zeno:** *Did he have an agent?*

**Walker:** I think it was a gallery that would take some of his work.

**Zeno:** *Did you ever discuss art with Curt?*

**Walker:** Well, we were always discussing art. Anytime the guys got together, we talked about it. That's why it stimulated us to get together.

**Zeno:** *Were there any stories Curt drew that he got fired up about?*

**Walker:** No, not that I recall.

**Zeno:** *You mentioned last time Curt's mastery of anatomy with his art? How did he become proficient?*

**Walker:** I guess he always drew when he was a boy. He used to draw from life; those were his models. But later on in life, when he worked on Superman, he didn't use models. He was very good at certain things, but not at others. One time we were planning an exhibit for the museum. We were going to build a sort-of-a building for the various galleries and I asked him, "Would you like to design the comic-book gallery? Maybe the outside of it could have lightning and thunder, super-

heroes flying through the air." He struggled and he struggled and he struggled, and he finally came back and said, "Mort, I just can't draw this." I said, "Gosh, Curt, I thought you could draw everything." (Laughter) He said, "No, I'm drawing a complete blank on this." Maybe he wasn't so good at architectural renderings. I went ahead and did it myself, but we never built it.

**Zeno:** *How close did he ever get to coming down to the museum and teaching some classes?*

**Walker:** No, he just mentioned it one time. We never acted on it. But I don't know how good he would have been at teaching.

**Zeno:** *I don't either. That might not have been his forte.*

**Walker:** He was kind of a complex man, not as simple as he appeared to be. He didn't reveal himself. I know of one experience I had... I was gonna leave my first wife. I just had to get out of there, and I packed up my bags and put them in the trunk. I went to play golf with him, and he saw them when I was taking my clubs out of the trunk. "What are you doing?" "I'm leaving my wife." "You're like the Rock of Gibraltar, Mort. What's going to happen to the rest of us?" So I thought about it for awhile, went back to her, and I stayed with her for another five years.

**Zeno:** *So he had a big influence there.*

**Walker:** Yeah, and I'm sorry about it to this day. (Laughter)

**Zeno:** *You're honest, anyway. Anything else along those lines you'd like to add?*

In Future Issues:

- 'KONNECTICUT— KAMELOT OR KOKONNO COUNTY?'
- TAXATION AND THE CARTOONIST
- BLACKS IN CARTOONING
- NEW TRENDS IN THE MARKET PLACE

BACK COVER BY CURT SWAN, WHO HAS DRAWN 'SUPERMAN' FOR OVER 20 YEARS... CURT LIVES IN WESTPORT, CONN. WITH HIS WIFE HELENE.

*Swan's back cover illustration for the first issue of* The American Cartoonist, *the official publication of the National Cartoonists Society (Sept., 1977). Note Swan's self-portrait in the bottom, left corner.*

**Walker:** I think I spoke to you last time we talked about what a terrible time he had controlling his smoking. I'll never forget his fingers drumming on his drawing board when he was trying to quit. He would hum, "Um-te-dum-te-dum." Finally, at dinner one night, he got up and I thought he was going to go to the bathroom. I got worried about him. He'd gotten in his car, gone into town and bought cigarettes.

**Zeno:** *How long had he lasted that time without them?*

**Walker:** That time was about a week.

**Zeno:** *Sounds like a tough one.*

**Walker:** Oh, boy!

# Murphy Anderson

*The following interview was conducted Saturday, June 14 , 1997 at Heroes Con in Charlotte, NC. It was extremely gracious of Mr. Anderson to take the time to talk, as there was a steady stream of fans waiting to chat and have him sign examples of his work. He is a true gentleman and a brilliant artist, with an amazing memory that grasps the history of comics as only a handful do. Mr. Anderson's wife, Helen, was also present; she is a warm and lovely person.*

**Zeno:** *Did you know Curt before the two of you worked together?*

**Anderson:** Oh, yes. Curt would come in and deliver work, and I'd be up there. We would chat. We knew one another, sure.

**Zeno:** *Approximately when was that?*

**Anderson:** Oh, I guess I got to know Curt on a personal level in the late '50s, early '60s. I'd met him before that, of course.

**Zeno:** *The first thing I know about you two working together was about 1969 when you had some covers to do under Mort Weisinger. Is that correct?*

**Anderson:** It may be the first time. I was basically doing work for Julie, you know; [Julius Schwartz] would lend me out to Mort once in awhile to help.

**Zeno:** *Any interesting anecdotes you'd like to tell about your relationship with Curt?*

**Anderson:** Yeah, we used to love to chat a lot about where we came from. And we'd compare notes. He grew up in a small town situation... part of his life in Minnesota, if I remember correctly. So we'd talk about that and talk about our days in the service. Curt, of course, was in the army, and I had a brief spin... uh, fling with the navy.

**Zeno:** *Did you do any artwork while you were in the service?*

**Anderson:** Oh, yes. I worked for the... did some stuff for the *Bainbridge Main Sheet*, and then for a little publication; I think it was called *Radio Chicago* when I lived out there. I was still doing some comic-book work all that time, also.

**Zeno:** *I had read that in a previous interview.*

**Anderson:** Yeah, Fiction House sent me the scripts and when I could get around to doing them, I did stuff.

**Zeno:** *One thing about Curt, he seemed to have a wonderful sense of humor.*

**Anderson:** Oh, he did.

**Zeno:** *Did he like to tell jokes, or was it just his way of looking at things? There was always a glint in his eye.*

**Anderson:** Oh, he would tell stories; I can't remember anything specific. I think it was just his general approach to life that made people like him. He was not known for just telling jokes. Some people are.

**Zeno:** *Did you two ever socialize outside of the offices?*

**Anderson:** Not really.

*[AUTHOR'S NOTE: It was at this point in the interview when a fan*

*A sampling of the Swanderson team's artwork on a Earth-2 Superman story from* Superman Family #186, *Nov.-Dec., 1977.*

appeared holding one of the giant DC treasury editions in which Superman's origin was retold and reprinted in color, as portrayed by Swan and Anderson over Infantino layouts. This seminal assignment was also Curt's favorite and a joy for Carmine Infantino to have worked on. See Mr. Infantino's accompanying comments.]

**Zeno:** *Any favorite projects that you both worked on?*

**Anderson:** That thick book that you just saw over there [pointing to the giant treasury edition in the fan's hands].

**Zeno:** *That was a favorite of his too, and he said that he enjoyed very much having Infantino lay it out.*

**Anderson:** Yeah.

**Zeno:** *What is your assessment of Curt's talent, if there is any way to sum that up?*

**Anderson:** Well, Curt—I think his ambition when he started out was to become an illustrator. And like several people I know, he never had any thought of doing comics. I guess he got kind of sidetracked into it. So I think of him as having been a potential illustrator on a par with almost any of your top men of that day. If he had been given the opportunity and had been able to work at it, I feel confident he could have been up there with Mead Schaeffer, Harold Von Schmidt, Robert Fawcett, all those guys that were top floor at the time.

**Zeno:** *That's a nice compliment. What was he like to work with?*

**Anderson:** He was very, very easy. We never physically worked together much; a couple of times, but it was very rare. But he was always very supportive; he would often bring something in and, "Anything you think should be fixed," and of course, I could only say, "No." (Laughter)

**Zeno:** *He drew a picture for another fan that showed you and he at the drawing table with Mort Weisinger present. Did you ever do covers together in the office?*

**Anderson:** Possibly, yes. Curt would come in and pencil a couple and they'd give them to me immediately when they needed them.

**Zeno:** *He seemed like he was always trying to learn from other professionals too. Is that true?*

**Anderson:** Well, yeah, that's true.

**Zeno:** *Did you give him any tips?*

**Anderson:** No. What could I...? He always maintained he couldn't ink, but I'm sure he could have inked his own work beautifully. But the problem was... a lot of guys, even Carmine himself... At DC, they felt that their ink styles were a little too "scratchy" is the word they used. I don't know what that means, exactly. But they wanted something that was a little sharper and what they called more professional. Really, what they were looking for is just a certain look. And these guys inked the stuff more or less as they saw it. And their pencils reflect that. They put things in that, maybe, were extraneous to an editor's point of view. I don't think that's the answer to your question. (Laughter)

**Zeno:** *I would like to ask Ms. Anderson a question. You seemed to have a great relationship with Curt, too. Anything you'd like to say?*

# Carmine Infantino

*On May 26, 1997, comic-book artist extraordinaire and former DC editorial director, publisher and president, Carmine Infantino, put a few thoughts about Swan on paper.*

As far as Curt:

I was privileged to know him as a man and artist. He had no peers in either category!

I was fortunate enough to lay out an Origin of Superman story for *Metropolis Magazine*. He was kind enough to finish the penciling—and it was better than anything I could do on my own. Unfortunately, he was underrated as an artist — I guess, because he was always on time with his work and always, always the most beautiful Superman pages done! He and his wonderful talent will always be missed, not only by his fans, but also his friends in the business — which I was proud to be one of.

**Helen Anderson:** No, nothing, except that he was a fine gentleman.

**Zeno:** *It seemed like he was the kind of person that had no enemies, that everyone seemed to like.*

**Anderson:** That's very true. I don't know of anyone that ever had a bad word, or a cross word to say about Curt.

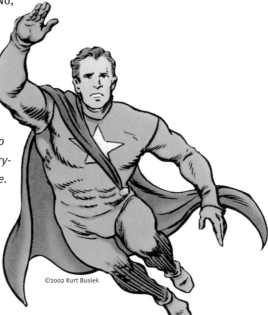

©2002 Kurt Busiek

*A Swanderson spot illustration of Samaritan from Kurt Busiek's acclaimed* Astro City *series.*

# Julius (Julie) Schwartz

Photo ©Beth Gwinn

*Handsome, friendly and charismatic — this portrait of the Boy of Steel is worth a thousand words toward explaining why Swan's characters were so appealing to readers.*

*This interview with "living legend" Julius Schwartz took place on June 30, 1999. Kurt Schaffenberger said of his friend Julie, "He's a fountain of information and a real gentleman." Arriving at DC Comics in 1944, this comics editor oversaw most of the company's great SF and superhero titles during his illustrious career. He helped to usher in comics' Silver Age via* Showcase #4 *in 1956, oversaw the exploits of the Justice League of America, revived Batman in the sixties with a "new look" and took the reins of Superman in the seventies and beyond with Curt as his primary penciler on* The Man of Steel. *When we spoke, Mr. Schwartz said he was expecting a long distance call about the upcoming San Diego Comic-Con International, so there was little time to talk. Second, he was reluctant to say too much at the time because he was working on his memoirs,* Man of Two Worlds. *As I paused, feeling defeated when the conversation had barely begun, ebullience soon returned when it became obvious that he was more than willing to discuss his old friend, after all. There were added bonuses in contacting this priceless repository of comics (and science fiction) history. Mr. Schwartz imparted several suggestions*

*on how to improve the book while seeking to add to his own knowledge by asking me questions about former Superman writers and about Curt. At eighty-four years of age at the time of the interview, to see this level of engagement was inspiring.*

---

**Schwartz:** First of all, when Curt passed away, there were several obituaries about him. There's really not much more to add... Well, I'll give you a one-sentence summary. When I gave him a script to pencil and I said I wanted the pencils on a certain day, they always came in on time. He never missed a deadline. A professional job, hardly any corrections. I would look at it: "Super! Here's your check and next script." He was very genial. I flew to several conventions with him and induced him to draw sketches of Superman in flight. When the stewardesses saw them, they crowded around asking for sketches. As an "inducement" they presented him those little cocktail glasses (chuckle). Early in his career there were no conventions to meet his fans. During the last few years, he enjoyed going to conventions and meeting his admirers. Frequently I'd travel with him and we'd meet early at the airport... coffee in mornings, drinks in afternoons. So he enjoyed the latter part of his life, except for the lack of work. "Out with the old, in with the new," he put it. I wish he had been alive to hear Jerry Seinfeld say on the Larry King program that he was gonna do a promotion for American Express and he was gonna do it with Superman. What he said next just floored me. He insisted that the animated Superman be a Curt Swan Superman!

**Zeno:** *Do you think he pulled it off?*

**Schwartz:** Oh, yes, it definitely was a Curt Swan, the definitive Superman.

**Zeno:** *When you mentioned going to cons together, didn't you two get to roast each other a couple of times?*

**Schwartz:** I never roasted him, but he sure roasted me. (Chuckle)

**Zeno:** *Did he prepare special material for that?*

**Schwartz:** No, no, we all winged it. There was a roast for me at the 1993 Chicago Comic Convention — at my suggestion! Curt Swan was on it, as well as another one in Pittsburgh. Curt had a *wry* sense of humor. He'd pull off a wisecrack and then say, "I'll drink to that!" (Only it wasn't "*rye*" but "scotch"!)

**Zeno:** *Did he come up with things off the cuff?*

**Schwartz:** I don't think he'd ad-libbed them. He knew what he was gonna say and said it like a professional.

**Zeno:** *I wonder if you'd summarize any artistic strengths and weaknesses he had.*

**Schwartz:** He followed a script to the letter, so to speak. Whereas other artists, without quoting names, say Neal Adams (chuckle), would edit the editor.

**Zeno:** *Were there any inkers you favored over Curt's pencils?*

**Schwartz:** Oh, yes, Murphy Anderson, of course. Their art appeared under the by-line, "Swanderson."

© DC Comics

FROM ONE **SUPER** FRIEND TO ANOTHER,

*Congratulations Jerry*

ON A GREAT FLIGHT!

**YOUR PALS AT**
**WARNER BROS. AND DC COMICS**

© 1998 DC Comics. All rights reserved.

**Zeno:** *Did you coin that term?*

**Schwartz:** Oh, I don't know if I did; it may have been used before. When I took over Superman, one of the things I insisted upon was to have Curt Swan handle the pencils and Murphy Anderson the inks. Another thing I insisted was to have Denny O'Neil script the first several stories. Denny balked at first—but my pitch overcame his resistance.

**Zeno:** *Do you remember when you first met Curt? Do you think it went all the way back to the '40s?*

**Schwartz:** I doubt it. First of all, he was doing work for Mort Weisinger in an office at one end of a long hallway. The first office was maintained by Editorial Director Whit Ellsworth. In the next office were Mort Weisinger, Jack Schiff, Murray Boltinoff and George Kashdan. And then further on, an office with Robert Kanigher and me. What Kanigher and I did had no relation to what Mort Weisinger and company did.

**Zeno:** *So you may have never seen Curt at the other end?*

**Schwartz:** Well, we probably had a nodding acquaintance. I knew who he was; I liked his work so, as I say, when I took over Superman he had to be the man! (Laughter)

**Zeno:** *Now that's when you got to know him better?*

**Schwartz:** Right, he'd show up at the office; we'd have small-talk. What he liked about working with me was I'd always have a check ready for him. Also, another thing he liked, when I gave him a script, it was a complete script. I gotta be careful about this—but Mort Weisinger sometimes had only part of the script ready—it wasn't edited yet. So Curt had to wait around for the rest of it. Mort Weisinger was tough on his "slaves," as he put it.

What you ought to do is try to contact Superman writers like Cary Bates, Elliot Maggin and Denny O'Neil to find out how they felt about Curt Swan interpreting their scripts.

**Zeno:** *Good idea. I haven't contacted any of the writers [true at that time].*

*Left: Swan and Murphy Anderson supplied the art for this ad congratulating Jerry Seinfeld on the success of his hugely popular television show.*

# Paul Ryan

*At the time this was written on June 6, 1999, Paul Ryan was illustrating* Fantastic Five *for Marvel Comics and a Batman "No Man's Land" story for DC. His previous work on Superman and other series always appeared to have a Swan influence, and I was not disappointed to find out that he agreed.*

©2002 Marvel Comics

You are not the first person to compare my work with the late, great Curt Swan. He was my all-time favorite artist whether it was his work on Superman or any other character in the DC lineup. If Curt was in the comic, that was good enough for me to put down my hard-earned coins.

I never had the privilege of meeting Curt Swan, but I did speak with him on the phone on two separate occasions. The first time, I had asked Mike Carlin for Curt's phone number just so that I could talk to him and let him know how much I loved his work. At this time I was still working for Marvel. Curt was very pleasant to speak with and, I discovered, very humble. The second time we spoke was when I commissioned him to draw a Superman/Supergirl piece for my office.

I first discovered the Superman comics at the local barber shop. My awareness of Curt's artwork began in the mid to late '50s. Wayne Boring was the standard in those days and I loved his stories but when I discovered Curt Swan, it was a whole new ballgame. His work was lightyears ahead of anything I had seen at that time. His Superman looked more realistic. His Lois was gorgeous. His supporting characters were more varied and life-like. Curt was "The Man."

Curt Swan's art was appealing to me for a couple of reasons. One, as stated above, the characters were so well drawn. Each character was distinct from the other. You don't see this a lot today. He was also detail conscious. As far as I could see he never faked anything. There was also a little humor and whimsy in some of his pages, especially the Jimmy Olsen stories. You don't see a lot of fun in today's "funny books." From all I have heard of him, Curt was a kind, decent, caring individual and these traits came through in his work.

*Above is a sampling of the Swan/Anderson artwork that graced the Superman titles during Schwartz's early tenure as editor on the books.*

**Schwartz:** Curt preferred working from a full script... not Marvel style where the artist is given a plot or a summary and he wings it. In Curt Swan's case, he always had a full script: caption, scene description and dialogue, which reminds me of an anecdote. When Elliot Maggin was describing what would appear in a panel, he'd sud-denly think of a joke. "There were three midgets in an elevator..."and he'd go on at length with the joke. After which he'd go on to the rest of the [panel] description. Curt Swan complained, "When I came to the end of Elliot's page-long description what to put into the panel, I forgot what was said at the beginning of the thing." (Laughter) Most writers took three or four lines per panel, whereas Elliot would sometimes take a whole page to describe a panel.

Did Curt ever do any work for Marvel?

**Zeno:** *He only did one pin-up for a Marvel comic that I'm aware of, and I wonder if Jim Shooter asked him to do that?*

**Schwartz:** I suggest you contact Jim Shooter and find out if he ever tried to get him to illustrate for Marvel. There was a lot of exchange between Marvel and DC artists and whether Curt Swan was ever offered any work from them, I don't know.

Then also talk to Murphy Anderson; he and Curt were friendly.

**Zeno:** *I did get to interview Murphy a couple of years ago.*

**Schwartz:** Oh, well, maybe you ought to try him again and see if he has second thoughts. I'd press him a little harder. But when you do, tell him the following: Under no circumstances when he talks to you about Curt Swan is Murphy to wear a jacket and tie! You don't know what that means but Murphy will start laughing. Murphy always wears a jacket, shirt and tie. When he goes to a convention... for breakfast he'll wear a jacket and tie. (Laughter) We went to a small convention out here on the island called Ramapo, and I forbade Murphy to show up with a jacket! He showed up with a windbreak-er... and a broad grin on his face!

**Zeno:** *That's a miracle.*

**Schwartz:** (Laughter) It is. And find out more about Curt's sense of humor.

**Zeno:** *What did you think of his sense of humor? I know he laughed a lot.*

**Schwartz:** Yeah, but I don't think he ever came out with anything funny. But if something funny was said to him, he came out with a hearty laugh.

**Zeno:** *That's what his friend Mort Walker said, that Curt called him-self a dumb Swede and that he couldn't think of any good lines.*

**Schwartz:** I suggest you contact other artists who may have known Curt and get their reaction. Call up Gil Kane *[Kane passed away before he could be reached]* and ask what he thought of Curt's work. Get other artists' opinions, whether they were inspired by him. That might be a chapter in itself.

*One of the innovations Julius Schwartz brought to Superman was Clark Kent's conversion from newspaper reporter to TV newscaster.*

**Zeno:** *Gil Kane, whose work I admire very much, once told me that Curt's work was old-fashioned, or words to that effect. But that was many years ago [the early '80s].*

**Schwartz:** Old-fashioned in what sense?

**Zeno:** *I never asked him to elaborate. I just remember those two words, "old-fashioned."*

**Schwartz:** You're old-fashioned depending on who's looking at the artwork. (Laughter) But an artist or a reader who's been reading comics for ten or fifteen years might say, "Well, I liked that stuff when I was a kid." The point is, who was Curt Swan aiming his work at? He wasn't trying to do Jack Kirby type of art. It wasn't his style.

**Zeno:** *Did you try to aim his art at a particular age group?*

**Schwartz:** No, I liked it just the way it was. I thought Superman had a younger audience than that of Batman. There was more violent action in Batman than in Superman. I just aimed it that way.

*A dynamic fight scene from* Aquaman *(1989).*

# Sheldon (Shelly) Moldoff

*One of the top Golden Age comic-book artists, Moldoff's Alex Raymond-influenced rendition of Hawkman was a standout. Shelly was a featured DC cover artist almost from the beginning. He also did work for other companies, followed by a long tenure ghosting Batman for Bob Kane. After years of working in anonymity, Mr. Moldoff was eventually "rediscovered." The following letter was written on July 27, 1999 discussing Shelly's work as one of Curt Swan's inkers in the sixties.*

Curt Swan was a friend and I knew him over 40 years. Talented and dedicated to Superman. Mort Weisinger (Editor) liked my inking and I did many *Supermans* of Swan's—and covers—and Legion of Super-Heroes—*World's Finest Comics*, whatever. It's difficult for me to remember the issues—

Curt liked my inking because I tried to keep the same feeling he imparted into his pencils. Whereas with most other inkers... it became their Superman—not a Swan style.

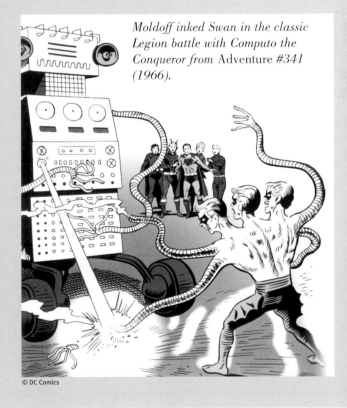

*Moldoff inked Swan in the classic Legion battle with Computo the Conqueror from* Adventure *#341 (1966).*

# Elliot S! Maggin

*Elliott S! Maggin (and friends) as depicted by Dick Dillin in* Justice League of America *#123, October, 1975.*

*Elliot S! Maggin was a principal writer of Superman stories for DC Comics from 1971 through 1986. He has also written five novels, three of which include Superman as a major character. These days he is teaching school and programming computers, and he says his current favorite super-power is to make Internet sites do flip-flops through force of will. He lives in southern California with his wife and two children. His memories of Curt were written on November 2, 1999.*

Curt Swan drew the first story I wrote that I ever saw drawn. It was an incredible experience. I didn't know what to make of the shock of having something I'd written turned into something rendered in a manner in which I was totally incapable of transforming it myself, so I brought everyone I could drag up to DC to watch it happen. My dad. My buddies from college. My girlfriend. My girlfriend's mom. Everyone I could drag along. Curt didn't work at the office in the city — which made his contribution that much more mysterious and Curt himself more mystical to me. Murphy worked at the office a lot, though. Murphy Anderson was inking most of Curt's pencils in those days, so I saw both the pencils and the inks and watched them get constructed pretty much page for page. By the time Curt was done with that first Superman story — it was called "Must There Be A Superman?" — he was not just this guy whose work I had grown up drooling over, but a guy who was molding a face and a soul to the words I was writing. Imagine my chagrin when I found he didn't like me.

True or not, that was what I heard. Our publisher made sure that was what I heard. It was the early '70s, after all, and divide and conquer was a widely respected management technique. I was a kid, and I would act out my therapy in my comic-book scripts. I'd go off on asides. Describe scenes and characters at length. Talk about their motivation. Tell jokes. Put stuff in the artist's notes that had nothing to do with the story — at least nothing this particular artist wanted to know. Curt, by contrast, was a grownup, with even the memory of being an inspired amateur — the condition out of which I was attempting, with this psychic self-medication, to outgrow — far behind him. Curt had places to go; people to see; deadlines to peg. He didn't have time for sophomoric humor masquerading as a comic book script. For him, this was serious business. So he came in one day to drop off pages and told Julie Schwartz, our editor, that he'd throttle me if I didn't cut out the elaborate digressions in my scripts. Curt was a very courtly, old-world kind of guy in a lot of ways and that was the expression he used: he wanted to throttle me. Julie jumped on it. He'd use it as a management tool.

"Curt wants to throttle Elliot," he told everyone who would listen, then Julie would laugh that throaty laugh and find someone else to listen. It was Julie's job, he felt, to

*Two pals just cruising around town: Swan ends up a character in this scene from* Superman Annual #9 *(1983).*

OH MY HEART!

OH MY SOUL!

I CHECKED YOUR HEART WITH MY X-RAY VISION, CURT, AND IT'S FINE!

BUT YOUR SOUL IS NONE OF MY BUSINESS!

Curt Swan: A Life in Comics • 77

put me in my place — whatever place that was — and make Curt feel secure at the same time. I was secure enough, he reasoned, I was barely twenty. Curt, at the time about the age I am now, was a seasoned professional; a valuable guy; an old institution of a fellow. I was crushed.

Well, maybe just a little wrinkled on the edges, but still...

We worked together for fifteen years after that, Curt and I, and we hardly ever met. Curt would wander up to the office, grinning his big Westport grin, wave at me, I'd mumble something and disappear in a cave somewhere until Curt was gone. The artwork was so incredibly good, I reasoned, and Curt was so definitively the guy who ought to be drawing Superman, that I wanted to give the man little enough reason to leave off my work. Didn't want to have him getting any further notions of throttling his least favorite writer.

It was years and years before Curt and I ever really sat down together. With every Superman script I'd practically beg Julie to give it to Curt to draw; I even wrote a story once where Curt fell into dreamland and had an adventure himself with Superman. Then sometime in the mid-1980s, around the end of the time we would be working together, we found ourselves at a comic-book convention up in the central woodlands of New York state. It was a little convention — Ithacon; I still have the t-shirt I brought home from it — and Curt and I were among just a small handful of professionals who

made it there that year. It went the weekend, and we managed to have a good enough time and, per our custom, avoid each other for most of our good times. Then late Sunday morning, soon after a breakfast where I'd gorged on sausages and omelettes because there was a girl — an angel, I was convinced — serenely playing a harp in the middle of the hotel restaurant, Curt wandered up to me and asked, courtly as ever, "Can I interest you in a little libation?"

"Libation," he said. I'm a sucker for anyone who knows how to use the language. We sat down as the angel gathered up her harp, around eleven in the morning. And we got up from the haze of alcohol and conversation as dusk fell. We drank. We talked. We gossiped. We had the same favorite subjects: Superman, Julie and politics. Turns out we both loved all three. To my surprise, I found Curt stood on the political spectrum just immediately to my left: right there among Emma Goldman, Allard Lowenstein and Thomas Jefferson — except for that whole troublesome slaveowner thing. Finally, after all those years, Curt Swan and I became friends.

We stayed friends too. We spent a lot of the time we were together after that ribbing Julie about purposely keeping us at odds. Curt and I talked on the phone occasionally after our Superman time was gone, occasionally danced around the idea of working together on somethingorother, hung out over a beer and a scotch whenever we were in the same place and in the vicinity of either libation. It made sense for us to have found

some common ground, as much sense as it hadn't made for me to be ducking into phone booths before whenever Curt came around. We were both philosophical products of the message we spent a career delivering to the hero-worshippers of the world. We both believed in truth, justice and the American way: a personal torah. It was good finally to learn that we had so much in common when finally we gave each other the space to reveal it. He was a good man, Curt Swan. I wish I had known him better.

*Swan added grace to the adventures of Wonder Woman for a short time in the 1970s.*

*Another of Swan's wonderfully imaginative robotic creations — this one from the early '90s incarnation of* The Adventures of Superboy.

© DC Comics

# Len Wein

©2002 Jackie Estrada

*Just having finished story-editing the animated series "War Planet," Len was kind enough to grant an interview on September 13, 1999. An outstanding comics writer and editor for many years, two of his best-known accomplishments are co-creating Swamp Thing for DC and Wolverine for Marvel Comics. Additionally, Len was one of the new breed of writers whom editor Julius Schwartz brought to the Superman title in the early seventies.*

*Len Wein co-created Swamp Thing for DC in the 1970s.*

© DC Comics

**Wein:** Curt was one of the most "humanistic" artists that I ever worked with. Other guys could give you accurate, incredible drama, but Curt could give you natural human beings interacting better than almost anybody else in the business.

**Zeno:** *Were you pleased with how he interpreted your scripts?*

**Wein:** Oh, without exception. I can't think of a moment that I wasn't happy with how Curt envisioned what I envisioned.

**Zeno:** *Did you always write full scripts for him?*

**Wein:** As a rule, I think it was full scripts [but] I probably did a few of them Marvel style. I hate to say "Marvel style;" it actually wasn't created by Marvel. I preferred working that way because I always felt that you had the best combination of writer and artist. I didn't have to write defensively. One of the things I was always concerned about when writing a script was when I didn't know how the artist would interpret it. There was a concern that if he didn't put in

exactly what I asked for in a certain picture, then a point of story was lost. So, occasionally I would put in captions or dialogue, but if the story was interpreted correctly it really wouldn't be necessary. Working in the so-called Marvel style, I knew exactly what Curt had drawn and I would be able to dialogue what was appropriate, what was not told in the visuals. And there was so rarely any problem with Curt's visual storytelling that it was a great joy to work with him.

With rare exception, almost every Superman story I did, Curt drew. I remember my very first Superman story. It was called, "Danger-Monster At Work!" [*Superman* #246, December, 1971]. It was one of my favorites... A: in terms of being my first experience at working with Curt and seeing how he would interpret my stuff and B: that was the issue where I introduced all of the people who lived in Clark Kent's apartment building. I had the chance to really use the human side of Curt's abilities.

**Zeno:** *Did you enjoy Murphy Anderson's inks on that and other Superman stories?*

**Wein:** Murphy was and remains a dear friend... always one of the best. The two of them together were an almost unbeatable team.

**Zeno:** *What about Julius Schwartz to round out the team as editor?*

**Wein:** I probably learned more about story structure and storytelling from Julie than any other editor that I ever worked with. I learned different things from different people, but Julie probably

taught me the most. That's the reason he's a living legend. He's got a great mind and without him, there probably would not be a comic book industry.

**Zeno:** *Did you see Curt at the office of DC Comics?*

**Wein:** I actually had a tendency as a freelancer to come in more often than many because I liked the interaction. It also provided me the need to get work done every

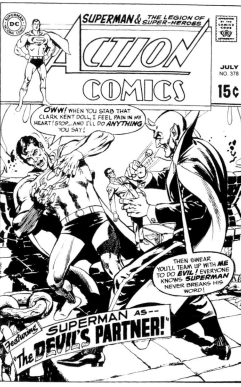

day. It kept things moving... progressing. Curt came in once every couple of weeks to pick up the next story and to deliver the previous one. I knew him fairly well. We had, on and off, a long-term relationship. He was a very friendly, open guy. The biggest story Julie probably tells is that Curt basically drew to provide money so he could take off the time to go golfing. (Laughter) Given a perfect world, Curt would have done no drawing, whatsoever. Just gotten to the links first thing in the morning and golfed all day.

Curt Swan: A Life in Comics • <strong>79</strong>

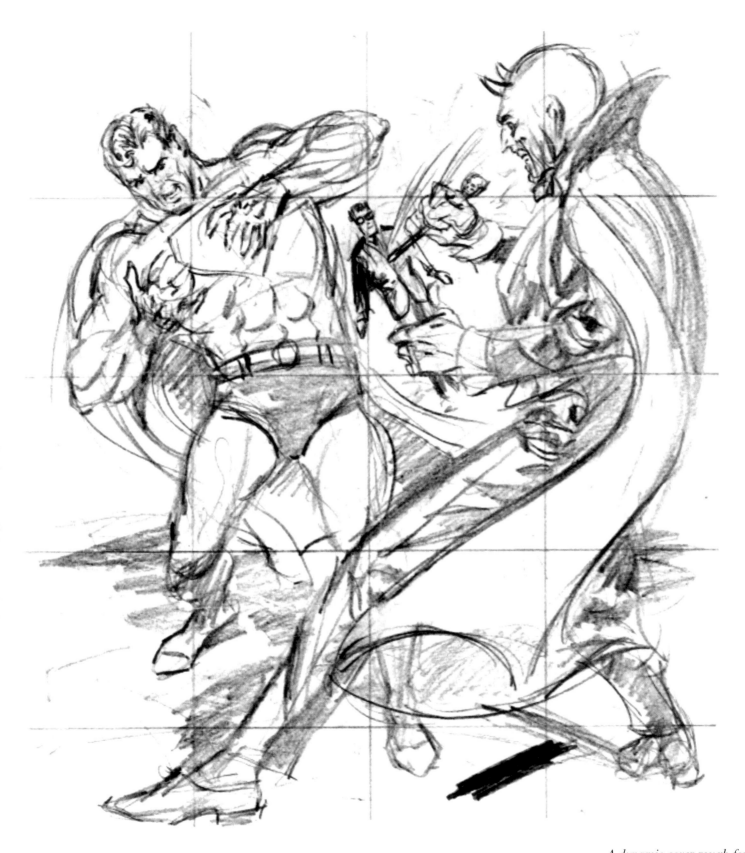

*A dynamic cover rough for
Action Comics #378, July,
1969. The finished version,
as inked by Neal Adams,
appears on the facing page.*

# Irwin Donenfeld

*Just out of college, Irwin Donenfeld began working at DC in 1947. (His father, Harry, with Jack Leibowitz, were longtime co-publishers of the company.) Starting as a production assistant, Irwin eventually became editorial director. Under his tutelage, the company was selling seven million comic books a month by the time he left in early 1968. Today, he owns and operates a marina in Westport, Connecticut. Thanks to Jon B. Cooke at* Comic Book Artist *magazine for telling me that Mr. Donenfeld had a personal story about Curt Swan's generosity. The interview took place on September 17, 1999.*

**Zeno:** *Tell us about your time at DC.*

**Donenfeld:** I was an assistant to a man who was in charge of the art department. He did all the scheduling. We had artwork all over the place. It was crowding us out. The first thing I did when I went in there was chop up all that old artwork.

**Zeno:** *I'll bet you're sorry you did that.*

**Donenfeld:** (A hearty laugh from Mr. Donenfeld.) Here's what I did. When the artist finished his work, we shot down with a camera and a black and white negative was made. From the black and white negative, they made what they called a silverprint, which came back to us, which went to a colorist and he put in the color. And that went back to the engraver and then they made the plate. So I said one day, "What do they do with the black

and white negative?" Well, they put it in the bath and they take the silver out of the solution. I said, "What kind of _____ is that? You tell the engraver I want the black and white negative." So I started a collection. Every single book we published, I had all the black and white negatives. Eventually, Jack Leibowitz said one day, "In order to bring down the cost of these books we should do reprints of some of the material we've run before." [I said] "Not a problem; we've got the black and white negatives and can go right from there." So what did I need the original artwork for? I chopped it all up. What happened to all my black and white negatives? I don't know.

We not only were publishers, but also had a distributing company. I

spent a lot of my time with the wholesalers around the country, befriending them and making sure that they took care of our publishers. So I've been in every town in the country, just about.

We turned out thirty, thirty-one titles a month. We closed a book-and-a-half a day. I was in charge of all the scheduling. When I left, I was really disheartened. I hated to leave, but when we merged with a company called Kinney, Steve Ross was the president and he made me all kinds of promises, none of which he kept. It got to a point where I was now in the third echelon of executives [after] running my own business for twenty years. I had to go to a meeting and find out where they're gonna put another funeral parlor [one of Kinney's other business endeav-

*At right, Swan's artwork for a* Continental Insurance *magazine ad, for which he won an advertising award.*

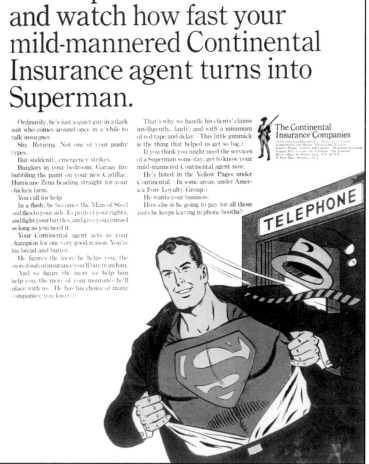

ors]? So I said, "I gotta get out of here while I'm still young and alive." I left the company in 1968 and we moved up here. I opened up a marina and sell boats.

**Zeno:** *What is the story about Curt and your son?*

**Donenfeld:** You know that I was Curt's boss for many, many years and had known him for a long, long time. In the old days, the cartoon artists, both comic book and newspaper artists, have a routine; I don't know if they still do. They went around to Korea or wherever U.S. servicemen were and put on a show. There were these blank sheets of paper and they would draw on them. It was funny and it was humorous... It was great! The kids absolutely adored it. Curt got them to come up here to Westport. In one of our schools they had this program; proceeds from it went to one of the local charities. Everybody who came got a raffle ticket. I came with my son Luke,

who was about five or six at the time [around the mid-1970s]. We each had a raffle ticket, and of course gave them to my son. When the thing was over, he started saying, "I pray I win one, I pray I win one." Well, he didn't. So he's sobbing and my wife is trying to say to him, "You have to learn how to lose and how to be a sportsman," etc. And I said, "Okay, he doesn't have to lose tonight." So I went up to the podium, Curt takes one look at me and he yells, "Irwin!" He put his arm around me and we hugged and kissed and the whole bit. I hadn't seen him in quite a few years. I said, "Curt, my son didn't win. I want him to win something." (Laughter). He said, "I'm going to do a painting for him that will knock your eyes out." He did, and we still have it on the wall somewhere. A beautiful watercolor of Superman and he [inscribed] it to my son, Luke. Another artist who used to work for me was there, and he also drew something for my son.

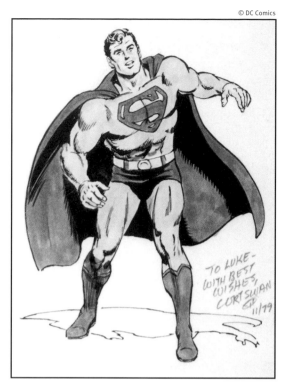

*This is the framed sketch Swan did as a consolation prize for Irwin Donenfeld's son.*

**Zeno:** *In your years at DC, did you get to know other freelancers as well as you got to know Mr. Swan?*

**Donenfeld:** My position was that basically, I was in charge of the editors. And the editors were the ones who spent all of the time with the artists. I oversaw every-

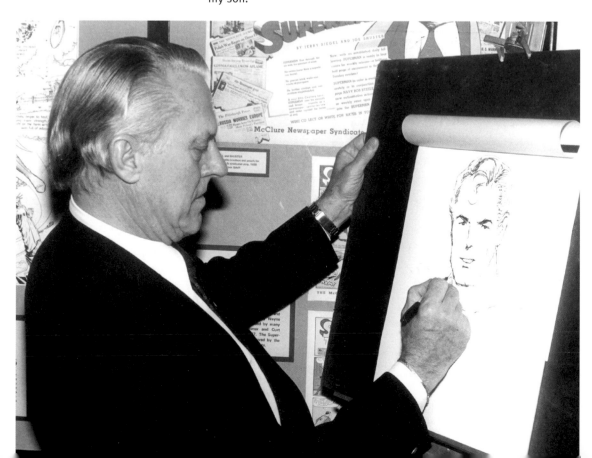

*Swan sketching before an audience at a public event.*

# Kerry Gammill

*Longtime Marvel and DC comic book artist Kerry Gammill was one of the major Superman delineators for several years beginning in the late 80s. He has spent much of the last decade storyboarding and conceptualizing monsters and heroes for television and movies. On December 22, 2001 he wrote:*

People sometimes tell me that my version of Superman reminded them of Curt Swan. I can't think of a better compliment. Some of the first comics I ever read were Swan's Superman books. His clean, naturalistic style was a perfect fit for the character and his clear, non-flashy storytelling was perfect for young readers of the time. Many artists have come and gone on the books, but I don't think anyone will ever have the impact that Curt Swan did. To me he is the definitive Superman artist.

*Right: a fan-commissioned drawing recreating some of the high points of Superman's Silver Age career.*

*Right: artwork done for a Red Cross blood drive promotion. It was inked by Swan himself.*

© DC Comics

thing; I didn't have that much to do with each individual guy. Curt, I knew very, very well for many reasons, because he was our top artist, to begin with. You know, he would come into the office and we would chat together. We'd talk about football or baseball or whatever. Curt came to me one day... You know that Mort Weisinger was his editor. And he said, "You know, I've been working here for a number of years," whatever it was, "and haven't had a raise." I said, "Okay, I can take care of that." I was the boss. (Laughter) That's why he was so appreciative of seeing me. Nobody really liked Mort Weisinger. (Laughter) I'll tell you

that right now. For various and sundry reasons, he was not popular with his men.

**Zeno:** *What was another reason you knew Curt so well?*

**Donenfeld:** Curt was a little different. He was more businesslike than anybody else.

**Zeno:** *Do you mean he was more professional than some of the other artists?*

**Donenfeld:** I would put it that way. A lot of them are kinda weird. (Laughter) But if [Curt] made an appointment, he was always there. He would come in on time. He'd spend the day at

the office, he got up and he took the train home.

**Zeno:** *Curt always said it was a job, one that he enjoyed, but it was a way of putting food on the table.*

**Donenfeld:** That's right. Somebody gave him a script, he went home and he drew. He brought it in, got paid and he went home. He wasn't one of the guys who fooled around all the time. Some of them spent the night going out drinking and having a ball. Curt, I do not recall ever doing that.

**Zeno:** *He would meet his deadlines?*

**Donenfeld:** Oh, yeah, always. Very professional.

HELP YOURSELF— BE A DONOR!

FOR THAT SUPER FEELING!

© DC Comics

*Penciled pages from Swan's last assignment — a mostly unpublished Superman story. Some of the pages from this story were inked by Butch Guice and utilized in* Superman: The Wedding Album *(Dec., 1996).*

*A 1995 penciled cover recreation of* Adventure Comics # 333, June, 1965; "The Civil War of the Legion!" *(From the collection of Tom Horvitz.)*

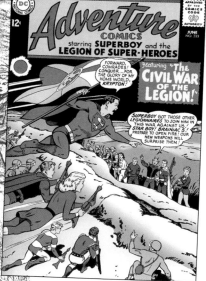

# Mark Waid

*Mark Waid started at DC Comics in 1987 as a staff editor but has gone on to become a prolific, award-winning freelance writer for many comics companies. He wrote* Flash *and* Captain America *for DC and Marvel, respectively. One of his best known miniseries was* Kingdom Come, *in collaboration with artist Alex Ross. A true comic-book fan and historian, as well as a seasoned pro, Waid was once quoted in* Comics Buyer's Guide *as saying that the Curt Swan/George Klein art team was his all-time favorite. On March 15, 2001, Mark kindly agreed to address that topic as well as why Swan has maintained an influence on his writing. At that time, Waid was working for CrossGen Comics and writing* JLA.

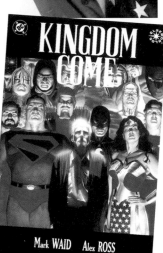

© DC Comics

*Swan's warm, naturalistic faces and understated expressions, complemented by George Klein's refined inking, made Superman and his supporting players real for a generation of readers.*

When I'm asked to list my influences as a comics creator, I'm liable to reel any random combination of writers' names off the top of my head, whichever ones are freshest in my walnut-sized brain. What surprises people, though, is that the name Curt Swan is always on that list, too—an odd mention coming from a writer who can barely draw a bath. True, Curt never taught me how to draw one single line—but what I did learn from Curt was far more valuable than any art lesson. While he was capable of so much, Curt's truest gift in this medium was this: he alone could take pencil to an alien powerhouse from a far-flung galaxy and give him humanity. Curt's magic was to perfectly portray The Man of Steel as a warm and gentle savior without sacrificing his grandeur or power. He understood and best conveyed that, of all the many things

Superman is, he is first and foremost (in the words of Christopher Reeve) a friend—and that's the approach to the character that I've always taken as a writer. As a DC Comics editor, I learned something else from Curt; the importance of professionalism in a field sorely lacking in same. Handling the anthology book *Secret Origins*, it was always my pleasure to keep Curt working on a variety of post-Superman assignments, for he never missed a deadline and despite the long nights he no doubt put in from time to time to help DC get a book out quickly, he never "cheated"; each and every panel of his work perfectly illustrated the script at hand. His consistency amazed me. There was no such thing as a "bad" Curt Swan job, and I wasn't the only one who knew that: it was a testimony to Curt's skill that during those *Secret Origins* years, a wide variety of highly talented and respected

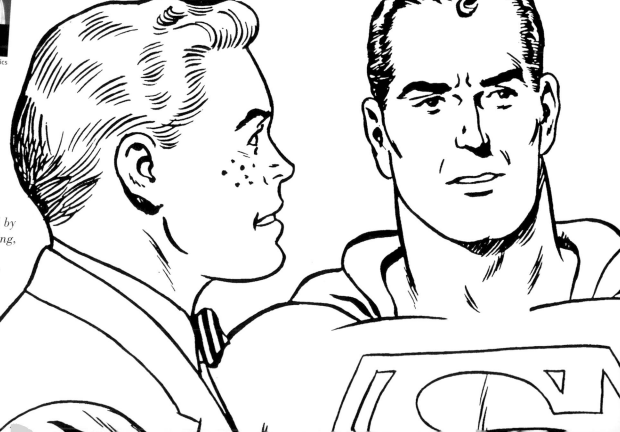

© DC Comics

artists were humbly lining up to ink his work, and not so much to embellish it as to learn from it. In fact, it was during that period that, by his own admission, Curt got the best inks that he'd gotten in twenty years when a young illustrator named Eric Shanower—who also specialized in warm, human characters—embellished Swan's pencils in a one-time special titled *The Legend of Aquaman*. The finished product, Curt later told me, made for one of the jobs over his long career that he was proudest of. I remember being impressed that, after forty years, something like that still mattered to him, but in retrospect that was a foolish thought—for that's the sign of a class act, and Curt was never anything but.

### The Swan/Klein Team

Murphy Anderson made Swan's work more powerful and dynamic; Dan Adkins gave it a unique weight and shading; yet those are only two of the three inkers who are consistently named as the best to ever work over Swan. The third is George Klein — and even today, over thirty years after their last collaboration, their work together is still fondly remembered, and for good reason. It's unlikely you'll meet anyone who'll argue the claim that — with all due respect to the many others who inked Curt's pencils during his long career — the Swan/Klein team

showcased Swan at his all-time best. Klein came to DC Comics in the 1950s following a long and varied career as an inker and illustrator for such companies as Marvel Comics, Lev Gleason, and ACG, and he was a godsend. Up to that point, Curt's pencils had often been overpowered by the relatively heavy brush inks of Stan Kaye and John Fischetti. Klein, by contrast, graced Swan's pencils with a much finer, sharper line — a sensitive brush stroke that in no way overpowered Swan stylistically. For the first time, Swan's illustrations were captured perfectly by craftwork that impeccably complimented his own, allowing all of Swan's strengths to show through. Thanks to Klein, Lois Lane never looked more elegant, Jimmy never looked more expressive, and Lex Luthor never looked more like a mad genius. That's not to say, however, that Klein simply traced Swan's drawings; instead, his inks sharpened Swan's softer lines, making the finished illustrations wonderfully clean and open to color without sacrificing one scrap of detail.

Sadly, in 1968, Swan lost his then-best inker when Klein, in failing health, left for Marvel Comics in search of better medical benefits before passing away the following year — but their body of work defined Superman for an entire generation of comics readers and will never be forgotten.

## Bob Oksner

*Bob Oksner illustrated superheroes during comics' Golden Age in* All Star Comics *but is best known for drawing humor features at DC for many years. He was a longtime collaborator on the* Dondi *newspaper strip with artist Irwin Hasen (after the original writer, Gus Edson, died). Mr. Oksner also had his own short-lived daily,* Soozi, *for a brief period in the late '60s. On Feb. 5, 2001, Bob relayed how he became reassigned to superhero features at DC toward the end of his career, when he not only penciled and inked his own work but also embellished the drawings of others, such as Infantino and Swan.*

By the late '60s, early '70s, humor mags. were dying. In 1972 *Jerry Lewis* died; the comic book, not the comedian. (Laughter) *Angel And The Ape* was one of the last humor features I worked on. I loved that! (Actually, *Welcome Back Kotter* in the late '70s was my very last humor mag for DC.) Carmine Infantino was in charge. He put me on Curt Swan [in 1973]. Joe Orlando, with whom I worked on the humor mags, told me to cut down my line. That's because I had used a very broad brush stroke for humor. I certainly appreciated Curt's artistic abilities, his solid draftsmanship; he had a sense of weight that I admired. His pencils were quite detailed. The only thing I can remember adding is shadows.

I don't know if you are aware of the Superman pop-up book Curt Swan and I did in 1979 for DC Comics. It was selected as one of the best children's books by *The New York Times*.

Because of the paper engineering of a pop-up book (by Ib Penick), the art was not done on individual pages like a comic book. Instead, the art was drawn and inked on a long sheet of paper — possibly 20 feet long — and we worked on it as we would a scroll. It was unwieldy, but it worked.

The first meaningful kiss between Clark Kent and Lois Lane in the comics was drawn by Curt and inked by myself. The panel was reprinted in *The (New York) Daily News*. [December 24, 1975].

But I never enjoyed superheroes. I did some covers for *Superman*, *Action*, *Wonder Woman* and even illustrated *Supergirl*. It wasn't as much fun, which is a big reason I retired in 1985. However, I enjoyed inking Curt Swan. The inking was a ball!

*At left: By 1976, a new stage was reached in comics' most famous unrequited relationship. These panels from* Superman #297 *generated national attention for The Man of Steel.*

"LADIES AND GENTLEMEN OF THE SCIENCE COUNCIL..."

MY *EYES!* WHAT ON KRYPTON IS THAT--?

THE WORST SOLAR PROMINENCE YET! SHIELD YOURSELVES!

*Scenes of Krypton's final days, again, with Williamson inking. From DC Comics Presents #87. (From the collection of Wally Harrington.)*

going to try and get together again, but we never did. He lived in Connecticut and I live up here. It was about a three hour drive, not like we were right next door to one another. I wish I'd gotten to know him better, spent more time with him. It was sad when I heard he had passed away.

**Zeno:** *You do know that he called you his favorite inker?*

**Williamson:** No, really!!? Oh, my God, how very sweet of him.

**Zeno:** *Yes, Curt had a quote that went, "[Al] was the best. A fine draftsman in his own right, an extremely talented artist, he could render even the little mechanical parts of vehicles. He had a very special flair the others didn't have." [From: Superman at Fifty! The Persistence of a Legend! edited by Dooley D and Engle G, Octavia Press, Cleveland, OH, 1987.]*

**Williamson:** Well, I'll tell you the thing is that it's there. What's the problem? I don't understand; you have a beautiful artist that does beautiful work, you give it to an inker

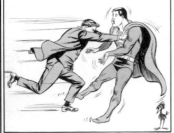

A SCENE WE'D LIKE TO SEE

ARTIST: GEORGE WOODBRIDGE     WRITER: DON EDWING

and he [messes] it up. If nothing else, trace it.

**Zeno:** *Did you only use a brush over Swan's pencils?*

**Williamson:** Oh, no. I started with a brush and had a little problem with that. Then I used a pen—then I started working better. So most of it is pen.

Curt was a wonderful artist. I'm just so sorry that he wasn't more appreciated because he could really draw!

**Zeno:** *That means a lot, coming from an artist of your caliber.*

**Williamson:** I'll tell you one thing about me. I have excellent taste in art and friends. (Laughter)

*When* Mad *magazine's George Woodbridge was called on to parody Superman, Swan was clearly his reference point for a definitive Man of Steel. This gag is from* Mad #103, June, 1966.

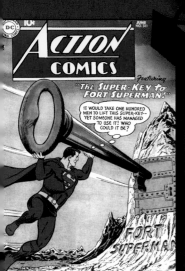

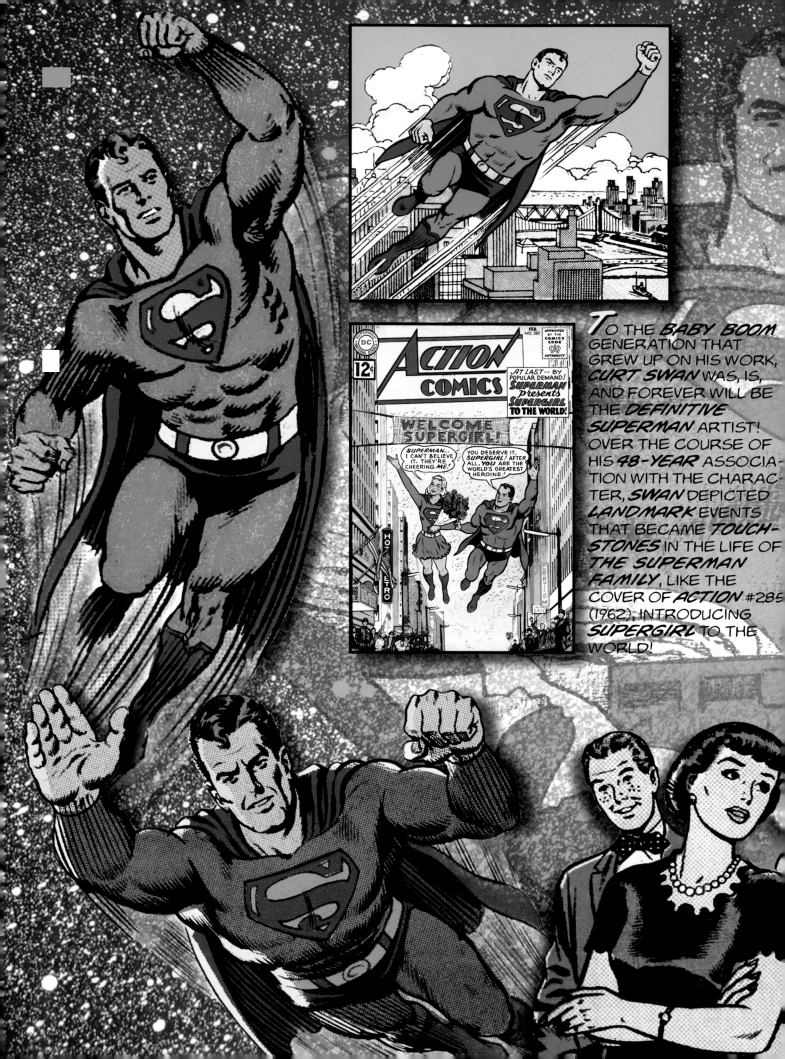

To the *BABY BOOM* generation that grew up on his work, *CURT SWAN* was, is, and forever will be the *DEFINITIVE SUPERMAN* artist! Over the course of his *48-YEAR* association with the character, *SWAN* depicted *LANDMARK* events that became *TOUCHSTONES* in the life of *THE SUPERMAN FAMILY*, like the cover of *ACTION* #285 (1962), introducing *SUPERGIRL* to the world!

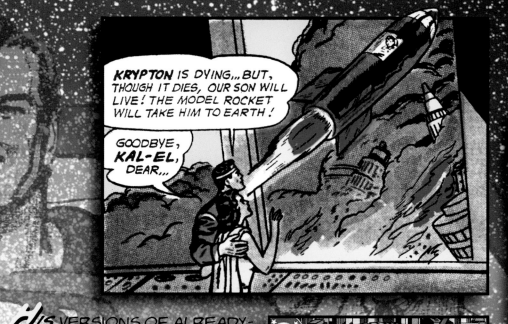

His VERSIONS OF ALREADY-FAMILIAR ASPECTS OF THE CHARACTER'S *ICONOGRAPHY*, FROM THE SCENES OF A DOOMED *KRYPTON* TO THE SIGHTS OF *SUPERMAN* SOARING ABOVE THE *METROPOLIS* SKYLINE, BECAME THE *NEW* ICONS AGAINST WHICH *ALL* SUCCEEDING *SUPERMAN* ARTISTS WERE *JUDGED*!

"*SUPERMAN'S* APPEAL TO THE PUBLIC AT LARGE *ALL* BOILS DOWN TO THE *DREAM* WE ALL HAVE OF BEING *POWERFUL*, OF BEING ABLE TO DO THINGS *NO ONE ELSE* CAN DO-- ESPECIALLY *FLYING*!" --*CURT SWAN*, 1996

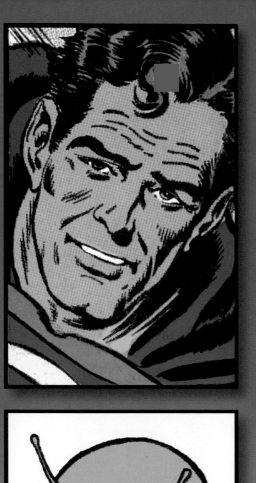

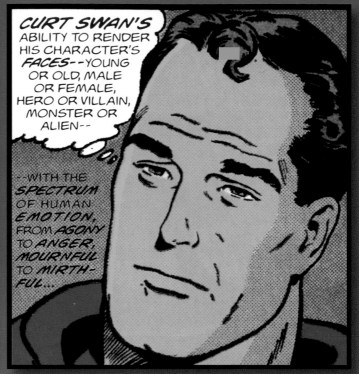

CURT SWAN'S ability to render his character's *FACES*--YOUNG OR OLD, MALE OR FEMALE, HERO OR VILLAIN, MONSTER OR ALIEN--

--WITH THE *SPECTRUM* OF HUMAN *EMOTION*, FROM *AGONY* TO *ANGER*, *MOURNFUL* TO *MIRTHFUL*...

...REMAINS ONE OF THE *HALLMARKS* OF HIS *REALISTIC* STYLE! *SWAN* ONCE WROTE, REGARDING *SUPERMAN*...

"EVEN A *BAWLING* CHILD-- IT *AGES* A CHILD ABOUT A *DOZEN* YEARS!" JUDGE FOR *YOURSELF*, THEN, THIS PANEL FROM "*THE SONS OF SUPERMAN!*" (#166, 1964), INKED BY *GEORGE KLEIN!*

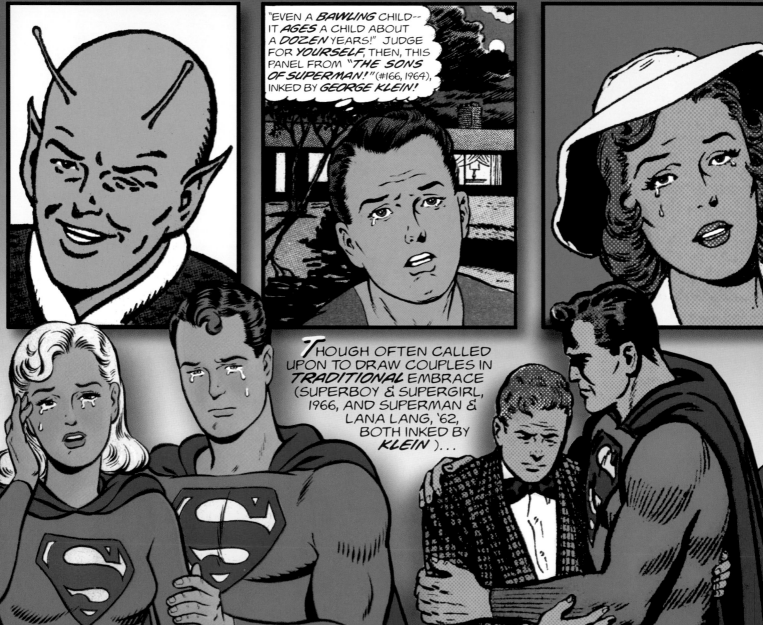

*T*HOUGH OFTEN CALLED UPON TO DRAW COUPLES IN *TRADITIONAL* EMBRACE (SUPERBOY & SUPERGIRL, 1966, AND SUPERMAN & LANA LANG, '62, BOTH INKED BY *KLEIN* )...

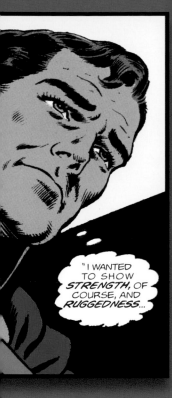

"I WANTED TO SHOW STRENGTH, OF COURSE, AND RUGGEDNESS...

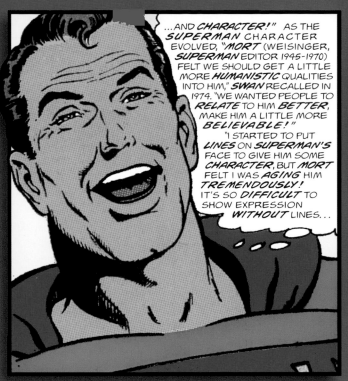

...AND CHARACTER!" AS THE SUPERMAN CHARACTER EVOLVED, "MORT (WEISINGER, SUPERMAN EDITOR 1945-1970) FELT WE SHOULD GET A LITTLE MORE HUMANISTIC QUALITIES INTO HIM," SWAN RECALLED IN 1974. "WE WANTED PEOPLE TO RELATE TO HIM BETTER, MAKE HIM A LITTLE MORE BELIEVABLE!"

"I STARTED TO PUT LINES ON SUPERMAN'S FACE TO GIVE HIM SOME CHARACTER, BUT MORT FELT I WAS AGING HIM TREMENDOUSLY! IT'S SO DIFFICULT TO SHOW EXPRESSION WITHOUT LINES...

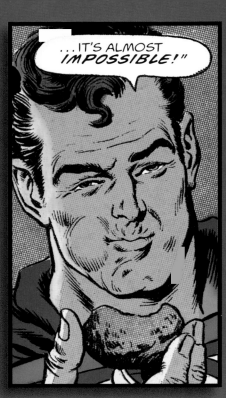

...IT'S ALMOST IMPOSSIBLE!"

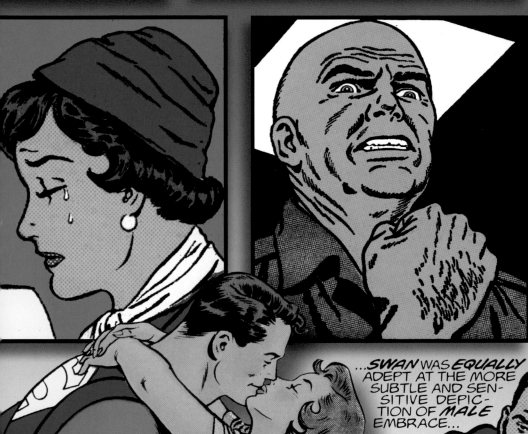

...SWAN WAS EQUALLY ADEPT AT THE MORE SUBTLE AND SENSITIVE DEPICTION OF MALE EMBRACE...

(SUPERMAN CONSOLING JIMMY OLSEN, 1956, INKED BY RAY BURNLEY, AND COMFORTING A DYING WONDERMAN, '63, INKED BY KLEIN.)

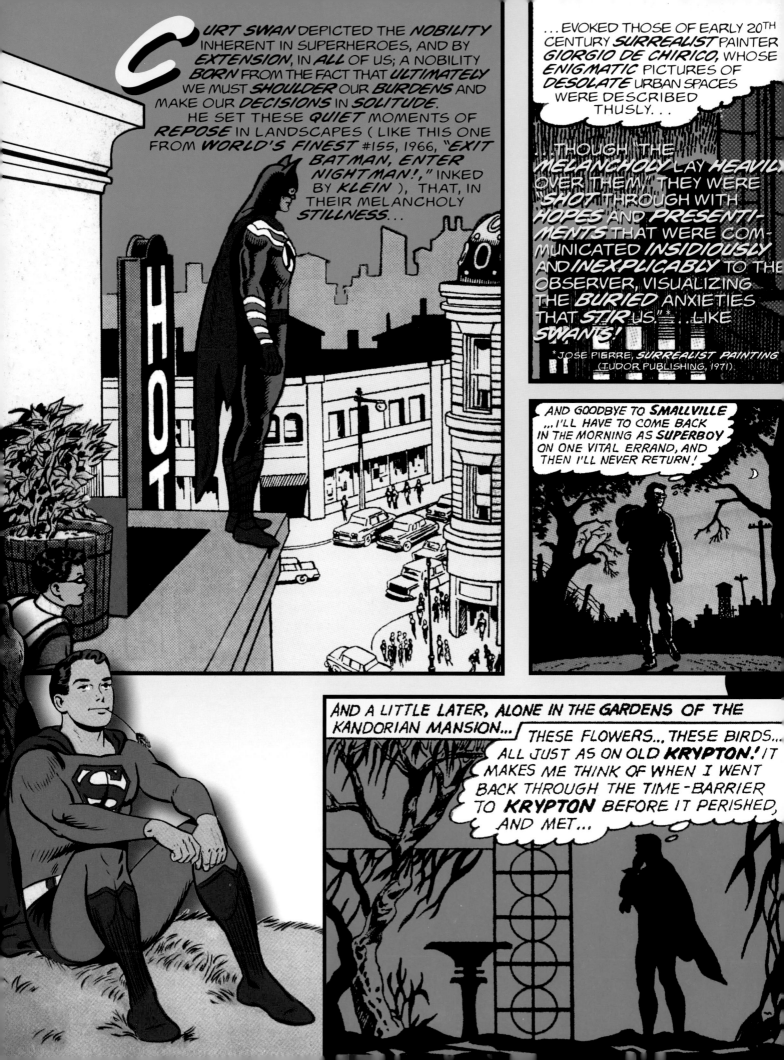

CURT SWAN DEPICTED THE *NOBILITY* INHERENT IN SUPERHEROES, AND BY *EXTENSION*, IN *ALL* OF US; A NOBILITY *BORN* FROM THE FACT THAT *ULTIMATELY* WE MUST *SHOULDER* OUR *BURDENS* AND MAKE OUR *DECISIONS* IN *SOLITUDE*. HE SET THESE *QUIET* MOMENTS OF *REPOSE* IN LANDSCAPES ( LIKE THIS ONE FROM *WORLD'S FINEST* #155, 1966, "*EXIT BATMAN, ENTER NIGHTMAN!*," INKED BY *KLEIN* ), THAT, IN THEIR MELANCHOLY *STILLNESS*...

...EVOKED THOSE OF EARLY 20TH CENTURY *SURREALIST* PAINTER *GIORGIO DE CHIRICO*, WHOSE *ENIGMATIC* PICTURES OF *DESOLATE* URBAN SPACES WERE DESCRIBED THUSLY...

"THOUGH THE *MELANCHOLY* LAY *HEAVILY* OVER THEM", THEY WERE *SHOT* THROUGH WITH *HOPES* AND *PRESENTIMENTS* THAT WERE COMMUNICATED *INSIDIOUSLY* AND *INEXPLICABLY* TO THE OBSERVER, VISUALIZING THE *BURIED* ANXIETIES THAT *STIR* US." * ...LIKE *SWAN'S*!

*JOSE PIERRE, *SURREALIST PAINTING* (TUDOR PUBLISHING, 1971).

AND GOODBYE TO *SMALLVILLE* ...I'LL HAVE TO COME BACK IN THE MORNING AS *SUPERBOY* ON ONE VITAL ERRAND, AND THEN I'LL NEVER RETURN!

AND A LITTLE *LATER*, ALONE IN THE *GARDENS* OF THE KANDORIAN MANSION...

THESE FLOWERS... THESE BIRDS... ALL JUST AS ON OLD *KRYPTON!* IT MAKES ME THINK OF WHEN I WENT BACK THROUGH THE TIME-BARRIER TO *KRYPTON* BEFORE IT PERISHED, AND MET...

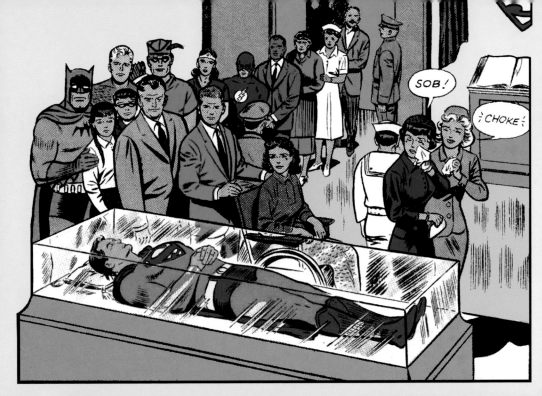

He waits in the gathering darkness, alone... and none can know his thoughts...

SWAN'S SUPERMAN SELDOM EXPRESSED FEELINGS OF MELANCHOLY; RARELY DID HE BROOD; YET THERE WAS OFTEN AN AIR OF PALPABLE SADNESS ABOUT HIM, TAKEN TO THE EXTREME IN 1961'S "THE DEATH OF SUPERMAN!" (INKED BY STAN KAYE), ABOVE, AND IN SWAN'S LAST SUPERMAN STORY IN '86, INKED BY GEORGE PEREZ, BELOW.

"HE LOOKED AS IF HE'D BEEN CRYING."

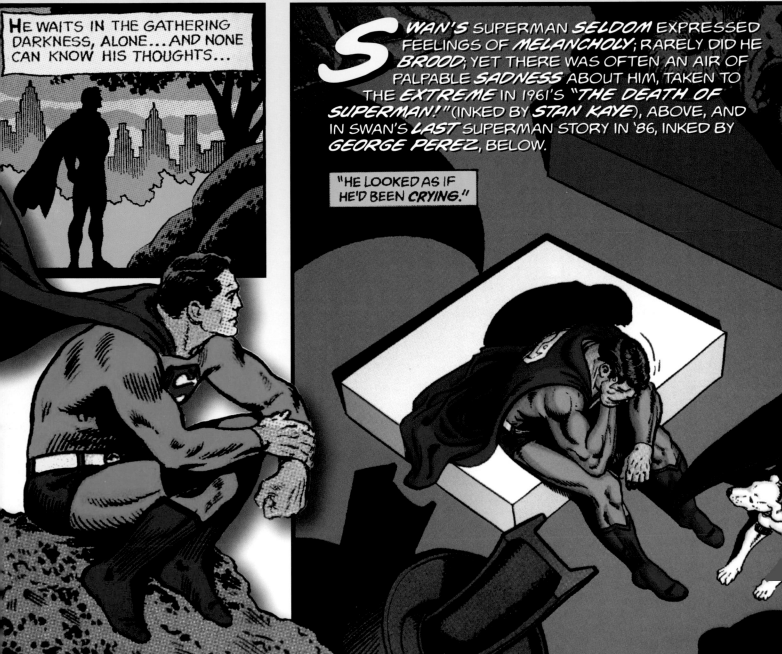

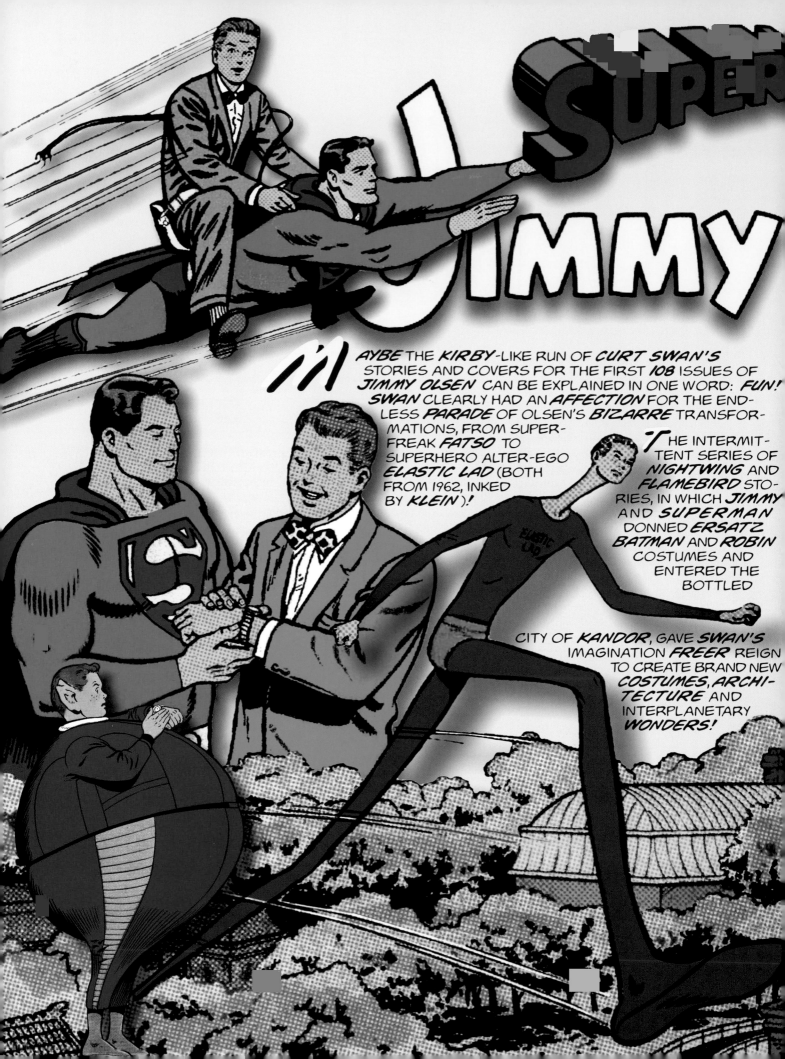

# SUPER Jimmy

**M**AYBE THE *KIRBY*-LIKE RUN OF *CURT SWAN'S* STORIES AND COVERS FOR THE FIRST *108* ISSUES OF *JIMMY OLSEN* CAN BE EXPLAINED IN ONE WORD: *FUN!* *SWAN* CLEARLY HAD AN *AFFECTION* FOR THE END-LESS *PARADE* OF OLSEN'S *BIZARRE* TRANSFOR-MATIONS, FROM SUPER-FREAK *FATSO* TO SUPERHERO ALTER-EGO *ELASTIC LAD* (BOTH FROM 1962, INKED BY *KLEIN*)!

**T**HE INTERMIT-TENT SERIES OF *NIGHTWING* AND *FLAMEBIRD* STO-RIES, IN WHICH *JIMMY* AND *SUPERMAN* DONNED *ERSATZ* *BATMAN* AND *ROBIN* COSTUMES AND ENTERED THE BOTTLED

CITY OF *KANDOR*, GAVE *SWAN'S* IMAGINATION *FREER* REIGN TO CREATE BRAND NEW *COSTUMES, ARCHI-TECTURE* AND *INTERPLANETARY* *WONDERS!*

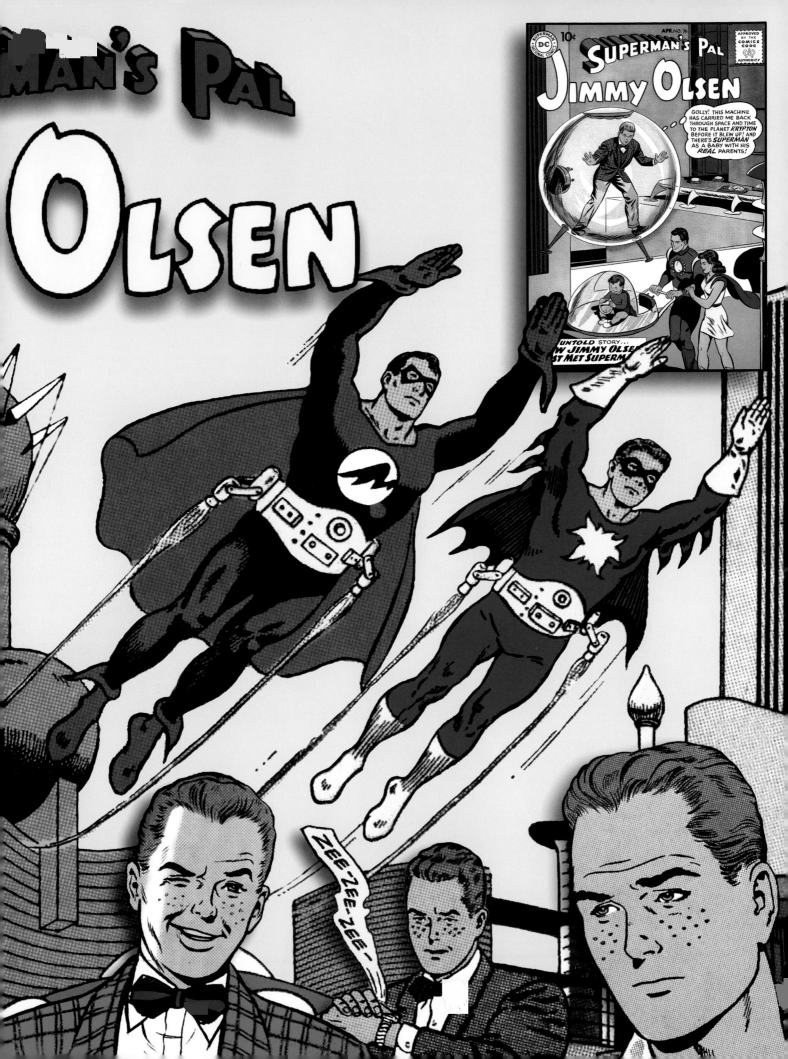

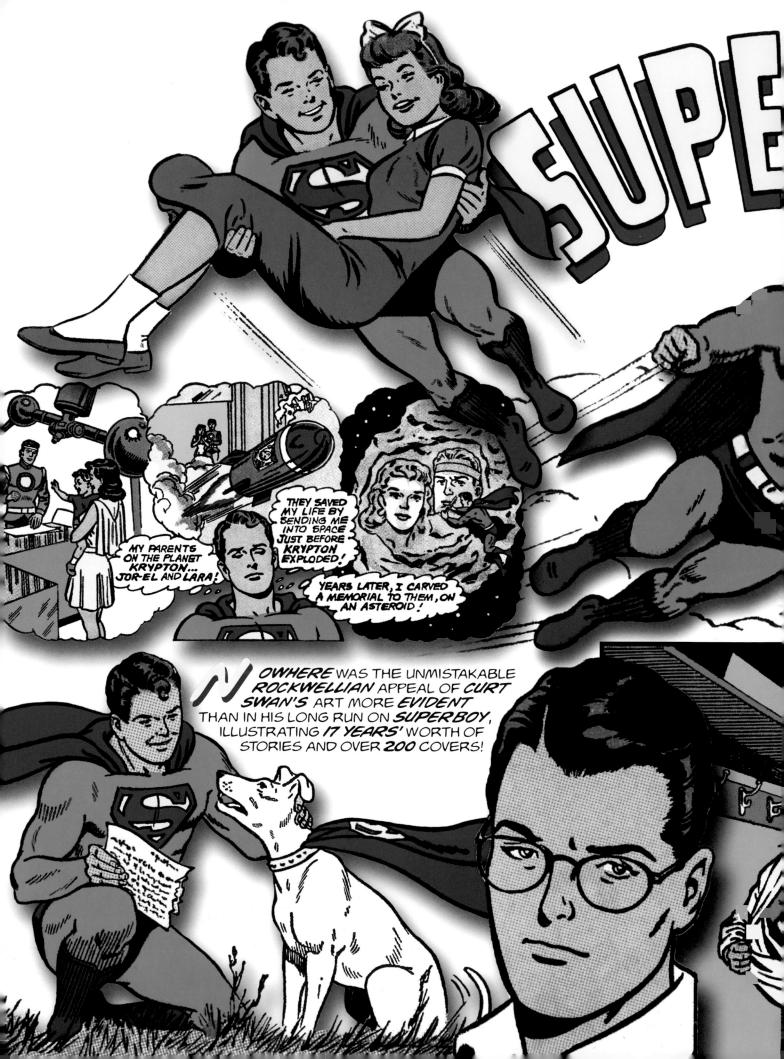

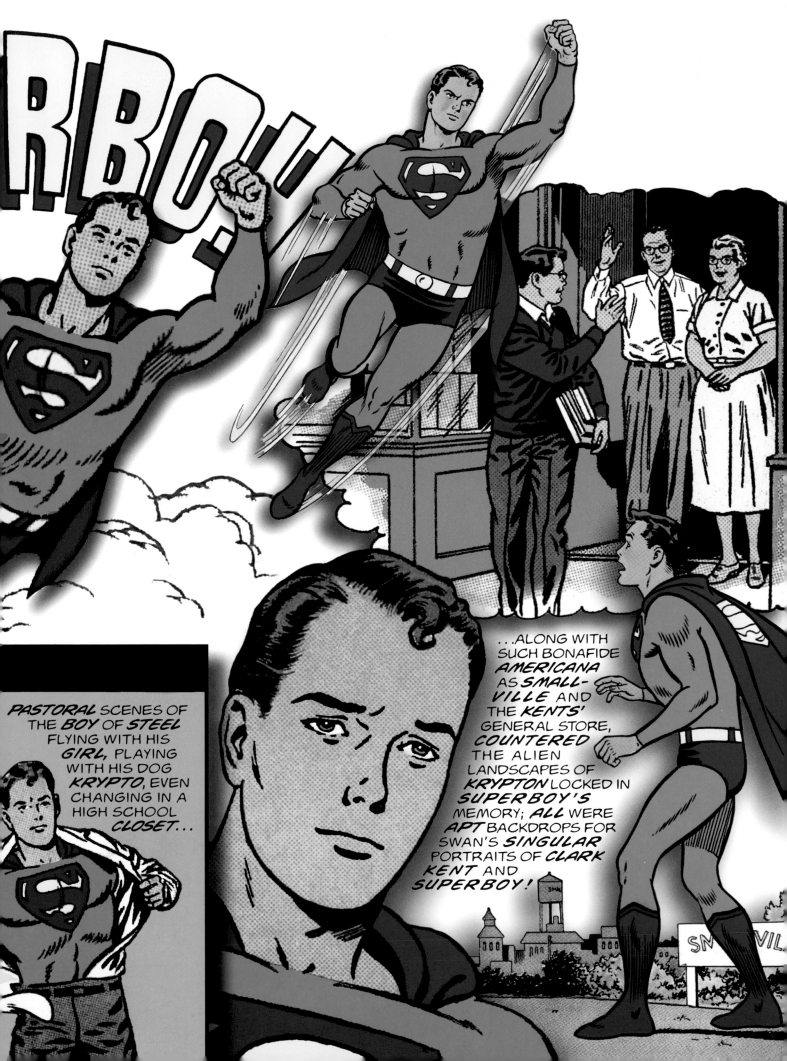

**RBOY!**

PASTORAL SCENES OF THE *BOY* OF *STEEL* FLYING WITH HIS *GIRL*, PLAYING WITH HIS DOG *KRYPTO*, EVEN CHANGING IN A HIGH SCHOOL *CLOSET*...

...ALONG WITH SUCH BONAFIDE *AMERICANA* AS *SMALL-VILLE* AND THE *KENTS'* GENERAL STORE, *COUNTERED* THE ALIEN LANDSCAPES OF *KRYPTON* LOCKED IN *SUPERBOY'S* MEMORY; *ALL* WERE *APT* BACKDROPS FOR SWAN'S *SINGULAR* PORTRAITS OF *CLARK KENT* AND *SUPERBOY!*

SM VIL

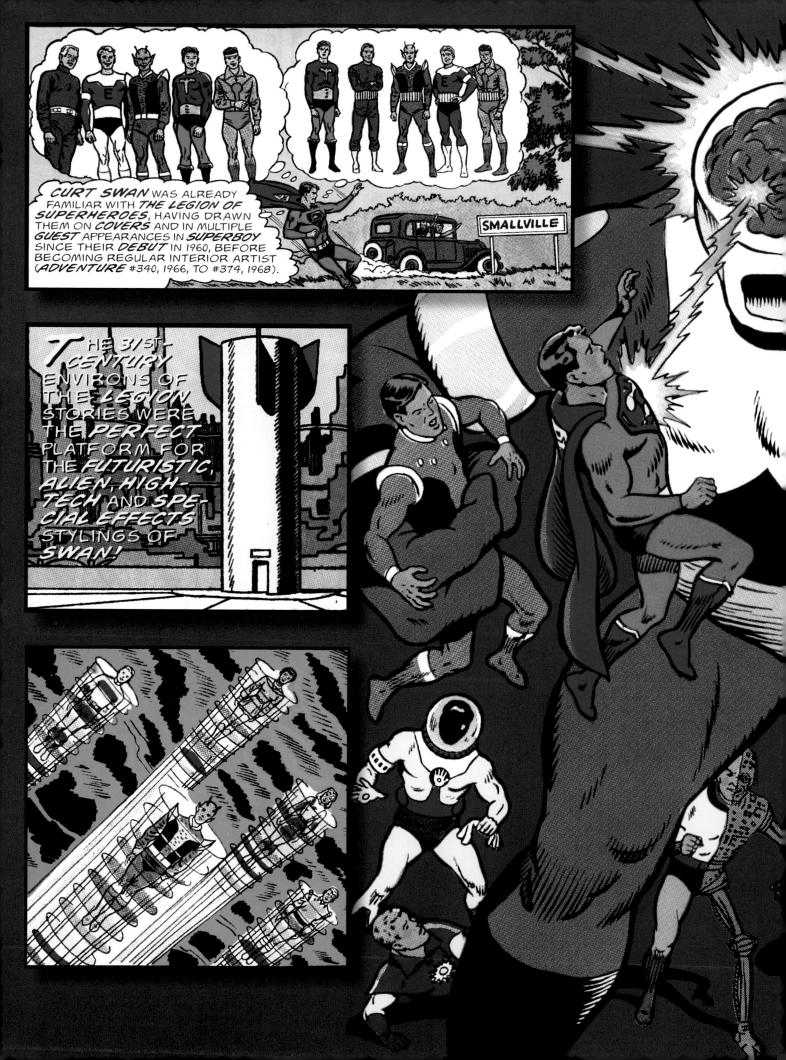

CURT SWAN WAS ALREADY FAMILIAR WITH THE LEGION OF SUPERHEROES, HAVING DRAWN THEM ON COVERS AND IN MULTIPLE GUEST APPEARANCES IN SUPERBOY SINCE THEIR DEBUT IN 1960, BEFORE BECOMING REGULAR INTERIOR ARTIST (ADVENTURE #340, 1966, TO #374, 1968).

SMALLVILLE

THE 31ST-CENTURY ENVIRONS OF THE LEGION STORIES WERE THE PERFECT PLATFORM FOR THE FUTURISTIC, ALIEN, HIGH-TECH AND SPECIAL EFFECTS STYLINGS OF SWAN!

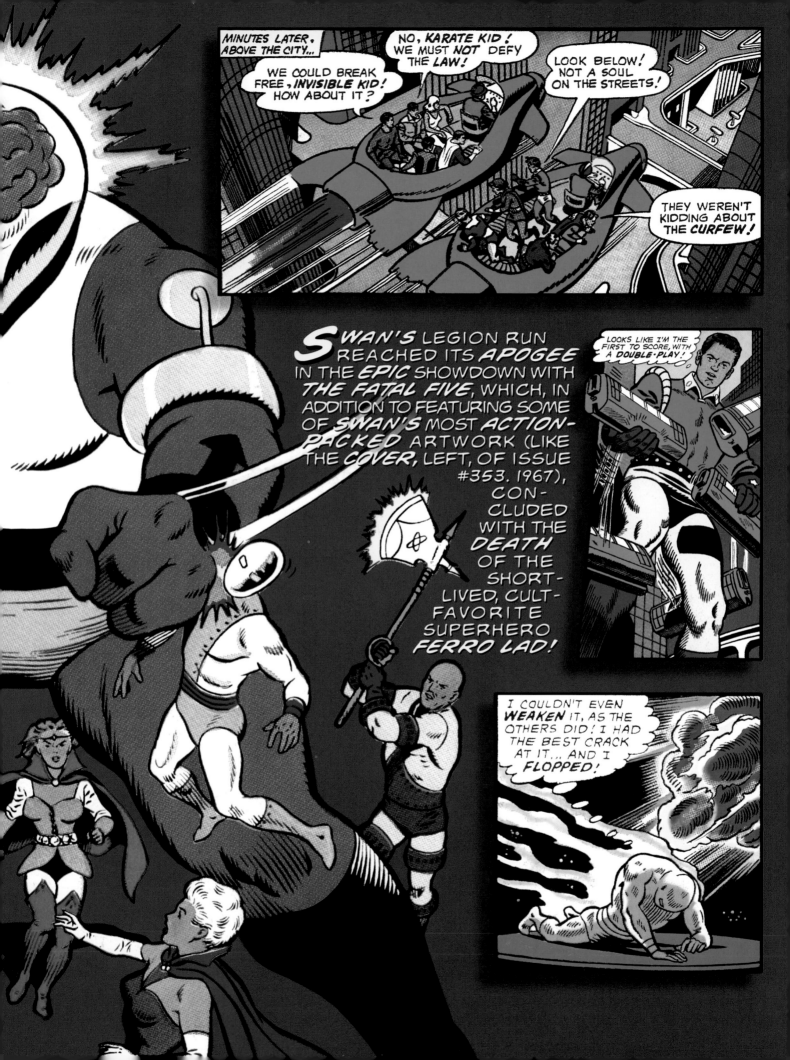

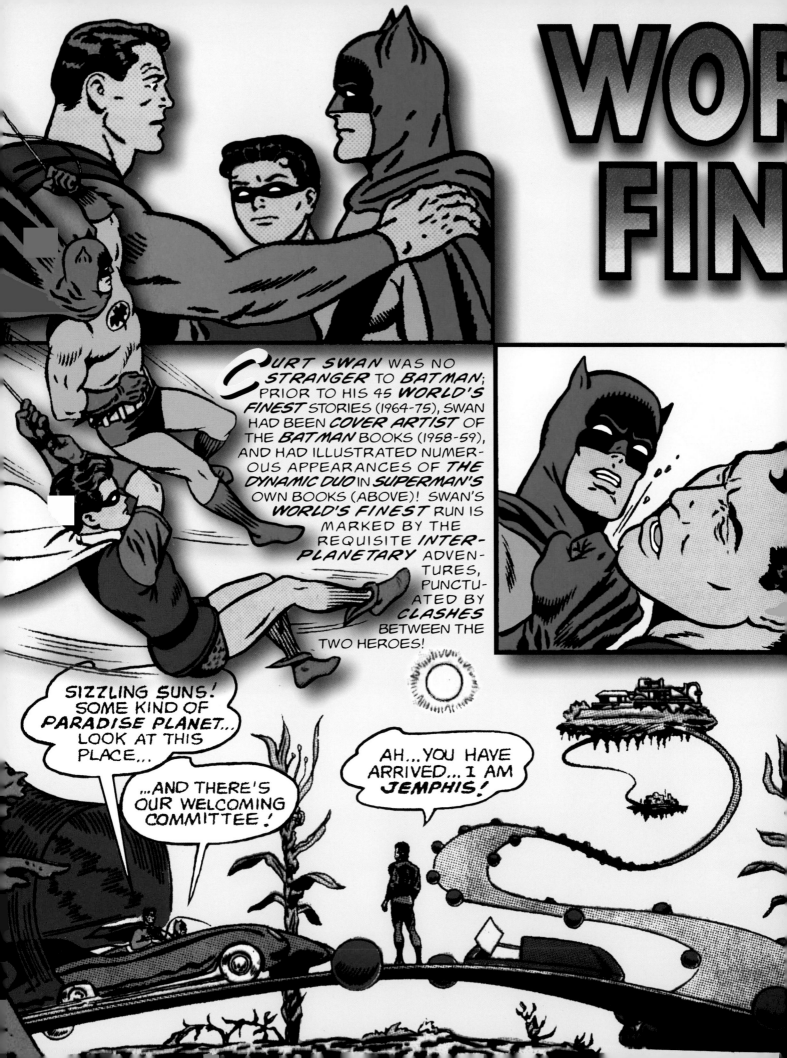

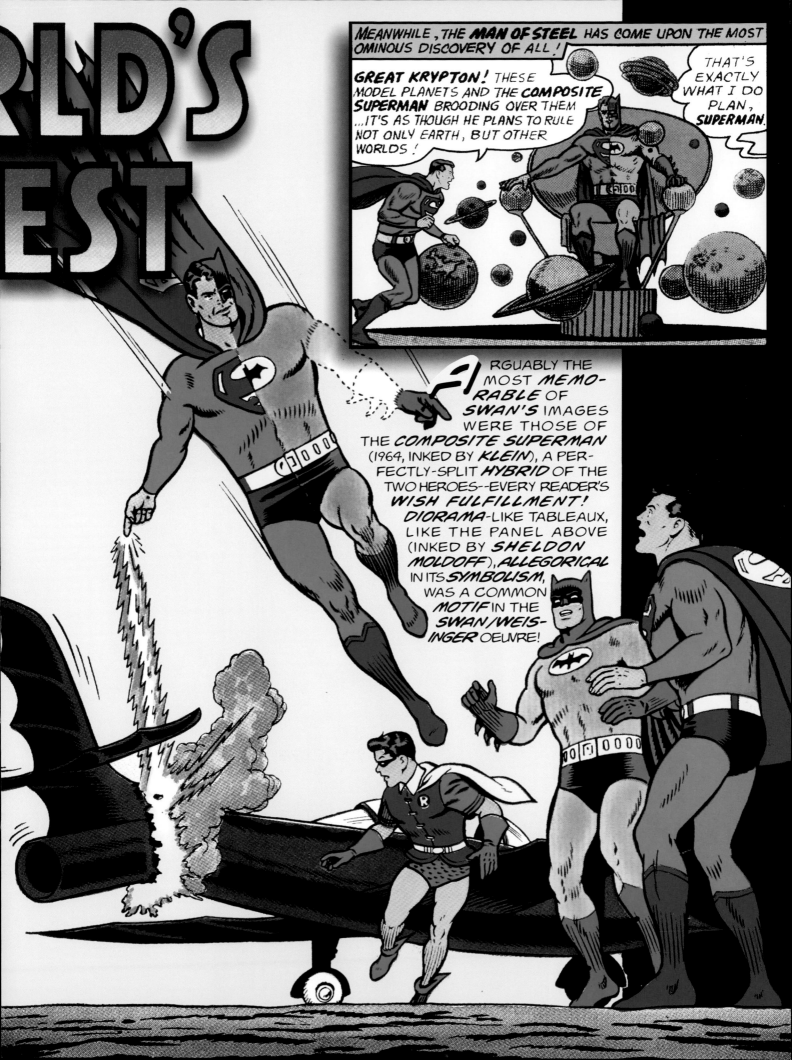

**WORLD'S FINEST**

MEANWHILE, THE **MAN OF STEEL** HAS COME UPON THE MOST OMINOUS DISCOVERY OF ALL!

**GREAT KRYPTON!** THESE MODEL PLANETS AND THE **COMPOSITE SUPERMAN** BROODING OVER THEM ...IT'S AS THOUGH HE PLANS TO RULE NOT ONLY EARTH, BUT OTHER WORLDS!

THAT'S EXACTLY WHAT I DO PLAN, **SUPERMAN.**

ARGUABLY THE MOST *MEMORABLE* OF *SWAN'S* IMAGES WERE THOSE OF THE *COMPOSITE SUPERMAN* (1964, INKED BY *KLEIN*), A PERFECTLY-SPLIT *HYBRID* OF THE TWO HEROES--EVERY READER'S *WISH FULFILLMENT!* *DIORAMA*-LIKE TABLEAUX, LIKE THE PANEL ABOVE (INKED BY *SHELDON MOLDOFF*), ALLEGORICAL IN ITS *SYMBOLISM,* WAS A COMMON *MOTIF* IN THE *SWAN/WEISINGER* OEUVRE!

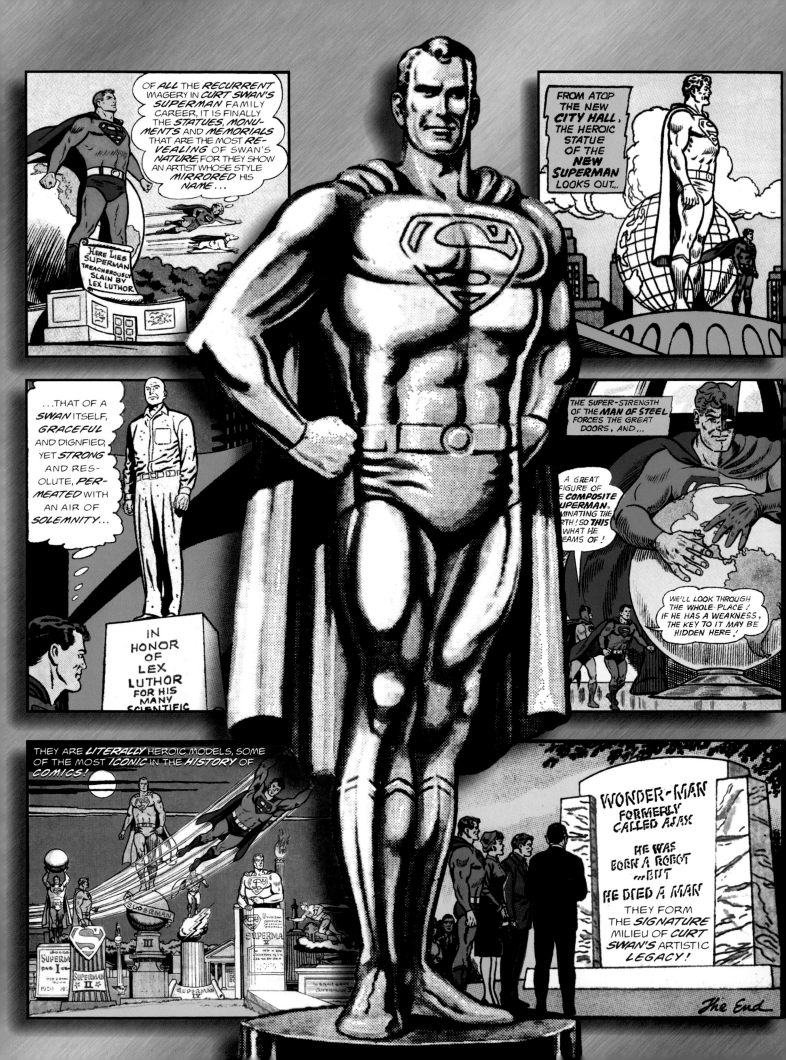

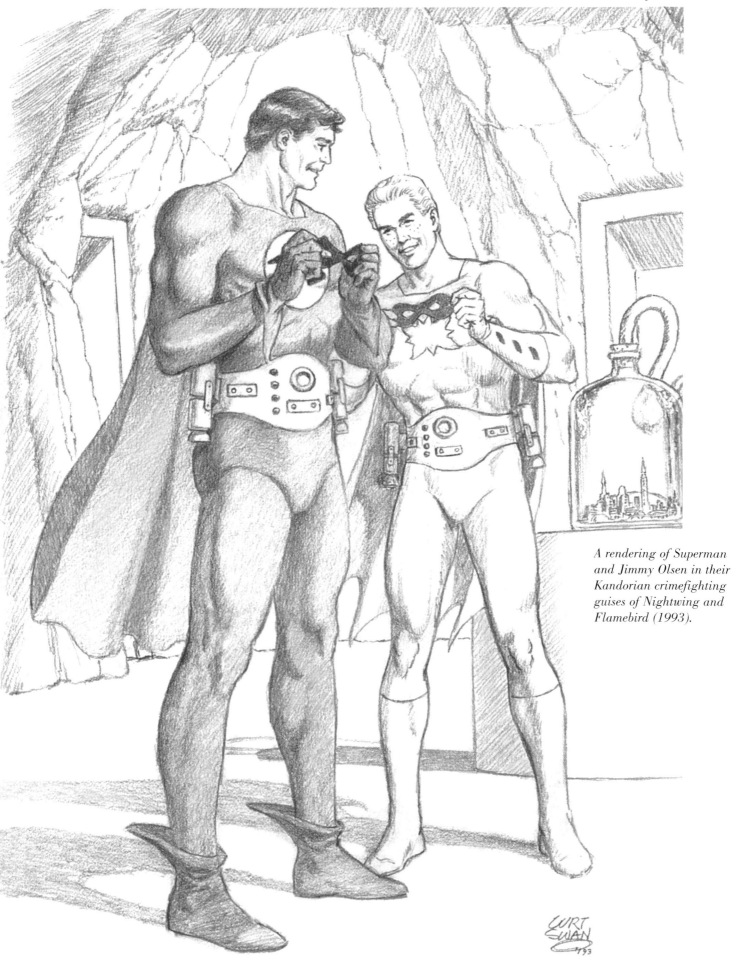

*A rendering of Superman and Jimmy Olsen in their Kandorian crimefighting guises of Nightwing and Flamebird (1993).*

# Dave Hunt

*Having worked at Marvel, DC, Tekno, etc., since his comics career began in 1972, Dave Hunt decided to concentrate on inking after assisting Joe Sinnott for several years. In the early '90s, he made another decision —"to specialize in comics for younger readers." In August, 1999, Dave was working on* Scooby Doo *while responding to my queries about his embellishing Curt Swan's pencils, beginning in 1982.*

---

**Zeno:** *How did you become Curt's chief inker after Frank Chiaramonte? Is it because he became too ill to continue working?*

**Hunt:** I don't think so. I had been working exclusively for Julie Schwartz for some time, and he liked my work and my reliability. Since I did so well with [Kurt] Schaffenberger's Superboy it was a natural to see how I would do with Swan's pencils. After a long wait at the office one fateful day, Paul Levitz came in and handed me the pages. It is also true that Frank C. died a couple of years later. History is not always neat or linear.

**Zeno:** *Any stories that you inked of Swan's which stand out as favorites?*

**Hunt:** Oh, yes. ["The Mark of Bizarro!"] story was fun in many ways (*DC Comics Presents* #71, July, 1984). The Bizarros were an in-joke with Julie Schwartz, Curt and others, and the fans responded. In fact, the guy who wrote the Bizarro episode for Seinfeld [the T.V. show] wants one of my remaining pages.

Often I'll remember pages, not stories. One was a splash with Clark and Lois in Times Square on a snowy New Year's Eve. (It reminded me of that famous Wally Wood splash from EC.) Another splash was a gunfight in a western saloon. It had a million characters on it that I'd have to ink. Curt wrote in the margin, "Sorry, Dave." Another story I remember as being beautifully drawn took place on an alien planet where the characters rode around on camel-like creatures. My favorite Swan stories from when I was a kid were his Tommy Tomorrows.

**Zeno:** *What types of things did he draw that impressed you most?*

**Hunt:** Figures. Figures in perspective. Fully realized environments. Women's faces. (His female faces were the best.) Machines.

**Zeno:** *You mentioned that his pencils were looser than expected, but that all the marks were in the right place. Please elaborate; I always thought he was a very tight penciler.*

*A futuristic cityscape and an unearthly jungle from Swan's run on* Tommy Tomorrow.

© DC Comics

**Hunt:** No, [Keith] Giffen and Byrne are tight. Infantino is loose as a goose. Curt was somewhere in between.

**Zeno:** *What ended your assignment as Curt's primary inker? Was it when Al Williamson came on board at DC?*

**Hunt:** No, it was when John Byrne came on board. Curt, Julie, Kurt Schaffenberger, Alex Saviuk, Cary Bates, myself and maybe one or two others were called in and told we'd no longer be teaming up and no longer working on Superman— the savior had arrived! A brilliant move by Dick Giordano et al.

I hope you'll mention inker George Klein in your discussion of Swan's earlier work. Many times my work has been compared with his and I take that as a high compliment. (Bad inking is tracing in the grooves. Good inking is a collaboration between two artists—something like a 'jam.' Frank Giacoia described it to me as "bringing something to the work." Klein did that, and I hope I did, too.)

**Zeno:** *How did you ink Swan's work? Did you use pen, brush or both? How do you vary your line? One thing I always noticed on your Superman inks were the eyebrows and glasses; oh yes, and Lois' hair.*

**Hunt:** Pen and brush both. A very fine watercolor brush and a #102 crow quill. I do all I can with the brush first, then use pen for details. As I work, I switch back and forth as I get tired using one tool. Line variation is done by subtle pressure changes.

**Zeno:** *You mentioned a couple of favorite stories, scenes and panels of Curt's. Can you think of any others?*

**Hunt:** Always loved a Tommy Tomorrow story from about '52 where space ships are being put in drydocks. The whole story is a masterpiece.

**Zeno:** *One of my favorites that you inked is a full page drawing where Superman and Lois are looking out over nature. I remember some wisps of clouds, and I believe it's on the outskirts of Metropolis. Always wished that page would come up for sale someday. Another is from* Action Comics #543, *where Superman and Lois go to the north pole so they can be alone together (with polar bears playing in the background).*

**Hunt:** Yes, I have two pages with the polar bears! I always thought they were pretty cool myself!

© DC Comics

**Zeno:** *In what way(s) is your inking over Curt's pencils similar to George Klein's?*

**Hunt:** About the George Klein thing; remember that other people compared us, not me. I guess it has something to do with our attention to detail, our respect for the penciler and our "bringing something" to the work.

*An example of Dave Hunt's inking over Swan's pencils in the 1980s.*

*Superman and Supergirl — the Cousins of Steel — were a favorite subject for Swan's sketch commissions from fans.*

© DC Comics

# Jeff Weigel

*My attention was first drawn to a comic book titled* Big Bang Comics *when Curt Swan and Murphy Anderson guest-illustrated a cover (Vol. 1, #3, Oct., 1994 ). The artwork of Jeff Weigel drew me to later issues. Jeff is a graphic designer by day, comic-book artist by night. He was nominated for a Russ Manning Award for most promising newcomer in comics in 1998. Weigel not only has a style somewhat reminiscent of Swan's, but a similar philosophical view of the qualities comic books should possess. These attributes allowed him to pay homage to Curt with a few of his covers and stories for Big Bang. Jeff is best known as the creator/writer/artist of the original superhero The Sphinx and a female successor of the same name.*

*Jeff Weigel's creation, The Sphinx, appeared in Image's* Big Bang Comics.

©2002 Jeff Weigel

*By the time of this interview on October 27, 1999, Weigel had progressed from solely penciling comic books to doing the entire job of penciling, inking, coloring, lettering and writing.*

---

**Weigel:** Superman has always been my favorite comic-book character because of the idealism he projects. I always thought that the great thing about Superman was not how powerful he was, but what he chose to do being as powerful as he was. A guy that can do all these amazing things, who then makes the decision to spend his life in service to humanity — that's what I think makes Superman really mythic. Not so much his ability to be faster than a speeding bullet — but his choice to be a beacon for the idealism of humanity. I really think that that aspect of the character did not come out strongly until Curt Swan became involved and made Superman a real person in a lot of ways. Curt Swan's Superman just seems to be an incredibly benevolent and accessible sort of a guy. And I think it has at least as much to do with the way Curt drew him as it does with the stories he appeared in.

**Zeno:** *When we talked before, you mentioned a particular issue of* World's Finest *drawn by Swan, featuring an imaginary story with Clark Kent and Bruce Wayne as brothers.*

**Weigel:** That's right. I can't remember the issue number [*World's Finest* #172, Dec., 1967], but I remembered it very vividly from when I was a kid.

**Zeno:** *Was it the story or the art?*

**Weigel:** It was both, I think, as is always the case with a good comic book. I think that the story was very emotional, as most of those imaginary stories were, because they could really cut loose and do things with the characters that they couldn't do within continuity. The story was about Bruce Wayne being adopted by the Kents after his parents were killed, and Superman and Batman grow up together. It was a Curt Swan and George Klein art job. I think it takes someone of Swan's caliber to bring a story like that alive because of the realism that he brings to it, but also the character that he brings to the [people] that he draws. You get the impression that these characters are very American, you know, very wholesome in a John Ford western sort of manner. They're like Norman Rockwell characters.

**Zeno:** *Also, what was it that you said about Curt Swan's personality based on his art?*

**Weigel:** I never met Swan and have barely read comments by him or interviews with him, so I have no idea what he was really like. But you get the sense from certain people's work of what they are like. And you get the impression from Curt Swan's artwork that this was an honest, hardworking American persona. Just an average guy down the street who works hard and who knows right from wrong, and knows that the real dignity in life is taking it on a day-by-day basis. Doing your best work and taking care of your own business, not in great feats of heroism and grand gestures. If Curt Swan's life had a soundtrack, you'd hear Aaron Copeland's music playing in the background. (Laughter) At least that's the impression that I had of him from his artwork.

**Zeno:** *As a fellow artist, what did you find appealing about his technique?*

**Weigel:** Something that has always impressed me about him is his draftsmanship, his ability to correctly render things and make them believable. I admired his ability to tell a story without overstating it. Now, there are certain artists out there that overstate and do a great job and make it very interesting. But there are also artists who overstate to the detriment of the story, I think.

A quote that I once heard attributed to a modern, high-profile comic-book artist was, "It's better to overact in comics than to underact." I disagree with that strongly. That attitude is an excuse to avoid distinguishing between the loud and soft moments in drama. It attempts to absolve the artist of the responsibility of finding the balance that gets it just right. Curt Swan is a guy who knew how to get it just right.

**Zeno:** *When did you first realize Swan was one of your influences?*

**Weigel:** It's odd that I get compared to Curt Swan so often... that I was unconsciously, I guess, influenced by him. But somehow, I suppose the calm and quiet of my characters are a reflection of my personality — much as I suspect Curt's style reflected his personality. In the end, I related more to Swan's view of the world than I did to the wild dramatics of, say, Neal Adams' world.

I pretty much had to be told that he [Curt] was an influence by other people. He wasn't someone that I was directly intending to look like before I began my work for *Big Bang*. I know that I took to heart a lot of the principles that are exhibited in his artwork. A lot of the overstatement that I was speaking about earlier has hurt comics, specifically in the last ten to fifteen years. And that is something that I have always tried to avoid. My approach to my craft is very much derived from the dignity of the characters people like Curt Swan drew.

**Zeno:** *Tell me more about Big Bang Comics. What is the company trying to accomplish?*

**Weigel:** What they're trying to do is to recreate the spirit of some of the comics of past generations. Specifically, they're trying to regenerate a lot of the aspects of comics that were abandoned by the modern comics industry. And quite frankly, when I first got involved with them, I had misgivings about that whole idea. I first came in contact with Gary Carlson, editor of *Big Bang*, back a few years ago at the first comic-book convention that I went to. I had just finished my first Sphinx book and I was taking it to that convention to see if anyone was interested in publishing it. I talked to Gary Carlson briefly about it. He had published a few issues of *Big Bang* already for Caliber [the first company to publish the title]. He was about to make the switch over to Image. I showed him the artwork and he said, "You know, I bet you could do a pretty good Curt Swan if you tried." And that idea didn't really appeal to me too much. The conversation that I had with him wasn't really very long. But after the convention, he contacted me again because I had given him samples of the Sphinx book, and we talked a little bit more about my doing a Curt Swannish sort of story for him. I

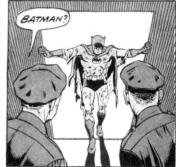

had reservations about whether this was just plagiarism (especially since Curt was still alive at that time), or whether it was a genuine attempt to rekindle something that comics had lost. I was pretty torn about that issue, until Gary sent me a script, which was for the story in issue #3. He said, "Look it over and see what you think." And when I saw that it was basically a Superman/Batman story from *World's Finest*, and that he was asking me to do a Curt Swan version of it, I couldn't resist any longer. My instincts about whether it was a good idea or not were completely overridden by my enthusiasm for trying to do this thing. That story turned out well enough that Gary sort of gave me carte blanche after that, and I've had a relationship with him ever

*From all-out action to quiet grief — without the usual histrionics that accompany such moments in comics — in a scene from* World's Finest *#172 (1967).*

*The Big Bang cast of characters as interpreted by the Swanderson team, with a peek at Swan's pencils from the cover of* Big Bang Comics #6.

©2002 Gary Carlson and Chris Ecker

since. I'm actually very happy about it. Still, in the back of my mind, I have some of the same reservations about what *Big Bang* does. But on the other hand, the pluses are still there, too. They're attempting to rekindle a style of comics that is very hard to find these days. If we're the only guys willing to keep that torch lit, I'm happy to participate in that.

**Zeno:** *When I interviewed Marv Wolfman, I believe he was talking about the early 1980s when he said that Swan's art was not in vogue as it had been. And maybe even a couple of years prior to that, Joe Kubert told me that he was asked to help Curt make his presentation more exciting. It was interesting, even that long ago, before John Byrne and company's revamping of the Superman character, that they were looking for a more "in-your-face" style than Curt was giving them.*

**Weigel:** I think I've heard that before. There's a period in [Curt's] work where I think he was attain-

ing some of that, and I'm not sure exactly what was going on there. If you look at some late '60s Legion of Super-Heroes that he worked on — a particular story that comes to mind is one from my childhood that left a terrific impression — it was an issue where there was an organization called The Dark Circle and they invade Earth [*Adventure Comics #367*, Apr., 1968]. It's the issue where the Legion gets their new headquarters after The Fatal Five destroyed it... a Jim Shooter [written] issue. If you look at some of the page layout in there, you'll see a lot of the sort of wild fore-shortening and eccentric panel arrangements that were becoming more in vogue at that time. The explanation I've heard as to why some of that was happening was

that they had decreased the page size. For many years the standard was for comic-book artists to work twice up, and they changed that standard to a smaller page size. I guess that's when they went to the 10 by 15 [inch] live area, for the purpose of fitting several pages onto a camera bed. I don't know the exact technical explanation, but they can shoot several pages at once to make film, something to that effect. That's why they dictat-ed the smaller page size. But the result was that it's partially responsible for a lot of people like Curt and Nick Cardy coming up with much more innovative page designs instead of the standard six panels to a page. I think that several other things might have been coming into play. I think Jim

Shooter was scripting his stories back then and was actually sketching out ideas that he had — how these pages would be laid out. So Shooter may have been contributing to that evolution in Curt's layouts. And I think the times contributed, too. There was a cultural revolution in the '60s that I think ended up influencing comic-book page design to a degree. Guys like Neal Adams pushed the envelope back then. I see a more radical approach to Curt's work from that era, although in the '80s *Superman*s that I read, I think that he backpedaled a little bit on that style. I have no idea why—I'm just speculating. I don't know what spurred it in the first place or how Curt felt about getting sketches from, basically, a fifteen or sixteen-year old kid in the person of Shooter. But I see a difference in his work back then, and I just see an evolution all through those years on into the '80s.

**Zeno:** *When the page size got smaller, why did that inspire some of the artists to be more dynamic?*

**Weigel:** I think it's because they could see the page as a whole. That was a theory that I had. It's one shared by Mark Evanier; he mentioned this in a column in *Comics Buyer's Guide* a year or two back. And it's something that had crossed my mind before, too. He just thinks that it's easier to see the page as a whole since they weren't trying to fill this huge field.

**Zeno:** *What do you think of the faces Curt Swan drew?*

**Weigel:** Curt was a master of that. Whether they were big or small, whether from the back or front or in profile, or an upshot or a downshot, Superman's face always

© DC Comics

looked consistent. That's the goal that I strive for. The goal of drawing realistic faces seems to be in decline today.

**Zeno:** *I agree. Even some of the best artists in so many other ways don't seem to make that particular effort, making it hard sometimes to tell one character from another.*

**Weigel:** There were times when I was amazed at the supporting characters in Curt's work, just walk-on parts! And it just impressed you that these people were real people because their features were so distinctive.

**Zeno:** *What was it about Murphy Anderson's inking style that you liked?*

**Weigel:** I think that Anderson added a weight and a substance and a volume to the figures with the sort of feathering that he did. That made them very dimensional on a page. He also always had that beautiful character to his line, on top of it all. I would say that Murphy Anderson added a lot of the blacks that give comic book art its depth; blacks in backgrounds, blacks in shadows that you don't see as well rendered in Curt's work [by] other inkers. I think that may be a lot of what Murphy Anderson contributed to that team.

*Swan's priority was always clear storytelling — a focus that led to his reputation for conservative page layouts. But the sequence above certainly contradicts the notion that Swan couldn't compose a dynamic page layout.*

# Chris Swan

*There is a video of the Curt Swan tribute presented at the Connecticut chapter of the National Cartoonist's Society a few months after his passing. Seeing how moved Curt's children were by Arlen Schumer's presentation, I knew it would be a mistake not to contact all three of them. The following interview was conducted November 3, 1999. Chris, as well as Cecilia, were instrumental in helping to obtain copies of Curt's World War II* Stars and Stripes *cartoons, some of which are published herein.*

---

**Zeno:** *Do you remember when your dad was working on the* Superman *newspaper strip?*

**Chris:** I remember that very well. That was the weekly strip that he was doing in the '50s, in that time frame. We were living down in New Jersey. We moved to Connecticut

in... June of '62, and it was prior to moving up here that he was working on that. So, yeah, that sounds pretty accurate.

The real productive years [in comic books] were obviously in the '60s and '70s. The '80s, I don't know... pre-1980 is what I like to remember.

**Zeno:** *Do you mean as far as the art?*

**Chris:** Well, a lot of things. In 1982, my parents got divorced; that's another element.

**Zeno:** *What was it like growing up with Curt working at his studio right there in the house?*

**Chris:** The studio was kind of like sacred ground... just a special place where we didn't really set foot that often. He was a guy that got distracted easily. We were always walking on eggshells with him doing his work there. What's a good way to put this? He just got very absorbed in his work. But it

was kind of fascinating to go in and watch him create stuff from the writer's text and just make a story come to life on the paper. Earlier, probably back in the '50s, he was drawing on a much larger sheet of paper. Then they were able to go to a smaller size. Probably in the '60s sometime they went to a different size photo reproduction to make the comic book from. But I just remember very large sheets of paper when I was first growing up, and then the fact that it got smaller over time.

**Zeno:** *Did you like the large art more?*

**Chris:** Well, yeah, the bigger stuff was more fun to look at. The smaller stuff was only maybe three times the size of a regular comic book and I think the initial paper he was drawing on was five or six times the size of a comic book and so it was more interesting to look at the larger sheet.

*Two more examples of Swan's cartoon work for* Stars And Stripes.

*"Any 'you guys understand Russians?"*

Maybe it was due to the fact of being a young kid and everything. It looked very lifelike on the big sheets of paper.

**Zeno:** *Did you collect comics?*

**Chris:** I never really got into collecting comics because they were always around the house. So having comics around was just a taken-for-granted kind of thing. I never really had that fascination with them that some kids might growing up. They were always there and, he was always bringing stuff home to use as reference. I probably got bored with comics quicker than a lot of kids did.

**Zeno:** *So the company supplied a lot of comics?*

**Chris:** Yeah, he was either getting issues that he had done himself or saving some past issues for reference, because the writers were always referring back to a previous issue. You know... *Action Comics* #such-and-such. You'd have to go back and look at them because there would always be readers out there to compare the old issues. In these letters to the editor, they'd take the company to task about inaccuracies. You know, there were those kinds of readers who always had their eye out.

**Zeno:** *Do you remember any of Curt's cartoonist friends coming over when you were growing up?*

**Chris:** Yeah, they would hang out together and come over for holidays, that kind of thing, occasionally for parties at the house. He had some good friends that were artists, but not just comic artists. John Fischetti was an excellent friend of my father's. John was a Pulitzer Prize-winning political cartoonist. They had been friends

## Fischetti

ARMED CAMP

*Samples of work from two of Swan's closest friends: at left, a self portrait of Pulitzer Prize-winning cartoonist John Fischetti; below, Dick Wingert's G.I. character, Hubert.*

during World War II and stayed in very close contact with each other. Dick Wingert was another very good friend of my father's. He created the comic strip *Hubert*. Dick passed away in the early '90s; he had relocated out in Indiana. They had been in Northern Ireland together on *The Stars and Stripes* paper during the war. They were both in the Army together drawing comics for *The Stars and Stripes*. They stayed very close afterward.

**Zeno:** *It sounds like you can remember* The Stars and Stripes *cartoons pretty well?*

**Chris:** Just from having that scrapbook you're talking about and from looking at those kinds of things when I was growing up and being fascinated by it. It was a lot of cartoons of the Nazis and poking fun at Hitler. There was that element to it. They were putting stuff in the weekly paper for the GI's and the cartoonists were there satirizing... politicizing the enemy, so to speak. It's kind of fascinating to look at that chapter in history.

**Zeno:** *Did your dad script* The Stars and Stripes *cartoons that he drew?*

**Chris:** Well, those were really just single panel-type cartoons. And then he really never stuck with

that style and went to the very lifelike style that he always had doing Superman. And that seemed to be what he was more comfortable with drawing... not so much the Bigfoot kind of stuff. For some of his friends, that was their specialty. All the guys, Wingert, especially.

**Zeno:** *Did you like the realistic aspect of your dad's art?*

**Chris:** Oh, absolutely. I thought he was terrific at drawing Superman in his very detailed style. I could

always spot his right off the bat from Wayne Boring and all the others. It didn't take but a second to know that it was his work. There were certain characteristics that he would draw, certain features... a very good style.

**Zeno:** *Did you ever meet George Klein or Stan Kaye?*

**Chris:** Yeah, George was inking my father's work and, when I was growing up, I used to go up to the city with him. We were living in southern New Jersey until 1962 and we would quite often drive up for the day and do some work and be with George Klein. We'd go over

*A Swan/Vince Colletta collaboration on the cover of* Parade *magazine.*

to George's apartment for dinner or whatever. I remember George quite well.

**Zeno:** *Do you remember what he looked like?*

**Chris:** George was a fairly tall fellow. He had striking blue eyes; [an] extremely good-natured, gentle kind of a guy... smoked a pipe a lot. Just a very, very nice guy, and almost like a western kind of feel to him. He wore jeans all the time, and I remember him wearing a very nice pair of western boots.

Stan Kaye, I met him and we visited... He'd gone out to Wisconsin,

and my father's family were all from the Minneapolis area, so we stopped out there on the way and visited his family. I can recall meeting him on several occasions.

**Zeno:** *Tell me about the relatives in Minneapolis.*

**Chris:** Curt had two sisters, Mildred and Lenore. And two brothers. Lloyd, who died during World War II, was in the Army Air Corps flying bombers over the Pacific. Whether he was shot down or ran out of fuel on a mission, he was never found. And a brother Stan. Stan passed away just within the last year. He was a few years older than Curt. Curt was the youngest of the five.

**Zeno:** *Are your aunts still alive?*

**Chris:** No, they aren't. Both passed away; Lenore, I want to say maybe six or seven years ago and Mildred three or four years ago. Both of them before Curt passed away.

**Zeno:** *In the book* Superman at Fifty: The Persistence of a Legend, *your father wrote about his early life in Minnesota, drawing in the winter when there wasn't much else to do and having sketching contests with the family.*

**Chris:** Yeah, I guess my grandmother used to encourage that a lot. That was something that Curt got a lot of pleasure from. You know, he was drawing... doing the contests and everything. She always made sure they had papers and colored pencils around, if nothing else when they were growing up.

**Zeno:** *And I believe Curt said both of his sisters were pretty good artists?*

ST. LOUIS POST-DISPATCH

OCTOBER 23, 1977

parade

I Flew With Superman

by Mort Weisinger

**Chris:** Yeah, they were creative. My Aunt Mildred... Millie, we called her, actually did a little plaque with a miniature easel when our son was born. She was creative, very good with her hands.

**Zeno:** *What about yourself? Did you take art classes? Do you draw?*

**Chris:** I never really showed an inkling toward art. I guess maybe if I wasn't really, really good at it I didn't want to pursue it. I was color-blind to red and green, too, so maybe that dissuaded me a little bit.

**Zeno:** *I always admired your dad's work ethic. Do you think it was due to growing up during the depression?*

**Chris:** Today people don't stick with the same jobs. [They] tend to jump career-wise, or if they're in the same career, at least company to company.

**Zeno:** *Do you work for Northeast Utilities?*

**Chris:** Right, I've been with them for twenty-three years. I'm general manager of one of the districts here in Connecticut. They have district offices that cover a certain county area or a number of towns. Bringing in the power from the transmission lines right into the houses or businesses. A bunch of folks there that I work with have been there thirty, thirty-five years. I think that as those numbers dwindle, we won't be seeing that in the future.

**Zeno:** *Did Curt ever talk about wanting to work solely for DC Comics for so many years?*

**Chris:** I don't (laughter) think it was... maybe it was one of the

things he'd get frustrated with. But he'd go back and realize he'd had a pretty good relationship with them. I never did hear him sit there and go, "Rah Rah DC Comics!" It never came out [that way] to me, anyway. In fact, I think at times he was probably a little fed up with DC Comics. Whether it was a necessary evil or not, he certainly enjoyed aspects of it. At times it was a real test for him. He had editors that he fairly clashed with, Mort Weisinger being one of them. He'd be at real odds with Mort. Other editors, he seemed to get along a lot better with.

**Zeno:** *Did you ever meet Mort Weisinger?*

**Chris:** Yeah, occasionally. Because that was in the time frame that I was accompanying [dad] to the city. I never really sat and talked with [Weisinger]. I just saw him and that was that. I was in elementary school at the time so I was just trying to make myself invisible up there. I'd sit around and watch the inkers and some of the other guys working there on a daily basis. You know, the letterers and that kind of thing, at their Lexington Avenue office.

**Zeno:** *Did Curt draw covers when you were up there?*

**Chris:** Yeah, I think that was the regular thing he was doing. The editors wanted to have a lot of input; I think that they kind of (chuckle) wanted to watch it as it was being produced, since that was what was going to be selling the book.

**Zeno:** *That must have been a pretty long day for you, waiting on Curt to finish up.*

**Chris:** Yeah, we typically would hit the roads early and didn't get home until well into the evening. At the time we were living a two- to two-and-a-half hour ride south of New York, down in southern New Jersey. We'd drive all the way up the New Jersey turnpike, into the Lincoln Tunnel, into the big city, and then we'd be there for the entire day. It was kind of fascinating to see the big buildings and everything. So it was kind of fun.

**Zeno:** *Mentioning your dad's home studio again, he said that he enjoyed working at home when you and your sisters were growing up.*

**Chris:** Yeah, something that maybe I got kinda spoiled with, because my mother was even around till I

# Arlen Schumer

*As Bill Janocha mentioned, it was Arlen Schumer who did a moving slide show tribute to commemorate the art and life of Curt Swan at a meeting of the Connecticut chapter of the National Cartoonists Society in the fall of '96. He began that evening's proceedings by mentioning that Curt's death was like the death of Superman himself in many ways.*

*Compiler and designer of* Neal Adams: The Sketchbook *by Vanguard Press, this graphic designer and comic advertising artist also produced memorable art histories of Superman, Batman and later Carmine Infantino. The following is from an interview which took place on April 1, 1999.*

[Curt Swan] was my first favorite comic book artist. He was the first artist that brought a realism to the comics. That's why Neal Adams' work is so popular. It's also why Alex Ross is probably the most popular comics artist since Adams, because of the realism. You can see a combination of Neal Adams and Curt Swan in the work of Brian Bolland. There's a quietness and an emphasis on the figure in Brian's work that's reminiscent of Curt.

I loved Murphy Anderson's art but Klein was my favorite Swan inker. George Klein was to Curt as Joe Sinnott was to Jack Kirby. Klein was the unsung hero of the best work Curt produced during the Silver Age; his feathering and thick-to-thin line work..!

*One of Swan's "bigfoot" style characters from his time on* Stars And Stripes.

*Dave Breger was another cartoonist who worked with Swan on* Stars And Stripes. *Breger is credited with originating the term "G.I. Joe."*

was fourteen or fifteen. She went and got her real estate license; prior to that, she was at home all the time. So both parents, in effect, were home. My father would go into the city to see the editors or he'd be out playing golf during the daytime. That was his favorite sport. It was nice to have parents at home, very different from today's situations.

**Zeno:** *And the studio was off limits at times?*

**Chris:** I think that was just my mother's attempt to try to (chuckle) keep him on track, because he'd get off on tangents. He liked to do a lot of work around the house.

**Zeno:** *He did?*

**Chris:** Oh, sure. He was very able with tools, very creative. In fact, if I got anything out of my father's skill bag that might have been it, rather than artistic talent. You know, the ability and the enjoyment of working with my hands and building things. I've done that

all through my married life here... just doing stuff around the house.

**Zeno:** *I never knew Curt was handy with his hands.*

**Chris:** Absolutely. He loved it. He used to always say to me, "You know, you and I ought to go into business." Occasionally he'd get a little fed up with the cartooning. Actually after college, I worked for some builders. Doing carpentry work. And he very much enjoyed doing that.

**Zeno:** *Your mother said Curt would try to work hard drawing for three days and take off four days during a typical week.*

**Chris:** Exactly. He would sometimes work till two or three in the morning once he got on a roll as far as the drawing went. Maybe put in ten, twelve, fourteen hours straight for two or three days, like you say. And then not do anything for maybe two or three days except for golfing or making things around the house. It would come and go as far as the drawing; it wasn't a five day a week type of thing. Although, sometimes he would be working on it for seven days, but it would be [for] lesser amounts of time each day.

**Zeno:** *Do you remember him drawing you in any stories?*

**Chris:** Prior to high school, certainly. Elementary school timeframe... that era, occasionally. But he was probably doing it more often than he would tell you about. I can't recall an issue or story, But yeah, I know he would do that from time to time. He would use your first name or something; you know, put in there like Alfred Hitchcock (laughter) appearing in one of his

own movies. I think my sister donned a pair of glasses once and he used her profile for a shot in a panel, that kind of thing.

**Zeno:** *Did any of your friends come over to watch him draw?*

**Chris:** The real attraction was the comic books supplied. That used to always kind of get me. I'd ask myself repeatedly, "Are they coming over to see me or to read comic books?" He would get a lot of, not just *Superman*, but *Flash* and all the other characters. And those were the ones that we could freely go through because the others, quite often were being kept by him for reference. So *Superman* was a little bit less open as far as being able to go grab 'em and read 'em and everything.

**Zeno:** *Are there any particular stories he did that stand out to you?*

**Chris:** Well, I know that Mxyzptlk, the little character, was one of these that'd drive him nuts. I think that Bizarro... that was another that kind of drove him crazy. [Jimmy Olsen] as Elastic Lad, that was another one that drove him crazy because he had to deviate from the normal figure and go to this distorted thing. Features that were just awkward, he didn't care for. So there were a few stories that tended to repeat themselves. It was very frustrating when he had to work on them.

**Zeno:** *Did your dad come to your school for show-and-tell?*

**Chris:** No, I don't recall him coming to any of my classes, but I brought him to my son's (kindergarten) class. He did little sketches. He would always be very safe

about it and put [©] DC Comics at the base of the sketch if he was doing something. It was a blast... a lot of fun!

**Zeno:** *So it was just Curt and your-self, the teacher and the kids?*

**Chris:** And the principal, and they had one of those big flip-chart type pads for him to do sketches on. Then they took the sketches he did and put them up all over the hallway at school; it was a real big deal!

**Zeno:** *Do you remember any of the charity work that your dad did, such as the time he went to Florida with other well-known car-toonists to draw Superman for a hospital fundraiser, as shown on a Garfield television special?*

**Chris:** Yeah, I recall that, [and] I remember him going on *The Today Show* with Jane Pauley... in the timeframe sometime between 1979 and 1983 because I can recall the house we were living in at the time. It was a very brief segment after one of their news things, like 7:35 [a.m.]. There he was; it lasted for several minutes and then he was off!

Then he was on QVC peddling stuff back in the early '90s, when QVC was very new. I sat there and watched him on that, and to me it was like... I don't know if he was very bored or what, but he looked a bit bored by the whole thing. That was just my impression.

**Zeno:** *Your sister Cecilia said she called him during that show just to try to rescue him.*

**Chris:** (Laughter) Yeah, he didn't look too at ease on that one.

*A Swan sketch of the First Couple of comics — Superman and Lois Lane.*

# Karin Swan Brooks

*The 1999 movie* The Straight Story *— recommended to me by Karin — reminded me of her father, as it did her. There was a scene wherein the protagonist, played by actor Richard Farnsworth, talked about growing up in Minnesota. He told of he and his brother lying under the stars every chance they got during the short summers to fathom the universe's mysteries. Curt wrote of similar experiences with his own brother in the book* Superman At Fifty: The Persistence of a Legend! *Karin's dad also seemed to be a very independent sort, as was the character in the movie. I'm grateful to her for telling me of the film and for the lovely conversation we had on November 30, 1999.*

*In 1994, Disney Adventures magazine held a contest where readers were asked to create their own superhero. First prize was to have Curt Swan, Dave Hunt and Marv Wolfman bring the creation to life!*

**Zeno:** *Did you receive an art degree?*

**Karin:** I did. I went to Pratt Institute 'cause my father went, but he went for a very short time. I must have needed to feel that I was following in somebody's footsteps. I started out there and then wound up transferring up to Boston Museum School. I graduated with a degree from Tufts.

**Zeno:** *Tufts?*

**Karin:** Yeah, you do your academic work at Tufts (outside of Boston), but all my artwork was done at Boston Museum School.

**Zeno:** *Your sister Cecilia said you still use that degree to some extent, with home design.*

**Karin:** Yeah, my husband and I bought a house, and proceeded to spend the last twenty-two-and-a-half years working on it. My husband's a designer, so the two of us together endlessly figure out something that's better and do it. Two weeks ago, one of our grand

designs, the final one, was using up all the building supplies that we had left over from the years. So we built one more shed addition to our barn. We put up some windows. It turned out very nice and we're going to be able to keep the tractor out there.

**Zeno:** *Is that the barn where your dad lived and had a studio for awhile?*

**Karin:** Yeah, my dad lived up there for close to a year and enjoyed it a lot, I think. It was nice for him to be nearby. Nice and difficult. His hearing was getting a little bad. There were certain things. He was a very sensitive guy, but also headstrong, determined to do what he was doing. So there would be a little bit of a clash.

**Zeno:** *What kind of person was your father?*

**Karin:** He did not know of cutting corners or cheating somebody out of anything, just completely honest. And he was the ultimate liberal;

he taught us all tolerance. That was what he insisted on. And he had a real sense of what was right and wrong in the world. It was amazing how he desired to help. He just couldn't stand one group taking advantage of another. So I was brought up in a world where everybody has a right to be here. My father never listened to "Prairie Home Companion" but it's his life. You know, Lutheran, Scandinavian good guy that would never impose his will on anybody. He believed that everybody had a right to exist. So isn't it interesting that he winds up drawing Superman? I don't know that that was the appeal for him, that he ever really thought of it in those terms but it's just the right character for him to be put in charge of. And I think he was a really good, sweet guy that way.

**Zeno:** *It's very interesting that you say that, because I was just writing about people calling Curt "The Norman Rockwell of the Comics." I mentioned that Rockwell didn't want to paint anything sordid. And your dad, by drawing Superman, who represented Truth, Justice and The American Way, often portrayed an idealistic America, also.*

**Karin:** Right. And it has to have its roots in his whole childhood and his whole upbringing. There weren't a lot of stories told; you didn't hear about all the relatives. We were never really aware of a lot of things that happened to him. He'd always talk about his brother Lloyd and how they used to spend a lot of time talking about common decency, the universe, and how it's all meant to work. It obviously made a great impression on him. [Lloyd] was his immediate

older brother. That was my Dad, this meek, kind, decent person. But there was a part of him; actually, there was a part of me, that when I would say something it would strike a note with him. If I said one thing, a lot of times he'd say the opposite. We had a lot of moments where I would think, am I causing this? (Chuckle)

**Zeno:** *Did this happen more with you than with your brother and sister?*

**Karin:** Yeah. And I just felt, a lot of times you were trying to figure out who he was arguing with. You know, maybe I [represented] his sister or one of the women that was pushing him around in his life.

© DC Comics

# Cary Bates

*The following is from a letter mailed Jan. 24, 2000. Beginning in the late 1960s Cary Bates, for years, wrote wonderful stories of Superman and The Flash, many illustrated by their two signature artists, Curt Swan and Carmine Infantino, respectively. Superman tales included the classic four-issue "Mr. X" saga beginning with the chapter, "Who Took The Super Out Of Superman?", co-written with Elliot S! Maggin. He also produced many small gems, such as "The Fantastic Foe Superman Could Never Meet!" in* Superman *#353, Nov., 1980. That tight 17-pager involved the Man of Steel's clever defeat of an other-dimensional criminal who switched places with him each time he visited Earth to wreak havoc. Before John Byrne brought back Clark's foster parents when he took over Superman in 1986, Bates wrote the sentimental favorite, "The Miraculous Return Of Jonathan Kent!" (Action Comics #'s 507 and 508, May-Jun., 1980). In an interview done around that time, which later saw print in* Comic File Magazine *#3, Heroes Pub., Inc.,1986, Cary stated, "... I've been really trying to do things that not only are entertaining but are emotionally involving, that show sides of Superman that have never been shown before." He succeeded. Mr. Bates has since worked in films and television.*

My earliest aspirations were to be a comic book artist. Toward that end, I used to draw my own cover ideas, complete with logos and lettering. As many of my ideas were for the "Superman family" of books, one of the artists I tried to copy was Curt Swan. My drawing attempts were crude, to say the least, but a couple of the ideas actually "sold" to Superman editor Mort Weisinger. Back in those days, DC didn't pay for cover ideas, they did something far better — they sent me the original art for the cover after it was redrawn. The cover of *Superman* #167 — Brainiac and Luthor holding up a birdcage containing a shrunken Man of Steel — was the first of my ideas to see print, and the cover was drawn by none other than preeminent Superman artist himself, Curt Swan. Needless to say, that original cover became one of my most prized possessions.

Within four years I was writing scripts for Weisinger (while going to college in Ohio), and I had the pleasure of seeing entire stories brought to life by Curt, who remained the principal Superman artist throughout Julie Schwartz's editorial tenure as well, all the way up to the arrival of John Byrne in the mid-eighties. During those 18 years or so I was fortunate enough to share my byline with Curt on what must have amounted to hundreds of stories.

Even after I moved to New York, I didn't see Curt that often. But whenever we crossed paths at DC he was always very encouraging, and seemed genuinely tickled to see how much I enjoyed poring over his pages. Whenever I wrote a Superman script, a trick I would use would be to envision Curt's Superman (whether he was actually drawing the story or not). The reason for this was simple; the excellence and professionalism he brought to his work would inevitably inspire me to be better than I was.

DEAR RONN—
THE DRAWING BELOW DOESN'T NECESSARILY CONTAIN A PARTICULAR MESSAGE — PERHAPS A PSYCHIATRIST WOULD FIND A HIDDEN MEANING. HE MIGHT GET THE IMPRESSION I'VE BEEN FLOORED BY THE 'COMIC MONSTER' WHO REPRESENTS THE MANY YEARS I'VE BEEN DRAWING PANEL AFTER PANEL, DAY-IN AND DAY-OUT. YET I FEEL FRESHER TODAY THAN EVER BEFORE AND MORE OFTEN THAN NOT, TRY MY DOGGONDEST TO DO BETTER. IF YOU FIND IT SUITABLE TO USE IN YOUR MAG— FEEL FREE.
THANKS FOR YOUR VERY NICE LETTER AND KIND THOUGHTS ALL THE BEST,
Curt Swan

YOU SAY YOU WISH FOR 17 MORE YEARS DRAWING COMICS? HA-HA! IF YOU'RE LUCKY, YOU MIGHT MAKE IT. SERIOUSLY THOUGH—AT YOUR AGE, YOU GOTTA BE KIDDING.

©2002 Ronn Foss Estate

*Swan's cartoon and missive from this letter to a fan hints at both his work ethic, his dedication to his craft... and a certain ambivalence toward his career. This art first appeared in* Alter Ego #6, Winter 1963-64.

He was the youngest in his family. So maybe I became that; he just needed to be the opposite. A lot of times we'd have some real good arguments, especially when I was a teenager. But through it all... he was a decent guy with his own ways.

**Zeno:** *What was it like with Curt working at home in his studio while you were growing up?*

**Karin:** It was a wonderful place; he always had air conditioning. (Laughter) In the summer I used to go sit out there and be comfortable and just hang out. We weren't rowdy kids, we were welcome there. And there were moments where you would actually wind up having some nice talks. Most kids are usually not around their father twenty-four hours a day. We had that our whole lives; it's very nice. So no matter what, you could always just sort of go and if you needed to have somebody else's ear to talk to, he was always there. He'd give advice but he wasn't forceful or anything. I don't remember my father being macho. He wasn't that way at all. He wasn't the heavy duty, strong father figure that told everybody what was right and wrong. There was never really any of that. He was a very peaceful, meek guy. And understated.

**Zeno:** *Do you owe a large debt to him for your interest in art?*

**Karin:** Yes and no. When I went to Pratt, my first year of school I was in a figure drawing class. My teacher was, I can't think of his first name—Foster, the cartoonist for Prince Valiant.

**Zeno:** *Hal Foster?*

**Karin:** Hal Foster's son was my figure drawing teacher. I was eighteen at the time. He seemed very old but... I have no idea how old he was. Artists' children make good teachers. My father was always somewhat critical of us and critical of himself. He never really glorified what he did. In his mind, he was doing a job. When we would do something, usually it was, "Well, this could be better." (Laughter) So that was a little unfortunate. As a parent now, I think it's important to, when you hear your kid doing something really good, say, "Hey, that's really good!" But my father would usually show you where it was missing something. That's probably his own upbringing coming through. And that was the times. Nowadays, maybe there's more of a tendency to praise or overpraise. When I was a kid, they were coming out of the time where you just totally pushed kids into a corner. I don't know that he was any different than anybody else. I just heard Hillary Rodham Clinton's father didn't even bother to go to her own graduation. But my father wasn't big on praising any of my artwork or encouraging it. Also, because the reality is, and maybe this is why I never really pursued earning my living in the art field. My experience is having a dad getting up around six or seven in the morning and starting to draw. At eleven o'clock at night he was still drawing. He'd have dry periods where he would leave the drawing board for awhile. But his life was just endlessly drawing. It was always working, seven days a week. He didn't leave it because he worked in the home. And I think that was unfortunate. Perhaps if he'd had a studio where you go there and then you leave, it might have been a healthier move for him. I came away from the whole thing thinking, why would you want to do art for a living? Why not just do that for enjoyment? And go and do something easier for a living.

**Zeno:** *What did you think of your dad's art?*

**Karin:** He was gifted. The pencil drawings that he did, he was just amazing! Anything that he drew was wonderful. And watching it evolve, coming out of these sketchy lines, really beautiful drawings would happen. But I

think the fact that it was how he earned his living—you know, you had to have this amount of money, I'm sure, to have your family. It does something to your art. In another circumstance perhaps, as in some of his paintings he would do amazing watercolors! And to the end of his life, he'd say that was what he wanted to do; he was gonna get back to that. So here is his middle daughter saying, "Well, why don't you do that?" And the reality is, he wasn't able to, I guess. Probably because he was just not in a great frame of mind to do good paintings at that point. Who knows what he could have accomplished under other circumstances? But his energy went into Superman, and he'd have some times that were difficult. During the Mort Weisinger years, there would be many times when my Dad would have a difficult time with a story. We'd have to hide from Mr. Weisinger [when he called]. Anybody else would work from 9 o'clock in the morning, take a lunch break, and at 5 o'clock they'd leave. My father would be telling us to say, "My father went out to mail something," rather than be able to say, "Well, he's playing golf now." He deserved (chuckle) to have a life. That was kind of sad.

And also, you had these parents that had been through the depression with their families as children. That made a lasting impression on them. If there's anything in my family, it's the work ethic. From parents that endlessly worked, and now my brother and my sister

and I work harder than a lot of people do.

**Zeno:** *Do you work in a doctor's office?*

**Karin:** Yeah, I manage a medical practice. It has a creative [side]. It's fun. There's a lot of problem solving, and it's doing good for people. It's an all women's practice, Obstetrics and Gynecology. We're a good team. I've done it for a long time, and do a lot of things there that are different than in most medical practices. We help a lot of people, so it's something I can be happy with. Other people would make a lot more money doing other things, but I feel comfortable, I can sleep at night. I have this sense of loyalty; where did that come from? It's hard work, though. Health care is a nightmare.

*These watercolors done by Swan in the mid-60s still hang proudly in Cecilia's home.*

[AUTHOR'S NOTE: We then com-
miserated about the problems
with managed care these days, as
I also work in that field.]

**Zeno:** *How many kids do you have,
Karin?*

**Karin:** I have two, a boy and a girl.
My son's a senior in high school,
my daughter's a sophomore.

*An unseen side of
Swan's talents: a
landscape watercolor
from the 1960s.*

**Zeno:** *Are they artistic?*

**Karin:** My son's a real musician
and they both are really good at
drawing. Avery is my son, and
when he was in second grade he
was supposed to be writing a
book. His teacher said every time
he started writing it, it kept turn-
ing into this comic book. And the
drawings all of a sudden would
happen. He actually draws really

well. It's like really good designer
style. But mainly he writes music.
My daughter draws horses a lot;
she's a real horse girl.

**Zeno:** *What sort of grandfather
was Curt?*

**Karin:** He loved them, but it was
during a point in his life where...
too bad he wasn't living over here
when they were younger because
I think he would have loved that
even more. I think as his hearing
went, it got more and more diffi-
cult. He just wasn't getting a lot of
stuff toward the end, the last cou-
ple of years. He'd be around them
but there'd be too much chaos to
be able to hear completely what
was going on. I think a lot of times
he opted out. But he was a real
nice guy and clearly loved every-
body. He would always worry that

he was going to say something
that would offend somebody. So
he'd always watch his tongue, and
tell the kids not to do something.
(Laughter) He would always think
that there would be a conflict.

**Zeno:** *Was it because he didn't
want to give too much advice?*

**Karin:** That was his fear, like he'd
overstep what was okay. And good
for him; that's sensitive. My own
approach would be to say, "Let's
work something out where it's okay.
We can disagree, or whatever."

**Zeno:** *When you mentioned your
dad's water colors, did he do
those in the 1960s?*

**Karin:** Yeah. I was a teenager, and
they were really beautiful. We had
just moved to Westport
[Connecticut]. He painted for two
years. I think he was probably in a
really good place in his head. He
was in his forties, prolific, and
finding real relaxation and enjoy-
ment in painting. He had the tal-
ent. He gave them to neighbors,
and the neighbors would die. Then
we went and tried to get some of
the paintings back. "Oh my God,
you did what with the paintings?"
It was just sad. I have one in my
house that I love. But there were
so many others that were wonder-
ful. Some, of like a Mexican cou-
ple—I love those paintings [in her
sister Cecilia's home]. They're very
different from the landscapes that
he was doing. I have one [of] a
barn that doesn't exist anyplace,
but it's very similar to one that
was down the street from my
house. I'm glad to have that.

But that's the other thing. Our
whole lives, Dad just sort of gave

"MY FAMILY LIVES ON A *FARM*, HUNDREDS OF MILES FROM THE CITY. THAT'S WHERE I WAS *BORN*.

"MY *PARENTS* ARE HARD-WORKING SMALL-TOWN FOLK... BUT THEY WERE NEVER SMALL-MINDED. THEY ALWAYS ENCOURAGED ME TO THINK BEYOND THE CONFINES OF THE FARM.

"I WONDER WHAT DAY IT IS BACK HOME?"

*Swan's skills at landscapes were also evident in his comic book work.*

away everything. When you look at what the history of Superman is, all the comic books, kids would come over and we'd give them all away. We didn't care. In the '60s and '70s he was doing a great job and I think he was happy to be doing it, but I don't know that he was proud to be doing it. He was just doing a job. Later on, when Chris Reeve came out in *Superman*, I think there began to be more of an appreciation. There were certain people that appreciated it, but my father always approached it that he was doing a job.

**Zeno:** *That's what he would say at various comics conventions. Very modest.*

**Karin:** Yeah, he was that way. And it would always amaze us that anybody would be interested; like, "Wow! People are writing you, Dad? Good." (Laughter) And we would always be surprised. But things would happen. When I was first at Pratt, somebody was following me around because they knew who my father was. I was someplace in New Jersey once and somebody introduced me as Karin Swan. The person said, "You're not by any chance related to Curt Swan?" That kind of thing would

always blow me away, like, "How have you ever heard of him?" He was just a dad working in the other room.

**Zeno:** *So you never thought of him as a celebrity?*

**Karin:** No.

**Zeno:** *Besides the watercolor of the barn, do you have any other art by your father?*

**Karin:** We have the first page of "I Flew With Superman." It's the story of my dad falling asleep. But that's it.

**Zeno:** *Curt wrote about giving each one of you kids a page from that story.*

**Karin:** Yeah, and that was weird because we finally said, "You know Dad, you've never given us any of these things. We probably should have one, you know." You just think it is something that will go on forever. It doesn't, does it?

**Zeno:** *Well, thank you for talking to me, Karin. I've gotten to interview a lot of wonderful people for this book. No one has had anything but nice things to say about Curt.*

**Karin:** He was a great guy. You got to know him through his friends. When we were kids [and] the

grownups were all together, they'd laugh so hard. It was fun to see your father and mother laugh. And the whole experience of [sharing] World War II together; the laughter and comraderie were great! It made me feel good to soak it all up.

## Mike Carlin

*At this time (the following was written August 21/23, 2000 and combined), Mike Carlin is DC Comics' Executive Editor. His importance as one of the major Superman editors is already covered in these pages. Therefore, it was nice that he chose to discuss how he first got to work with Swan.*

Guess the only thing ta say about Curt would be:

It was so cool to grow up reading *Superman* comics by Curt Swan and then have one of my first assignments at DC be to work on *M.A.S.K.*, on which Curt was the artist. As you can imagine, sometimes the licensed toy-related comics series are the least popular to work on... lots of "outside" folks voting on content and all... but I had done several at Marvel (*He-Man* and *Thundercats*) and I was the new guy at DC... so I inherited the "toy book" at DC at the time... and the chance to work with Curt Swan... so I WON!

If you woulda told me when I was a kid I was going to be calling and hanging out with Curt, I woulda said you were crazy! And if you woulda told me Curt was gonna be NICE too... well, as we say in Brooklyn, Fuhgedabowtit!

Curt was a pleasure to deal with, a consummate professional and super-sweet man... it was my honor to have worked with Curt.

# Roger Stern

*The following interview was conducted 12/11/99, at which time this prolific comic book writer was working on the twelve-issue series* Marvel: The Lost Generation. *In addition, with Mark Bagley, he was writing a three-issue miniseries called* Avengers Two, *which was sort of a "buddy movie" with Wonder Man and The Beast. Remembered as one of the chief Superman writers for several years beginning in the late '80s, Roger later wrote the bestselling novel* The Death and Life of Superman. *Prior to that, when* Action Comics *turned weekly for several months beginning with issue #601, he wrote a serialized Superman story that ran two pages per week and was penciled by Curt Swan.*

© DC Comics

*In 1988,* Action Comics *went on a weekly schedule and returned to the anthology format long since abandoned by comics. Swan and Roger Stern contributed a Sunday-strip style Superman spread to each issue.*

*At right, Aquaman and Ocean Master face off in this Swan illustration for an entry in DC's* Who's Who *series.*

**Zeno:** *Jim Shooter said you'd have some memories of Curt at Ithacon 10 [1985 comics convention in Ithaca, New York].*

**Stern:** The first time I met Curt, it was being held at a hotel downtown. I went into the hospitality room, was pouring some seltzer and this incredibly distinguished looking fellow walked up to me and said, "Roger Stern? I'm Curt Swan." (Awkward laugh). "Oh, hi," while juggling glasses and putting things down; "How are you?" So that was how I met Curt Swan.

**Zeno:** *Besides your work together on* Action Comics Weekly, *on what else did you collaborate?*

**Stern:** Besides that, an *Action Comics Annual* [#2, 1989], and there were some special issues of the Superman titles done sort of "jam special" style, where I got to do a number of sequences with Curt. I made sure we did *Action* #700. I was determined to have some sort of wedding in there, so Lana Lang and Pete Ross were married and Curt drew those sequences. I made sure there were some Superman flashback scenes in them.

**Zeno:** *Was it you that asked for Curt to contribute to that issue?*

**Stern:** I suggested it. Mike Carlin was going, "Sure!" (Laughter)

**Zeno:** *Was the Superman strip in* Action Comics Weekly *specifically meant to be like a Sunday newspaper cartoon page?*

**Stern:** Exactly like a Sunday page. I was basically trying to emulate the big Sunday strips of the '30s and '40s. Not in the same vein as *Prince Valiant,* but it was like *Flash Gordon,* which started as a Sunday page. You would get this big chunk of a story coming out every week. And in some respects, the old Sunday pages of the *Superman* strip, although I'd only seen a few of them at the time. I basically tried to structure it that way, and with the exception of the first few issues, it was in the centerspread. Open it right to the middle and there it is, here's this week's *Superman*!

**Zeno:** *That was one of the best things about it. And you did a wonderful job with the continuity of that story, the serialization.*

© DC Comics

**Stern:** Thank you. It was a little touch and go at times because I was increasingly busier as the series went along. Other things were starting up, other strips. I give a lot of credit to Tom Peyer, who had been doing a weekly gag strip for sometime. I finally gave him a call and said, "This comes out every week. It's a deadline nightmare." (Laughter) "I don't want Curt to get behind the eight-ball. I don't want Murphy [Anderson, who took over from John Beatty as inker shortly after the series debuted] behind the eightball on this thing. Can you help me break this thing down?" Basically I had the outline and would send him portions. He would break down the continuity and suggest rough dialogue. I'd do a final draft, ship it off, and we'd start the next one. It's like: "Oh, Lord, it's a weekly book, you can't miss shipping on it." (Laughter)

*Zeno: Was it harder to write than two pages of a regular story?*

**Stern:** Ah, it had a completely different rhythm. I've done some newspaper strip work. It was one unit, like a Sunday page. It wasn't quite as harried as the situation of doing dailies and a Sunday, which have to integrate with each other. So it was simpler than that. Because you're dealing with a smaller unit of a larger story, it's a different rhythm. You have to set things up precisely. It has to end a certain way, sort of a cliffhanger situation. Not necessarily a literal cliffhanger but a dramatic pause [with excited tone of voice]: "What happens next week?" The only disappointment I had was that a lot of the readers of *Action Weekly* had never really followed a Sunday comics adventure strip

before. They'd say, "Well, how come there aren't more pages of this?" Well, that's not what it is. (Laughter) I was always encouraged, though, that Curt and Murphy picked up on it. I got a call from Curt just a few weeks after he'd started the thing. He said, "Oh, this is just like the old Sunday strips, just so old fashioned and great!" It was like: Oh, Curt Swan likes the Superman story I'm doing! So I'm closed, I'm done. (Laughter)

*Zeno: That's wonderful! And you were aware of his work on the* actual *Superman* newspaper strip *decades before?*

**Stern:** Yes. Almost anyone who'd worked on Superman at all during that period did some work on the strip. Mainly Wayne Boring taking over from Siegel and Shuster. The Burnley brothers worked on it at one point. Win Mortimer did, Al Plastino probably. "We need some more dailies done, here do some quick!" (Laughter)

*Zeno: Were you pleased with Curt's interpretation of your* Action Comics Weekly *strip?*

**Stern:** It was wonderful, absolutely gorgeous. I was working full script. Periodically I'd tend to work Marvel style, but working full script I knew I was working with Curt, so I knew he would pull it off. I knew he would leave the room for copy, I knew he would place it properly. I knew it would pace out, and it was so much fun seeing it weeks after I'd written it. Because the first time I would see it would be in the completed book. "Oh, that's great; look at that!"

We'd work funny little things in there. There's one scene that takes place in an airport and this fel-

low's an Orange Julius fan, so we made it Julie Schwartz. (Laughter)

*Zeno: How did Murphy Anderson get on the series as inker after John Beatty?*

**Stern:** I'm not sure of the exact circumstances. You'd have to ask Mike Carlin. John started out, and I think he was needed on one of the regular books or something. John did a great job, but the combination of Swan and Anderson has always been one of my favorites.

*Zeno: Why was the teaming of those two artists appealing to you?*

**Stern:** For that sort of strip where Superman was the main fantastic element... Darkseid later came in. But where you have a lot of people, Curt and Murphy, separately and in combination, captured the humanity of ordinary people, which makes Superman even more impressive. We all like to see Superman go up against some incredibly strong alien and have them whip the tar out of each other. But when you have Superman among ordinary people, bullets bouncing off his chest, lifting cars, flying through the air, that's what Superman's all about. It was always fun. We ended [abruptly]. I was originally told we would be doing *Action* on a weekly basis for at least a year. Two-thirds of the way through, they said it's not gonna be a year. So we hurried to complete it and were told: Oh, we've got an extra three weeks! So we had to put together this short story that was three strips long, to finish out the run. (Laughter) I think it worked out all right. We'd have put some more twists and turns into it if we'd had another ten weeks, or whatever.

*The World's Finest team in graceful motion*

**Zeno:** *One of the things I liked best about that series was that Curt was supposedly retired from doing Superman, and then suddenly he returned to draw The Man of Steel in the weekly two-page spread, taking up the flagship centerfold position of the comic.*

© DC Comics

*Swan's interpretation of Ocean Master from* Who's Who. *Inks by Joe Rubinstein.*

**Stern:** And as I said, he did sections in an *Action Comics Annual.* When we did the big launch of *Man of Steel*, the series, and the four books were all double-sized as jam sessions, he did a Superman and Lois sequence in the chapter that I did [*Action Comics* #667, July, 1991]. It was a lot of fun working Marvel style with Curt because I got to see his pencils. It was just great because I think he'd just turned seventy-one or so, and when the pages came in I said, "Look at this stuff!" I showed it to my wife Carmella; "Not bad for a guy who's in his seventies, huh?" Curt never peaked. His stuff just got better all

the time. I'm sure if you were to look back over his stuff you could say, "Oh, this wasn't so good." But you look at it artistically and you don't see any valleys. This wonderful sequence [in *Action* #667] where Superman and Lois are at Professor Hamilton's lab. He's off someplace, so they can be themselves. Superman is running this computer check trying to find out more about what's going on, and Lois comes up behind him. And he doesn't have a cape because he lost it in battle. He stored some capes there at Hamilton's. She picks one up, settles it around his shoulders and they kiss. They're sharing coffee and talking about stuff, then he opens the window and jumps out. (Laughter) He jumps up and keeps going. And it's just wonderful!

Looking back over things, I realized the first time I actually worked with Curt was in *Action Comics* 600. It was the first work I did for DC. John Byrne had plotted a number of shorter stories and needed a hand. So I wound up scripting a Lois Lane story and a Jimmy Olsen story. Kurt Schaffenberger drew the Lois story and Curt Swan drew the Jimmy story, which was great because my earliest memories of Curt's work were from the *Jimmy Olsen* book. So that was great fun.

And then, when the *Action Comics Annual* came out, it was fun because Jerry Ordway and George Pérez and I were doing alternate scenes throughout, and Curt drew the scenes that I wrote. Superman was a gladiator with a beard on an alien world, and Curt perfectly captured the look! That's Superman under that beard; there was no mistaking it.

**Zeno:** *That's one of my favorite stories too.*

**Stern:** What's amazing about it is we cut from Jerry Ordway work to Mike Mignola work to Curt Swan work, but it all flows.

**Zeno:** *You mentioned that some of your first memories of Curt's work were on the* Jimmy Olsen *comic book.*

**Stern:** Right, because I'm so old. (Laughter) I'm so old that when I first started reading Superman, it was being drawn mainly by Wayne Boring and Al Plastino. And Curt sort of came in—the first book I remember was *Jimmy Olsen*. At this time, Wayne Boring was starting to concentrate on the daily strip and Curt was starting to show up in *Action Comics* and in the *Superman* title itself. So it was like you would identify Kurt Schaffenberger with *Lois Lane*, who was the chief artist there. You originally saw more of Curt's work on *Jimmy Olsen*, inked, I believe, by Ray Burnley. DC's going to reprint the first issue [rereleased in early 2000]. That was really sweet stuff. Jimmy is down to earth, in the city, often with thugs, gangster things going on, before the Elastic Lad days. There were always interesting shadows; there was a lot of texture and atmosphere to the stories.

**Zeno:** *Did you like the way Burnley inked Curt?*

**Stern:** Yeah, I didn't know it was Burnley at the time. It was: Oh, look at that. Neat! Curt has had some very good inkers. Burnley, Stan Kaye, George Klein and of course, Murphy. And there were a number of years with Al Williamson. That was really sweet stuff.

**Zeno:** *When you visited with Curt at cons, what was he like?*

**Stern:** One of the nicest, most gracious people you could ever meet or want to meet. Curt, Murphy, Joe Sinnott, guys like that, they're just salt of the earth. Very good, friendly gentlemen artists, absolutely unpretentious. I remember Curt in 1988 at the big Cleveland Superman Exposition. One of our first [group] Superman meetings was there. One evening, we all trekked over to this restaurant. Mike Carlin, Jerry Ordway, George Pérez and Kerry Gammill were there. I was there with my wife. And, "Curt, come on." Because he was doing some stuff, working in the annuals, the weekly series, and some things here and there. We were tossing ideas around and we asked for Curt's input, too. "Curt, you've been doing this for thirty-five years. What's great about Superman?" And he really got into it; he was telling us stuff. Afterwards we were saying, "Ever get a chance to do things like this in the old days?" "Oh, no. I'd sit in a room somewhere, they'd send me a script and I'd draw it." What a waste! To have this guy who so understood how the character moved and lived and had ideas about it. And they never used it. They never tapped into that resource. It just breaks your heart. And he was really jazzed! He loved getting into this, being given a chance to do the feedback. I wish I could go back there with a videotape to get the whole night.

**Zeno:** *Did you get to know Curt well?*

**Stern:** Not as well as I would have liked. He was in Connecticut and I was over here. We were both busy. But he was always so damned good. He was amazing. I would

see the penciled pages. Look at that! There's Lois, easily identifiable no matter what crazy hairstyle we gave her. (Laughter)

**Zeno:** *Do you think he was underappreciated as an artist?*

**Stern:** For a generation of readers who didn't have credits, they knew him as "the good (Superman) artist." The way that people would say that Carl Barks was "the good (duck) artist." Amongst other professionals, I know that people were just impressed and amazed by his stuff. There are a couple of generations of artists, some of whom we've lost, and some who are still with us, that really don't get the glory they should. For so many years they worked in anonymity. For about half of Curt's career, there were no credits. (Chuckle) And during a lot of that period, there was a definite effort to make all the art look alike. When Curt first started working on Superman, the idea was to make it look as much like Wayne Boring's as possible. Till he became the chief Superman artist; then the idea was to make it look as much like Curt Swan's as possible.

**Zeno:** *How would you sum up his art?*

**Stern:** It was definitely dramatic, but it was a quiet, subtle drama in many ways.

*A sketch from Golden Books'* How To Draw Super Heroes.

# Shel Dorf

*Mr. Dorf is well known as the founder of what is now known as Comic-Con International: San Diego. His most beloved comics memory is working as Milton Caniff's letterer on the* Steve Canyon *strip for over a decade. On January 18, 2001 he shared this anecdote about Curt Swan:*

I met Curt at DC Comics in 1964. He was penciling a page of *World's Finest*. I was so taken with his pencils that I said, "My God, is there any way we can make a record of that, before they're inked?" He said, "Yes, we have a new machine," and we went down and made a xerox. I still have that page to this day, along with the inked, published comic page on display.

# Jerry Ordway

*The following interview took place on December 23, 1999. A twenty-year industry pro, Jerry Ordway has worked on numerous projects ranging from* All-Star Squadron *to a* Batman *movie adaptation for DC, to* Wildstar *(with Al Gordon) for Image Comics. He was a key penciler, inker and writer for several years on the* Superman *titles after the revamp in 1986. From that stint, Jerry went on to a wonderful run as writer, cover painter and occasional interior artist for* The Power of Shazam! *featuring Captain Marvel and family. Portions of some of his scripts were interpreted by Curt's drawings. They also collaborated as penciler and inker on a couple of special projects, discussed herein. Ordway's endeavors at the time of this interview included working as a self-described "Mr. fill-in guy" at Marvel Comics.*

*An example of Jerry Ordway's work from an Image* Wildstar *graphic novel.*

© Al Gordon and Jerry Ordway

**Zeno:** *When did you initially meet Curt?*

**Ordway:** I don't think it was until 1988, two years after I was asked aboard on the Superman relaunch. At that time, DC was trying to put a new look on Superman. Curt kinda got lost in the shuffle, in a sense. He had put in a lot of years on the book. I felt bad about it. We're all human beings, and as much as the assignment was cool, you hate to see somebody left out in the cold. To Curt's credit, I never got a sense of him being jealous of people. I'm sure guys like Curt saw the young guys come up and then eventually take work that he would've gotten, but he didn't seem bitter. He was the young guy himself once, and I'm sure he felt the same sense of enthusiasm and dread we all feel when we check out the competition. I just felt honored to be rubbing elbows with him.

I remember after John Byrne had left the books, Roger Stern, Mike Carlin, George Pérez and I had a story conference to plan the relaunch of *Action Comics* into Superman continuity, at a convention honoring Superman's fiftieth anniversary that was held in Cleveland [June, 1988]. And Curt was there, too. We were all guests of this thing. We had a nice dinner, and I think that was the first time I met Curt. At this dinner, Curt was going to be drawing parts of the *Action Comics Annual* [#2, 1989] that was leading into George Pérez' doing *Action Comics* at that time. We were all there. We thought, okay, DC's paying for our dinner (chuckle), so we thought we'd work a little bit. And I remember being impressed that Curt genuinely seemed to enjoy this kind of creative input. I doubt that he'd really had much input over the years other than drawing and visualizing the scripts. You always wonder what would have been if

*A rare treat: Fawcett's old characters — Minuteman, Bulletman, Captain Nazi and Spy Smasher — as depicted by Swan in* The Power of Shazam.

this guy had been able to sit in on story conferences. He seemed to have a lot of ideas. Again, it was a really good first meeting, and I came away from it feeling that, after all those years in the business, it was heartening to see Curt still had some enthusiasm for his work instead of coming across like he was burned out and looking down at comics with disdain. That's something I hope for myself. (Laughter)

**Zeno:** *Do you remember any of the ideas that he put forth that night?*

**Ordway:** It's hard to. It's like a creative flow. You're sitting at a round table, one guy says this, the next guy says [that]. But he was not sitting back and just listening. He was definitely a participant. I think it showed in the work that he did. He obviously didn't need to prove himself at that stage of his career. But in the different Superman stories that Roger Stern, Dan Jurgens

or I wrote for him to draw, I always thought that he was competing. And I think that's a good thing. He was definitely working hard. I don't think I've ever seen a subpar job on anything. And I got to see his pencils, which were also kind of a treat. Because as a comic book reader, you tend to see the final product. I think there are a lot of pencilers out there whose work... some or all of it doesn't always transfer well into ink. Curt's stuff had a definite 3-D quality that I never saw anybody really bring out, with the exception of somebody like maybe Murphy Anderson, or Al Williamson on that brief stint that he inked him. But Curt did a lot of pencil shading which was very hard to interpret as an inker, unless you were willing to use some sort of zip-a-tone shading film or lines or whatever. It was very full stuff. I was always very impressed.

**Zeno:** *But few were able to keep that 3-D quality?*

**Ordway:** Right. It's not like I'm passing judgment. I'm sure there's an editorial aspect, too. *Superman* was a book that had a very clean style for that period in the '50s, '60s, '70s. The printing quality wasn't that great. So I'm sure that the overall idea was to keep it clean and simple. But I was impressed to see that extra element of depth. You know, it's within context here, but there's a big group of people who have been championing Jack Kirby. In *The Jack Kirby Collector*, they've been reproducing a lot of pencils. That's a real eye opener for a lot of fans, to see that kind of art. These guys work on kind of an assembly line. You turn your work in and don't really have a choice of who's gonna ink it, color it, or what have you. You see a lot of work that really does get lost in the translation. Again, an extra ten, fifteen percent that gets erased off the

page by editorial directive or the inker making a choice. Curt inked very few of his own jobs. He did a couple here and there, and I think you get a closer idea of what the artist was trying to put down when you see their own inks on top.

**Zeno:** *Did you ink over Curt's pencils prior to meeting him?*

**Ordway:** Yes, working through the mail while I was living in Wisconsin at the time. The first time I'd worked on anything of his, I wound up doing the finishes on a Superman piece that was in a DC portfolio [*History of the DC Universe*] somewhere around '85, '86. I put a lot of work into that, too. Knowing it was gonna be a black and white portfolio, I asked Mike Gold, the editor of that project, if I could use grey-tones on it. I said, "You know, this would be a great spot to use the airbrush." I bought the equipment back in the '70s but never had a compelling reason to use it before. I airbrushed the background with gouache, an opaque paint medium, and when you look at that portfolio it's certainly a standout piece. It looks like we went the extra mile. I remember talking to him at that Cleveland show, and he had complimented me on that piece. And the sad part is I don't think I even have a good copy of it, because being in grey-tones it didn't reproduce very well on a photocopy machine. So at least I have a couple of copies of the portfolio to look at from time to time. It was just one of those things where no one had directed me. I remember Mike Gold being very supportive of my attempts, promising that production at DC would make it work.

(Laughter) This was going to be black and white and I could've used shading films and stuff, but I thought... At that time you didn't get many opportunities to work in any painted kind of fashion, so I pushed the angle myself. Of course, I didn't want to paint his Superman figure, just the background.

**Zeno:** *Did you do it over the original pencils?*

**Ordway:** I don't remember any more. Very likely, I did. Back then I wouldn't have had easy access to a copy machine like nowadays, where I could have copied it and then lightboxed it. I would've done that only if the original was either really stained or bent, or something like that. You do need a flat surface for the airbrush.

**Ordway:** You could tell [Curt] was a smoker. When you're an inker, you usually work with your nose off the page about five inches away. You tend to know. (Laughter) But his work was great, very meticulous! It was always very complete. It would be interesting to see if anybody preserved much of his pencil work beyond the few things here and there that I've copied. Like Joe Rubinstein, I know, used to make photocopies of the pencils. I would guess that probably most of it's lost.

**Zeno:** *Some nice copies of pages that I have of Swan's pencils are those featuring the Legion of Super-Heroes, from "Whatever Happened to the Man of Tomorrow?" in* Superman #423 *written by Alan Moore. I was amazed how true to the pencils George Pérez was with his inks.*

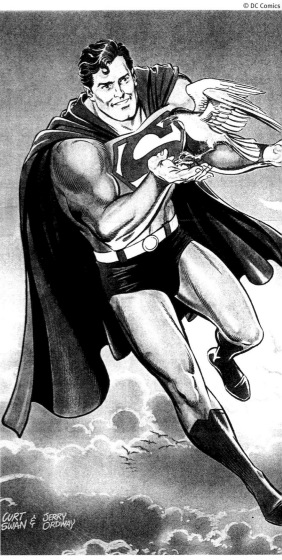

CURT SWAN & JERRY ORDWAY

**Ordway:** George is a big Curt fan, too. You don't jump on to try to change everything. You jump on because you really want to bring out what the guy put down. That's certainly how I felt. I know I inked "The Earth Stealers."

**Zeno:** *Was that the second time you worked with Swan?*

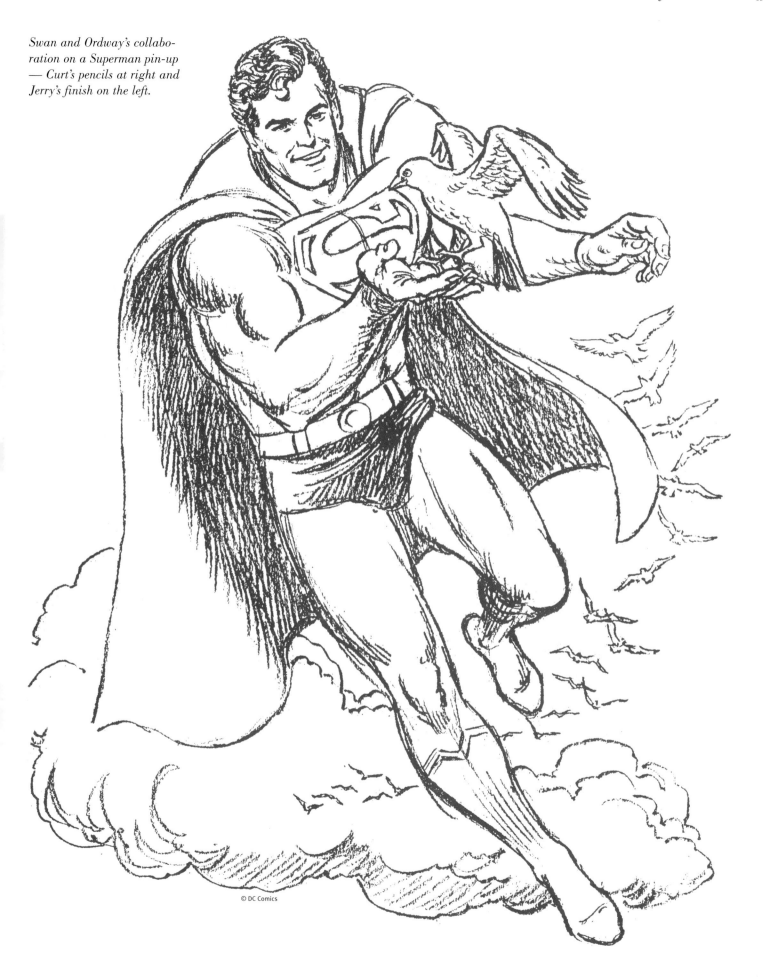

*Swan and Ordway's collaboration on a Superman pin-up — Curt's pencils at right and Jerry's finish on the left.*

© DC Comics

*Whether they were villains, supporting characters, or just extras filling out the scene, Swan's people always had distinctive faces that revealed a deeper personality than the stock characters trotted out by most of his peers in comics. The following pages show just a few examples.*

All © DC Comics

**Ordway:** Probably. I think maybe I'd inked a few things in *Who's Who* [for DC] here and there. It's hard to track down those things memory-wise from around '88, '89. But "The Earth Stealers" was the next thing because, as I recall, it was one of those projects that had been sitting in a flat-file, fully penciled, for awhile. They didn't really know what to do with it. Originally, it had started out as a John Byrne storyline for a Superman movie. it was like a proposal that Warner Brothers paid him some big bucks to write, like a treatment. It would have been around the time of the fourth [*Superman* movie], "Quest for Peace," that came out around the fiftieth anniversary. DC decided that since Warner Brothers didn't use it, they had Curt pencil it for prestige format (square-bound). And it sat and it sat in the drawer for a time until finally at some point somebody said, "Hey, let's finish this

thing." Denny O'Neil was the editor on it. It had been decided to do it as a big annual or something, and they'd asked me if I wanted to ink it. I said, "I'll ink it, but I don't think it's fair to anybody at this point to do it as a regular comic. Just do it as a prestige thing; it'll look good!" It had been drawn on the oversized paper they used at the time, big 12 x 18 [inch] sized paper, so it had a nice reduction. You can certainly put more detail into it when it reduces down like that.

But like all projects, once they gave the go ahead, they needed it next week. It would have been nice to savor the experience, but in addition, at that time I was still working on the Superman stuff. I think maybe I'd taken a month off; I got a fill-in or something. So I basically had to ink this thing in what amounted to less than a month. Sixty-four pages, that's a lot. I'm not a speed demon. And the last, probably twenty-something pages of that book were done in my apartment in Westhaven, Connecticut. Mike Carlin and his wife at the time came up. Dennis Janke came in from Seymour, Ct. Jonathan Peterson was working up at DC at the time. All of these people came over for a weekend and we just had fun in a way. It was the closest experience we could have to being in an old studio system. (Chuckle) Carlin, Peterson and anybody else who walked in were inking straight lines or filling in blacks. Dennis was helping with backgrounds and we wound up doing probably twenty-five pages over that weekend. I did all the main figures and whatever textured stuff there was. Someone else erased the pages. It was one of those things where we

had to do it and everybody pitched in. When you look back on it, I don't think it suffered for it, even though I look at it and say I would have done this or that differently. But then again, after the book came out, I recall Curt specifically saying, "Thanks. You really saved me on that one." I think he felt that

on the second half of the book, knowing it wasn't scheduled or anything, he lost inspiration. I still have a bunch of original pages and they are fun to look at; they're big!

When the artwork was divided up—I think the penciler gets two-thirds or something—it was unfortunate, because there were a couple of double-page spreads that the art guys divided. Well, that's kinda dumb. I think Curt sold most of that stuff pretty quickly, not for very much. I think twenty-five or thirty bucks a page and people snapped it up. (Laughter) Because Superman's practically on every page. You don't find many pages where he's not in costume somewhere. It's fun thinking back on that experience. Your back's against the wall! It was the only experience where my editor, Denny, called me up after the book

was done. And he was so appreciative that it didn't ship late, he said, "What can I get ya'? What's your favorite drink?" I said, "How about a bottle of Irish Whiskey?" And it didn't even occur to me, here I'm asking someone who had problems with alcohol... Thankfully, I think that Jonathan Peterson actually went out and bought it. For me, the '80s were a very exciting time; I felt like I was still the new guy. I'd started in the summer of 1980. Even by the summer of '86, '87, it was still amazing to be on the same page as someone like Curt Swan. Earlier, I'd gotten to ink a couple of Wayne Boring pencil jobs.

**Zeno:** *Did you specifically request inking these former primary Superman artists?*

**Ordway:** No, I think I was lucky during that phase to be associated with these things that Roy Thomas was doing. I think Roy appreciated my ability to "slick" up a drawing. In Wayne Boring's case, these were some of the last things he had done. He hadn't drawn in awhile and they were a little rough around the edges. Basically, it was all there. I just needed to add a little black; it's a polishing kind of job. I'm really glad Roy asked me, [with] a bit of ego on my part, too. When I see somebody else do a job and I say, "Ah, here's this guy who really botched it." That was part of the impetus to take on "The Earth Stealers." This is gonna be a prestige story. If I don't do it, somebody else isn't gonna do justice to it. We all have to have our egos. (Laughter)

**Zeno:** *We could move next to* The Power of Shazam! *How did Curt come to do occasional work on that series?*

I think, in comics, there's a bit of hesitation for the editors to use what we call the old-timers. I always disliked that idea. We used to hear it so much, and I think it was something that held Roy [Thomas] back in The *All-Star Squadron* days. I think he bought into this hype, that you were better off using someone that has never been seen by anyone than someone on whom people have formed an opinion. With the new guy, no one will say, "Oh, that won't sell." Stores will order without the feeling that this old guy's gonna drag down the book. To this day I hate that feeling because there are certain fields where experience is a plus. I always thought art was a lifelong quest to learn how to draw. I'd see guys like George Tuska or Don Heck; it was happening to Curt Swan... who were just not getting jobs. I know there was a point Curt was looking for work. I said to Carlin [editor of *The Power of Shazam!*], "Why don't we try to build some little segments for Curt to draw? I think it'd be cool to see Curt draw Captain Marvel after being associated with Superman for so long." It was merely a gesture, because I respected and Mike Carlin respected Curt's work. In a way, even there, it's kind of sad because they basically would bury the guy. You could do five pages in the book but you're not gonna do the lead story, or you're not gonna do a whole issue. Again, because of the perception that these guys would somehow ruin the sales. And I

always say, "Look, if that's the case, you've got nothing to lose. Sales are in the toilet already. At least we can get a book [out] that you can read and enjoy!"

I think he was having a pretty slow time. It's not a slam at DC because I think that as a company, they really did find work for these guys. For a long time, they did kinda look out for them as [well] as a company is gonna look out for you. And Curt had asked to get off his exclusive contract around this time because he was looking to get work elsewhere. I think that kind of backfired in a way. Therefore, DC didn't have the obligation of guaranteeing him a certain amount of work. So there was a period in the last couple of years where he was doing work for other publishers. He had done stuff for, I

*More of Swan's walk-on and supporting characters.*
All © DC Comics

think, Malibu. So I knew he was looking and I said to Carlin, "Let Curt do this." He said, "Yeah, great!" It was nice, because after a couple of years of Curt doing stuff that he felt was really obscure, he was back working on a character that at least people knew. (Laughter) He was probably over-appreciative in a sense, because it wasn't any grand gesture on my part. I was just happy to have the guy. My philosophy is that if I'm eighty years old and I can still hold a pencil, it would be nice to think that someone would want me to draw something for them.

**Zeno:** *Let's switch back to The Man of Steel. I recently reread an interview that Curt once gave in which he stated that he didn't like to draw Superman with a*

prominent chin because it made him too powerful. Of course, you liked the prominent chin when you penciled the character.

**Ordway:** Right. I had a similar conversation with Murphy Anderson. He didn't like the trend of Superman looking too much like a bodybuilder. He felt his power was within and didn't necessarily need to be shown in an overt way. The Superman chin thing was kind of a joke anyway. A little in-joke that John Beatty was instigating. At the time when I first started on Superman, I was competing with Byrne in a sense. I was doing one book and Byrne was doing two others. I was looking to get noticed, to make a mark on the stuff, too. So I found a hook that I liked and I was going for that old Joe Shuster/Wayne Boring prominent chin. There is a point where the bigger the chin, the dopier the guy looked. At some point I backed off. I said, "Okay, I've gone too far." (Laughter)

**Zeno:** *What was interesting to me was why Curt would even associate having a big chin with being too powerful. (Laughter)*

**Ordway:** There was a *Far Side* comic in the late '80s. Inker Bob Smith had clipped it for me. There were three guys in rocking chairs on a front porch, and it says "The Old Cartoonists' Home." And one guy was talking like, "I once drew..." I don't remember the body part but he's got his hands held out really wide. Well, Bob had changed it and [named the guys] Ordway, Mike Zeck and I don't remember who else. It was the old

cartoonist's home and I was saying, "Yep. One day I drew a chin that must have been this big!" It cracked me up. (Laughter)

**Zeno:** *Even with a big chin, I liked your Superman very much. One of the best things about your work is the anatomy, just as it was with Curt.*

**Ordway:** I think some people go in one direction. Within art, there's always been different schools. One is the school of exaggeration, like cartooning. The other one is more illustrative. I know Curt fell in that more illustrative mode. I always felt more kinship toward that aspect, as well. John Buscema was a big influence when I was reading comics as a kid, more than Kirby at that time. He was the guy that I always tried to swipe and draw figures like. Gil Kane was another. It was drawing the human form and giving it some kind of power and motion. That's something that I really came to appreciate in Alex Raymond's *Flash Gordon*. Reed Crandall was another artist whom I thought was fantastic, always very realistic. Even back in 1940 when everybody was slopping out pages, this guy was obviously putting a lot into it.

*[AUTHOR'S NOTE: Jerry then proceeded to tell me how he learned that Swan had worked on* The Stars and Stripes *newspaper with Andy Rooney during World War II when Andy wrote a brief memorial in his newspaper column after Curt died.]*

Jack Kirby, with whom I had four or five wonderful encounters during comic conventions, always told war stories. Kirby was a reflective guy; he was always looking at the

past. With Curt, you would never even know he was in the war. That's kind of a whole unexplored side to him. It's funny how some talk and some don't. I had uncles who served in the war and most didn't say anything. I guess it affects people differently.

A few months after Curt passed away, there was a memorial dinner at one of the Connecticut meetings of the National Cartoonists Society. There was a great turnout of famous strip cartoonists, as well as DC people. I stood up and said my two cents worth. I didn't know him as well as these guys, who were drinking buddies and golf buddies. But I got to meet his family. He had three children and they were very appreciative of the memorial. During this dinner, Mort Walker mentioned when the Superman changeover happened back in '86 and Curt was gonna be off the book. Mort had either called or gone in to talk to Paul Levitz to campaign for him to keep his job. (Chuckle) Wow! That was impressive, Mort Walker going in to put in a good word. It's surprising that Curt didn't get to stay on one of those Superman books. (Laughter)

Curt was extremely well liked among this group. He was very personable. Another cartoonist, Guy Gilchrist, who draws *Nancy* and has a couple of other strips

was a good friend of his, too.

When I'd left the Superman books in '93 or '94, I'd been on 'em for what amounted to seven or eight years. My wife wanted to do a little dinner to surprise me. She invited Mike Carlin. And Carlin said, "Hey, the other Superman writers and artists are in town; we're doing our story conference. Why don't we drive everybody into Connecticut to this restaurant?" So they surprised me. My wife tried real hard to get Curt to come. Curt just came for cocktails because he had to go golfing that afternoon. (Chuckle) It was funny. Curt comes in, shakes my hand, gives me a little encouragement. And I said, "Curt, this dinner should have been for you. I put seven years in, you put thirty." He just kind of laughed it off. He always struck me as somebody who didn't have any bitterness. He was always good natured about it.

**Zeno:** *I think that was so true of him, that he didn't wish to dwell on the past, but preferred looking forward.*

**Ordway:** He did the *Aquaman* miniseries. I still think that's one of the nicest things he's done. A friend of mine who used to work with me in the studio in Milwaukee, Al Vey, inked that thing. Al was very conscientious about it too, and certainly thrilled to be working on Curt Swan.

I had a studio in Milwaukee starting around '84 with Mike Machlan and Pat Broderick, who had moved from Florida to Wisconsin. He was there for about a year and a half.

Then there was Al Vey, who was trying to break into comics. We gave Al space in the corner. He usually worked off his portion of the rent by erasing pages and filling in blacks. He was at a point where he was given that assignment and knew it was kind of a make or break thing. He had his foot in the door but they kept trying to close it on him. (Chuckle) One of the things that I tried to instill in him was that you shouldn't fake stuff. If you don't know what you're doing, you've got fifty years of comics history to look upon.

# Kurt Schaffenberger

*Kurt Schaffenberger was a longtime artist for Fawcett Comics, illustrating various features including Captain Marvel, Jr. and The Marvel Family. Besides doing memorable work for other companies such as American Comics Group, he was known to many DC fans during the Silver Age of Comics as the definitive Lois Lane artist. Kurt went on to draw Supergirl and later Superboy, along with a plethora of other characters for that company. The following information came from a phone call which took place on June 28, and a followup letter on September 4, 1999. Many thanks to both Mr. and Mrs. Schaffenberger (her help was invaluable).*

"I met Curt when I first started working at DC, which would be about 1950, somewhere in there. I used to go in about once every week or so to deliver and pick up work and we'd bump into each other at the office. We didn't meet socially, just say a few words during professional things. He was a very good artist, one of the best. Inking Swan's work was a pleasure. His work was 'tight,' not unlike [my] own."

Asked why Schaffenberger redrew (and inked) only the faces of Lois Lane and Lana Lang on some of the Swan-illustrated stories of the early sixties, "Weisinger had the faces changed as a result of his own personal taste. This was done only when [I] happened to be in the office."

Regarding some of Curt's finest inkers during the Silver Age, Kurt's wife wrote that her husband didn't know Stan Kaye. Between George Klein and John Forte, Mr. Schaffenberger preferred Forte's inking.

*Two versions of the cover for*
Lois Lane *#96, October, 1969.*

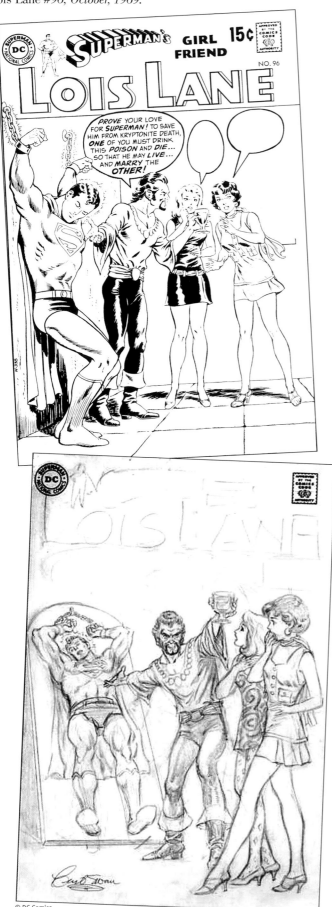

© DC Comics

And when he was doing Aquaman, having some Al Williamson and Flash Gordon and Prince Valiant stuff open in front of him was inspiration while inking... I think that's a big part of doing a good job. Not just sitting down and going, "Okay, I've gotta ink three pages today and plowing through it." You could maybe do that after twenty years when you know what you're doing.

What I always got out of Curt's stuff, if you asked him to draw a nuclear bomb, you didn't get just something that looked like a big bullet. He was pretty conscientious about trying to do what you asked him. Again, that was a distinction with him, because he never really shortcut anything.

I think I had more contact with Curt from about 1987, when I moved to Connecticut, until he died. And I guess you get more of a chance to see people in a casual setting. I mentioned that there's a local chapter of the National Cartoonists Society. Curt was a member of that and twice a year, they'd have a gathering in a restaurant or something. That was really where most of the casual contact came. He was just a really sweet guy. Besides his drawing, he had three other passions—enjoying a smoke, a cocktail and playing golf. I didn't play golf and I didn't smoke, so we certainly had a couple of drinks at these things. (Laughter) But he was always a very "up" guy. Again, from my perspective, there was a lot of looking up at him and appreciating the guy as a human being. He always met his deadlines. He really made an effort, I think, to do his best work even when he wasn't getting assignments that were challeng-

ing. I think he still always put in a good amount of work on these things. It's evidenced by the fact that he worked right up until the day he died. A lot of people don't have that type of longevity in comics.

That reminds me of another thing about Curt Swan. He had done a flashback scene in *The Power of Shazam!* with Dr. Sivana, and I had a script for him. It was one of those things where with his schedule and my schedule, he was looking for it right away. So I called him and we agreed to meet at a diner not too far from my house. And I brought my daughter, who was three. "Hi, How ya' doing? Here's the script and reference. Bye." It was always a thrill. And he went up to have his dinner alone at the diner. I remember feeling bad about leaving, and thinking: You know, that's stupid. I should've just gone and had a meal with him... Well, it's not like you're not gonna have other opportunities. You always think back on the regrets. I wish I would've, because we had talked about it a lot of times.

When Al Gordon and I did *Wildstar*, we actively sought out Curt to do a pinup and got Joe Sinnott to ink it. We always thought that was a teamup that could've been fun. *[AUTHOR'S NOTE: Sinnott inked Swan one other time on a pinup for* Superman: The Man of Steel Gallery *#1, Dec., 1995.]* When I called Joe, he was very happy to work on Curt. It was fun and it was during the heyday of everybody making pretty good dough off these things. So I was glad to say, "Here Curt, here's a check for five hundred bucks." It was like: Here's your best page rate ever. (Laughter)

Again, Curt was the supreme gentleman. I called him and asked, "Have you got it done?" Curt asks me, "Are you home? Why Fed Ex it when I can just drive over?" I showed him the upstairs to my house which I had done finish carpentry on. He also was an amateur carpenter and was impressed that I had done the finished work.

In closing, I think it's nice to see some project about Curt. I don't think he was one of those flashy, stylized guys, but was quietly influential through a solid body of work.

**Zeno:** *And the goal is to look at the total body of work including the '80s and '90s, not just the Silver Age. It's been a lot of fun, especially talking to people like you. Everybody's been so kind.*

**Ordway:** You know what? That's what he leaves with people. Artistically as the aside, it's nice to know that he was a decent guy. You think about how many people can say something bad about you; I don't know anybody who can think of anything bad to say about Curt. (Laughter) He wasn't an angel but he was a gentleman, I guess is the best way of putting it.

Years ago, he did a long interview in *The Comics Journal*. What stood out was they would do these gigantic interviews and they would pull out certain quotes that were inflammatory. In that [particular issue] they'd ask these leading questions trying to get him to criticize someone, without success. I remember friends of mine at the comics store going, "Can you believe this? Curt didn't say anything bad about anybody." (Laughter) Again, that was probably a look into the guy's life.

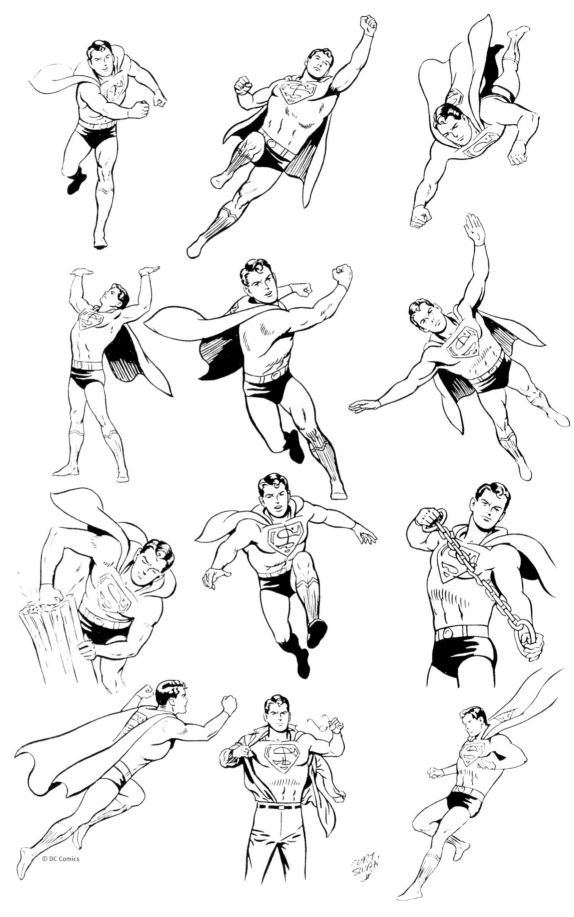

© DC Comics

*Swan produced this model sheet of The Boy of Steel as a guide for other artists working on the character. Despite Swan's examples, other artists had a hard time matching the grace and dignity Curt brought to the character. (From the collection of Steven Weill.)*

# Dan Jurgens

*Dan broke into comics in 1982 illustrating* Warlord *for DC, followed by* Sun Devils, Booster Gold, The Legion of Super-Heroes, Flash Gordon, Teen Titans *and other characters for that company. In Sept., 1994, Jurgens wrote and drew the* Zero Hour *miniseries to update the DC universe with his buddy Jerry Ordway finishing the art. Dan became one of the major Superman artists and writers for over a decade beginning in the late 1980s. He created the hero's most worthy adversary of the '90s — Doomsday.*

*Swan's influence can be seen in Jurgens' illustrative, more modern form of storytelling. At the time of this interview on January 14, 2000 Dan was writing* Aquaman *and The* Titans/Legion of Super-Heroes: Universe Ablaze *miniseries (also penciling the latter). In addition, he continues to work for other companies, most notably Marvel Comics.*

---

**Zeno:** *Jerry Ordway said that you did Curt a favor by helping to get him an assignment in the last few years of his life. Does that sound familiar?*

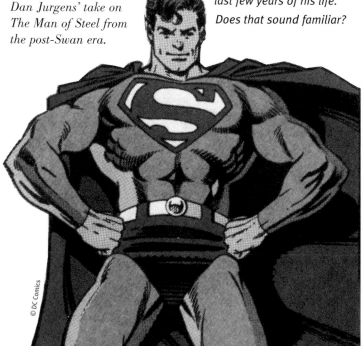

*Dan Jurgens' take on The Man of Steel from the post-Swan era.*

© DC Comics

**Jurgens:** Yeah, it does. I don't know that I would phrase it exactly as Jerry did, or as you would. It would be more appropriate to say that I was always a big fan of Curt's and felt that DC owed him a great deal. So whenever possible Jerry and I would encourage Mike Carlin, who also wanted to give Curt all he was due, [to assign him] work whenever possible. It would be maybe a fill-in issue of *Superman* or something like that, whenever we could squeeze it in.

**Zeno:** *Do you remember any particular issues that would fall into this category?*

**Jurgens:** I remember an *Adventures of Superman Annual* [#2, 1990] I wrote that Curt penciled a part of. I think it was divided into three artists, where Bob McLeod penciled and inked a section, Curt penciled a section and Kerry Gammill penciled a section. That was one I tend to recall with some specificity. There were more, but I just can't place them all.

**Zeno:** *Your career reminds me of the way artists used to start in the comics. You seemed to have a slow climb to the top. Working on the bestselling titles is not where you started. There seemed to be a breaking-in period that a lot of artists don't get nowadays. Would you say that's true?*

**Jurgens:** Yeah, it probably is, although I still think that it works that way. Right now, if you pick up a mainstream, big character book—one of the iconic characters, and you see a new guy drawing it, that sort of sticks out. But I think for the most part what happens is, it is more often than not going to be done by people with some sense of experience.

**Zeno:** *I'm glad to hear it. Did you ever ink over Curt's pencils?*

**Jurgens:** No, I didn't.

**Zeno:** *Of course, you drew cameos of Swan, Murphy Anderson and others in* Superman: The Wedding Album *[December, 1996].*

**Jurgens:** I was the penciler and Jerry [Ordway] inked those.

**Zeno:** *What did you use for reference?*

**Jurgens:** For Curt, I think I had a couple of convention photos of him around. Plus I found a couple of photos of him that had been published in something; I don't remember exactly what. More than anything it's having met Curt several times. I live in the twin cities area [Minneapolis and St. Paul] and Curt grew up here. I don't know if he has family here anymore, but when he was alive his brother was still here in a nursing home. Curt would periodically come visit him and he and I would get together for lunch whenever he flew into town. So as much as anything, it comes from knowing somebody, I suppose.

**Zeno:** *Any particular memories of what you two talked about when you spent time together?*

**Jurgens:** Usually it was industry related. A lot of times, I'd say it had to do with Curt's frustration in not getting as much work as he wanted or the type of work that he wanted. Or not being able to understand what the industry had become. It had undergone a great deal of change, as it continues to do. I think at some point, Curt had difficulty in understanding exactly how the nature of the industry had changed and where he stood in it.

It was very understandable. I'd say that was a frequent aspect of the conversation. It was different to him because he had been a DC loyalist for so long, and had gotten to the point where he didn't feel that was necessarily reciprocated. He had a hard time really understanding what all that meant, and trying to define why it happened.

**Zeno:** *Why would you say it happened?*

**Jurgens:** Oh, there are a number of reasons. As we all know, styles change. Those of us who become familiar artistically tend to become "yesterday" artistically according to new waves of editors. And for a long time, Curt had been linked so much with Julie Schwartz. Then Julie was no longer actively editing and I think that had something to do with it. In DC's desire to have a different look for Superman, for example... I think it's those things that end up hitting a lot of people, if not everybody at one time or another.

*You mentioned that he was an influence on your work?*

**Jurgens:** Yeah. I think Curt for me, as I always told him... You know, one of the things about Curt is he always seemed just so terribly touched and impressed by the fact that people knew his work, that people associated his work with him as a person, somehow. Of course as we all know, there was a time in comics when the artists and writers really didn't have much in the way of contact with their audience. And I remember I always told Curt (and this is the truth), "You are the first artist that I remember cracking open a comic book and saying: I like this art better than I like it in the book next to

it." For me that would have been a function of seeing it in *Superman*, or maybe even primarily Legion of Super-Heroes [in *Adventure Comics*] as a kid. Curt would draw a couple of issues of Legion and then someone else would draw it. And I'd always say, "Man, where's that other guy? Bring back that other guy; I like his Legion better. They're nicer looking kids." (Laughter) For me, Curt was the first artist whose work I really recognized as liking better than the next guy's. And that sort of opened the door to realize that with other artists like Carmine Infantino and Joe Kubert and later Jack Kirby. But Curt was the first one.

**Zeno:** *When would you have first seen Swan's work?*

**Jurgens:** Mid-sixties, probably around '66, I believe.

**Zeno:** *What did you find appealing in his artwork? I know it's often hard to put something like that into words.*

**Jurgens:** For me, it was actually very easy. It was the storytelling. When you read a Curt Swan comic book at that time, he carried the look of the character throughout the book. Superman, Clark Kent, Lois, Lana, Perry, Jimmy... They looked like the same characters from panel to panel, from page to page, from issue to issue for an entire year. They had different qualities as people and you were able to recognize that. Earlier I mentioned the Legion. Curt's characters just looked good! He drew attractive looking people and friendly looking people. I think to a certain extent when you're a young kid, it was like: "Oh, yeah, I'd like to hang out with these Legion guys. They look like a lot of

*A rare sample of Swan's work for independent publishers near the end of his career.*

fun! And he maintained that throughout the book. I think that and his skill as a draftsman, which just plain translates to the reader.

**Zeno:** *And when you mention storytelling, do you mean layouts?*

**Jurgens:** Yeah, the storytelling is part of it in terms of layouts, even though there wasn't much deviation at that time. Most of those books were written full script. Storytelling in shorthand is seen by many people as how you draw, within each panel or how panel leads to panel. For me, it's much more than that. It's also how you define characters. Curt was able to define characters very well. His Superman was a very steady, very solid, very rock-of-the-Earth character that was communicated visu-

*In 1983, Swan illustrated a guide to drawing some of DC's flagship characters for Golden Books called* How To Draw Superheroes. *Some of his instructional sketches appear on these two pages.*

ally. Storytelling with regard to the Legion of Super-Heroes was Curt sculpting a world that was so consistent it looked like it could exist. That involves costuming; it's the set design; it's character design; it's the design of the technology. To go back to the '60s when he would have been doing it all, it's all of those things. And Curt was very adept at communicating that stuff. I also thought that he didn't take much in the way of shortcuts, whereas a lot of artists did at that time.

**Zeno:** *When you were with him, did he do or say anything which you remember that displayed his sense of humor?*

**Jurgens:** I don't know whether I would get so specific in terms of that. I agree with you, he always had a good sense of humor. One of the things I always enjoyed was asking him about the days of yore (laughter) in terms of comic books, and some of his recollections. Whether it was editorial conflicts or conflicts with a writer, or going golfing with somebody down the street, things like that. Curt represented an era, I suppose, when the artists tended to be (I always use the shorthand term) "Connecticut gentlemen" to a certain degree. They seemed to be… Guys from that era had more room in their lives for a real life, whereas so many artists now, especially the younger guys—it's all computer games and videos and buying toys. And it's like: Hey, there's a big world out there; are you aware of it? And I'm gonna get in a lot of trouble for that one, I can tell already. (Laughter)

**Zeno:** *Any particular memories of Minnesota experiences you shared with Curt?*

**Jurgens:** Yeah, Curt actually is responsible for one of the scariest moments in my life. Curt and I were at lunch one day. I was going to say within a year; this was certainly within two years of his death. He was in town visiting his brother, who at that time was in a nursing home. Curt, even then, was smoking. We're sitting there having lunch and Curt had gone through a couple of cigarettes already. All of a sudden I looked at him and he started to shake. Curt went into convulsions and it was really frightening! I immediately jumped out of the booth and started looking around: Where's the phone? I've gotta call 911 or something. I got about two steps away from the booth and he snapped out of it. He said, "No, don't worry, just let me catch my breath." It was frightening for a couple of reasons besides just the obvious. One of those is because all of a sudden, Curt became much more human to me. I think that whenever we meet somebody like that, we tend to put them on a pedestal. I know I did. And all of a sudden he became very vulnerable and human. That's always kind of sad and frightening but it also reminded me of his age. I can still look at it and say, clearly Curt could draw as well as ever. I think the line quality had gotten a little shaky, but otherwise it was all still there. I just remember that as being an awful experience where: "My God, Curt's wanted here and something bad is gonna happen, and he's gonna die when I'm having lunch with him." It would have been too horrible to even contemplate. But

as much as anything, it was a real shock to see by that time, and I want to choose my words carefully, Curt was sort of on the way down. That's always sad to see with anybody.

**Zeno:** *Yes, it is. Some of the other people that I interviewed didn't have that frightening an experience but they mentioned a decline in his health. It tells a story that's important about Curt as he approached the end of his life. I last saw him in late 1993 and he looked well at that time.*

**Jurgens:** Well, you mentioned Curt looking good. I don't remember exactly how long it would have been [that] I last saw him before he died. I'm sure it was within a year and that was the thing about Curt. He always looked pretty good. (Laughter) He did; he looked like the gentlemanly cartoonist and it was a role I think he assumed very, very well.

**Zeno:** *Any other memories about the assignments he was getting when you got together, what he liked and didn't like about what he was drawing?*

**Jurgens:** That's one of the things that was always interesting. I told Curt many times how much I liked his Legion work. He'd throw one hand up in the air and kind of wave it off, saying, "Oh, the Legion. I never enjoyed drawing that feature." He always referred to it as a feature. And hey, it is a hard book to draw. (Laughter)

**Zeno:** *You should know, having drawn it also.*

**Jurgens:** A lot of characters — and you could tell that he always had that frustration with it, which I can

appreciate. So there was that. Clearly, to him, his identity was built around Superman. I think what he enjoyed was the association with the character; there was some sense of accomplishment and achievement. For the most part, while he was drawing Superman he was probably recognized at that point as being DC's top artist. Not having been there I can't say for sure but I think that would be a safe assumption. And I think he enjoyed that recognition, the sense that he had achieved that. But it was funny. It also seemed to me if you asked Curt [for example], "I loved Superman #186, what's the deal with that?" He'd say, "I don't remember." (Laughter) Part of that is because artists were much more inclined to disinvolve. They were seen as artists; their contributions weren't solicited beyond that point. Curt always made a big deal of the fact that his opinion was never asked on anything with regard to Superman, or really much of anything else. Later, as the industry changed and artists became more involved with things like that, I think Curt was always sort of tickled and shocked and amazed and somewhat bewildered by the fact that had occurred.

**Zeno:** *When did you first start working on Superman?*

**Jurgens:** I think it was '87. My first issue of Superman was The *Adventures of Superman Annual* #1 by Jim Starlin. And I believe I did that in '87 and it was published in '88.

**Zeno:** *Had you wanted to work with The Man of Steel prior to that first assignment?*

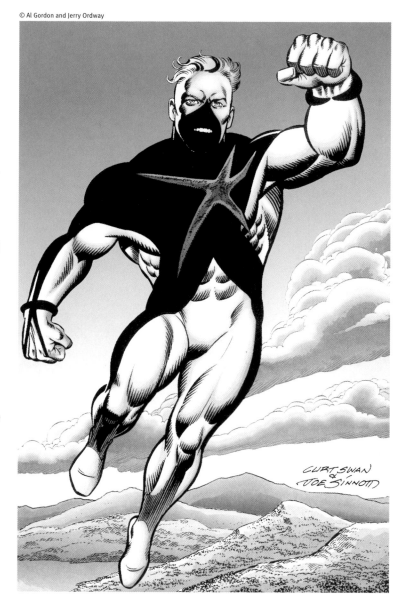

*A unique pairing of two of comics' greatest talents: Marvel Comics stalwart Joe Sinnott inks DC Comics mainstay Swan in this pin-up of Image Comics' Wildstar.*

**Jurgens:** Oh, I had always wanted to do Superman, yeah. When I started at DC I was doing *Warlord*. One of the things that was asked of me was, "Can you draw superheroes?" because Warlord was pretty much swords and dinosaurs? I said, "Well, yeah, I want to draw Superman." In fact I remember it very clearly. Karen Berger, who is now a Vertigo editor, called me up and said, "Can you draw Superman?" Honest to God, this would have been, like '83. My response was, "No, only Curt Swan can draw Superman — but I'll give it a try." It didn't work out at that point; I don't even remember the reasons for sure. But for

me, even in the early '80s, Superman was Curt's.

**Zeno:** *What do you think shows in your work that you've carried over from the standards set by Curt?*

**Jurgens:** More than anything, for me as a kid, and this will hearken back to something I mentioned earlier. If I was buying, say a couple of issues of the Legion and Curt drew two of them and the next one was drawn by somebody else, I was always tremendously disappointed by that. As a kid, fill-ins disappointed me to no end. I think the one thing I valued so much as a reader back then was

seeing Carmine Infantino on Flash every issue, or Curt on Superman every issue, or on Legion almost every issue. Because that bugged me as a reader, that appreciation that as a pro I should try not to do that to anybody else. I think that's something that you get from the talent you were subjected to as a reader at one time. It's also some-thing that seems to be in precious short supply these days.

**Zeno:** *You're addressing with that statement the importance of a work ethic and dependability along with the talent the artist brings to the work. Is that the way you meant it?*

**Jurgens:** Yeah, very much so. Other guys and I talk about this all the time. There was something significant about Dick Dillin, for example, doing the Justice League for so many issues. Or Jack Kirby doing whatever book you'd pick up that he was on. He was there and I firmly believe that that reliability of look was very important to what comics were at that time. Obviously, it was important to those guys because that's how they had to make a living. In those days, you couldn't do eight issues a year; you would've been fired, probably pushed out the door. But at the same time there was something there that was tangible and beneficial and contributory to the industry as a whole that we lack today.

**Zeno:** *Well said. I think that even in other media today, such as television, you see the same thing.*

**Jurgens:** If you pick up the daily paper and read the comic strips you'll see fill-in guys. And on television I certainly have a much harder time being interested in what's on these days because a show is on for three weeks, then they're throwing on reruns or something else. Or I don't know when it's on; it's all that stuff. Ultimately, like I said, you lose something, a great deal as a matter of fact.

**Zeno:** *Is there any particular aspect of Swan's life that you'd like to see written about?*

**Jurgens:** My answer to that would be something you could never achieve because it would depend on Curt still being alive. To me, the

# Yellow Hair

As discussed in Mort Walker's entry, Curt once submitted a strip for syndication. Swan once discussed it with fan and friend Wally Harrington. Harrington recounts: "As far as I recall, *Yellow Hair* was the name of the strip. That is what Curt called it when I showed them to him in Greensboro [N.C.] back in 1991. [They] were done circa 1954. This was a rare instance where Curt pen-ciled *and* inked the art. He told me then that he didn't like ink-ing, felt he was heavy handed and thought his line was too "thick." He preferred Stan Kaye, at the time. I also remember him saying that he did two weeks... 12 of them (2 x 6 days; no Sunday). As I recall, Curt had been in comics a few years and was considering whether to continue. He tried this strip, then went to advertising for awhile, then came back. He was only a little disappointed that the strip wasn't picked up because he felt it was a lot of work."

one magic question I would've asked Curt that I never did would've been, "If you could do it all over again, would you have done it the same way?" I think Curt did well in this industry. He told me about the value he placed on... While he was working at home, for example, he was [there] when his kids came home from school. But as he got up in life, dealing with comics and with the industry he was in was much rockier. So I would ask him that, and certainly, I don't know that any of us could answer [but] I suspect he would! I don't think he would change but I'm not the guy to make that call and should probably retract that statement. I just don't know.

**Zeno:** *Overall then, you feel like he would have made the same career decisions?*

**Jurgens:** I think so. Again, this is just a guess on my part. He was at the point where he enjoyed the recognition he was getting in the industry. I think he enjoyed going to shows, especially if Julie was there. If Julie and Murphy were around, I think he had a lot more fun. At the same time there were some struggles in his personal life, where if he had been getting more constant work, it would have made things easier for him. So I guess I really can't say.

**Zeno:** *Curt was primarily a penciler. He didn't write the stories which he illustrated. He rarely inked his own work, yet he is still highly thought of as an artist. What is so special about his pencils? It almost seems undefinable. Earlier, you said the characters that he illustrated looked good, but why?*

**Jurgens:** If you say the people all looked so good, I wouldn't say that's undefinable. The characters he drew were very, very attractive and consistent. I think even if you look at some of the other Superman artists of that time, their Jimmy, for example, might all of a sudden be almost as tall as Clark Kent. With Curt, the physical difference between Jimmy and Clark was very consistent and he put Perry somewhere in the middle. His Clark Kent always looked like: "Yeah, that must be Superman under that suit 'cause look at those shoulders." And the nuance of expression Curt was able to give characters, especially female characters, was always tremendously solid. And not something that many guys can pull off.

**Zeno:** *Why can one artist pull it off and another can't?*

**Jurgens:** I don't know, because if I knew the answer to those things I would fix the weaknesses in my own art. It was just something that Curt was able to do.

**Zeno:** *Some people would say that Swan's work was not dynamic. Do you agree?*

**Jurgens:** (Pause) That is a term that can stretch so many different ways. But if we are to accept the traditional meaning of it in this medium... Let's go back to Curt's contemporaries because I think that's the fairest thing to do. Probably the foremost dynamic artists at that time (I'm probably forgetting somebody), and I think we're talking '6os here, were Kirby obviously; Joe Kubert was a tremendously dynamic artist; Carmine and Gil Kane. Those were the guys who, if you go back to the books even then, in the mid-sixties; and I think we have to predate it before Neal Adams came on the scene. That's really when everything started to change. But even before then, when Kubert and Carmine and Kane were working under the same sort of boundaries that Curt was, which was full script, they found ways to make the work a little more dynamic. *Green Lantern* and *Atom* were just more dynamic looking books than *Superman*. The same thing when Kubert did Hawkman in *The Brave And The Bold*; that was some dynamic stuff! And Curt didn't do a lot with that. Curt did not do a lot in terms of lighting tricks, didn't do a lot with when the fist would come straight toward you right off the page like Gil could do so incredibly well back then. When he drew head shots he didn't take the head and tilt it in all manner of form like Gil did. Gil was doing up-the-nose

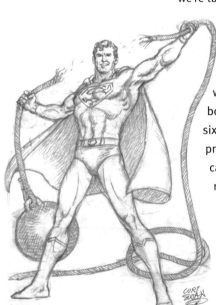

*This drawing was done for Bill Janocha in 1992.*

© DC Comics

shots, he was moving the camera up above the head. I mean Gil was moving that camera all over the place! Curt sold his books, his characters, I think, on a sense of recognition and reliability. It was a quiet reliability but I don't think it was any less effective to the readers, and that's the most important thing.

**Zeno:** *Curt always struck me as being very independent. Did you see that in your dealings with him?*

**Jurgens:** Yeah, I think so. One of the things is that the industry had gotten to the point where you didn't have to move to New York. A couple of times I said to him, "Well, you could still live in Minnesota." He said, "I don't think so. It's too cold there." (Laughter) But that was something too that was very different to him in terms of the industry, because he always saw it as having to be much closer to the office.

**Zeno:** *Do you still live in the area of the state where you were born?*

**Jurgens:** I grew up in a very rural part of Minnesota... a few hours from here.

**Zeno:** *Did you also spend time with Curt at cons? Wasn't there a convention in Minneapolis during the last few years of his life in which he went bowling and a good time was had by all? Were you at that convention?*

**Jurgens:** Yes, I was.

**Zeno:** *Did you bowl with him.*

**Jurgens:** Now you've got me on the spot. You know, they do that here every year and I go, so I probably did. They tend to run together. Usually, it's on Sunday night after the con when everybody's so tired

you don't remember it the next Monday, let alone five years later. But I do remember that con very well and Curt having a grand time here.

**Zeno:** *Was that the only time he attended that con?*

**Jurgens:** It probably was. Here again, I ended up seeing Curt at so many conventions that they all run together. There are some cons that tend to do a real good job of bringing in some of the older guys. Probably the last con I saw him at might've been at a Detroit Motor City Con but I may have been places with him after that. My memory of it is sitting down and having a fun chat once with Russ Heath and Julie and Curt. I didn't get a word in edgewise with those three guys. I just let them run.

**Zeno:** *Was Russ Heath good friends with the two of them?*

**Jurgens:** I don't know that they were good friends as much as they were contemporaries, and liked hanging out with each other much better than they liked hanging out with young punks like us. (Laughter) That might have been it in a nutshell right there.
[AUTHOR'S NOTE: Russ Heath and Swan used to see each other on the train occasionally while heading into the city.]

**Zeno:** *Thank you for taking time out of your busy schedule to talk, Dan.*

**Jurgens:** I always considered Curt as a friend. I always considered him as somewhat of an inspirational light so when I said it's always fun to talk about Curt that was no B.S.

# Tom Mason

*After his run on* Superboy The Comic Book, *Curt continued to work occasionally for DC while taking on a few assignments for the so-called "independent" comics companies. In 1993, he completed a cover and a short story for the Malibu Comics feature,* Dinosaurs For Hire. *Tom Mason was VP-Marketing at Malibu and creator of that series. These days, Tom is CEO of MainBrain Productions (which creates and develops television shows, among other fun things). On April 5, 2001 he shared his thoughts about whether he enjoyed working with Swan and how the assignment came about.*

"Of course. He's cool, y'know. Who wouldn't want the artist most associated with Superman to draw one of your stories? I met Curt Swan once many years ago at a cocktail party at the Museum of Cartoon Art, back when it was located in Port Chester, NY. We got into a conversation about knowledge and curiosity. His view was that you should never stop learning or growing intellectually. There's always something new and exciting to explore and never a point where you think you know it all. That always stuck with me."

"Well, for the longest time, everyone knew that he was under exclusive contract to DC. When that ended, we heard through the grapevine that he was looking for other opportunities. At the time, I was creating several 8-page stories to use in my book, *Dinosaurs For Hire* (among other places). The shorter features weren't audition pieces; they were just an opportunity to let me work with other artists — anyone I liked who wanted to draw dinosaurs with big guns. I had just gotten to work with Joe Staton, who was one of my favorites."

"Roland [Mann] was working on a big crossover event with the Malibu titles that he edited that included *Dinosaurs For Hire* and *Protectors*. Somebody — I've long since forgotten who — came up with the idea of doing a [*Genesis*] #0 issue to introduce the characters and the crossover concept to make it seem like a big deal. Someone had contacted us on Curt's behalf as I was writing the script and the pieces just sort of fell into place after that."

Roland mentioned that Curt didn't interpret something in the script as intended and Tom confirmed: "Yeah, but it was the funny kind of problem you get with any artist who doesn't draw the characters on a regular basis. Plus my panel instructions in those days were probably not as clear as they could have been. But it wasn't a big problem at all. Curt had never drawn any of the *Dinosaurs For Hire* characters before and he misunderstood which character was which and drew the wrong one in one of the panels. Rather than get it redrawn, I just rewrote the joke."

# Alan Moore

*Mr Moore's career writing comics began in 1980 on* Dr. Who Weekly *and* 2000 A.D. *He burst on the American scene in* Saga of the Swamp Thing #21, Feb., '84 *. Some of his best known projects after his extended run on Swamp Thing are* V for Vendetta, Watchmen *and* From Hell. *At the time of this interview, Alan is busy writing* Promethea, Tom Strong, Tomorrow Stories *and* Top 10 *for his America's Best Comics line. He recently completed his first* League of Extraordinary Gentlemen *multi-part story.*

*On September 19, 2000, Mr. Moore was kind enough to give his take on the famous 1986 two-issue "last" Superman story edited by Julie Schwartz and penciled by Curt, which he authored. He also discussed a pastiche of The Man of Steel,* Supreme, *which he later wrote for Image Comics.*

*At right, the covers of the two-part story scripted by Alan Moore that drew to a close the Silver Age version of Superman — and Swan's thirty-plus year contribution to the character.*

**Zeno:** *What did it mean to have Curt Swan illustrate the "last" Superman story?*

**Moore:** It was especially magical to me to see Curt Swan and Kurt Schaffenberger on one of my Superman stories, just because both of them had been very special Superman artists in my particular firmament.

**Zeno:** *Do you remember when you were first exposed to Curt's artwork?*

**Moore:** I think so, although if I was to go back and check the issues, I might find out that it was Al Plastino. (Chuckle) I would have

been about seven years old, which would have been about 1959, 1960. At that time, the only American comic books distributed over here were distributed very haphazardly. I believe that they came over as ballast on ships. Thus, if you got one issue of a series, it was hit and miss whether you got the next three. I think the first American comic book I picked up was probably *The Flash*; either one of the early *Showcase* appearances or one of the first appearances in the new *Flash* comic. Pretty soon after that, I found that simply because of the number of books that were allocated to both Superman and Batman, I was able to develop quite a healthy buying habit on all of the early Superman books of that period. So I was very quickly introduced to Curt Swan's work. There were wonderful artists around then. People like Wayne Boring, who perhaps, looking back, I find it hard to choose between Wayne Boring and Curt Swan's interpretations of Superman. But Curt Swan to me was the essential Superman artist. Whether he was working on *Superboy* or *Superman* or any of the other books, there was something about Curt's line, the actual line itself. Especially if it was inked by a sympathetic inker. Probably the best Curt Swan inker was Murphy Anderson. This is all very subjective. I know there was something about the crispness of Murphy Anderson's inks which perfectly set off the just-so quality of Curt Swan's pencils. There was something about Curt's

Superman that was exactly right. The line was so clean; the three-dimensional figures were so perfectly placed. They had weight, they had solidity. And the whole world, there was a coziness to it, a warmth, a softness. Again, this is very difficult to actually describe because you're talking about the psychological effect of one artist's ink line over another. (Chuckle) But with the Superman books and with the ones that Curt did, I don't know; his Superman was always

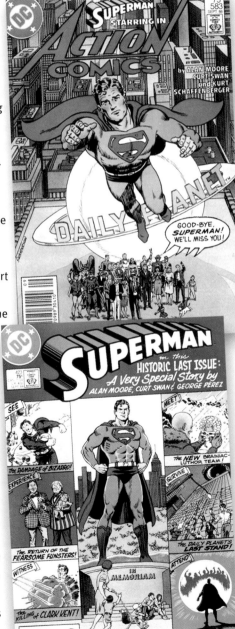

very avuncular. There was a slight fleshiness to him. He certainly wasn't a kind of hyper-steroid muscle man, as in the later 1980s and '90s incarnations of the character. His musculature was powerful but kind of soft looking. The fleshiness of his jawline, for example; it wasn't a chiseled jaw. There was this quite human softening of the flesh just under the jaw, which made him... He looked like your favorite uncle, a big brother, something like that. There was a paternal quality to him. Added to this, there was Curt's depiction of the milieu, the world that Superman existed in. The Kandor stories, the Krypton stories, the Fortress stories. All of the artists contributed, but there was something about what Curt did that in my seven or eight year old mind, was the very essence of what Superman was. Later, I discovered Jack Kirby, and I was at first repulsed by Jack Kirby's work because it was so much the antithesis of the kind of clean stuff that was being done at DC. Of course, I came to love Jack Kirby's work. But back then I almost thought of Jack Kirby as the anti-Curt. Jack Kirby's world had a rough, brick texture to it,

whereas Curt, like I say, it was warm, it was human. There was a precision to the lines but it wasn't a mechanical precision; it was a very human precision.

**Zeno:** *Did you know when you talked to Julie Schwartz that Curt would be illustrating your story before "handing over his pencil" to John Byrne?*

**Moore:** It's difficult to remember the exact sequence of events. I believe the actual conversation between me and Julie took place at the San Diego convention. I think we were having breakfast at the hotel. Julie told me that he was gonna be finishing off his run on the book in preparation to John Byrne coming in. And that he would like his last issue of *Superman*, his last issue of *Action*... He'd like to do a two-part story that tied up all the threads of the Superman mythology. Now Julie tells a very colorful version of this story with me actually leaping from my chair, grabbing him by the throat, probably punching him in the kidneys a couple of time, a couple of karate kicks, flinging him out the window, dragging him

back in again and roughing him up... saying that I'd kill to write this story. I may have said (laughter) that I would kill to write it. I don't actually remember carrying out physical violence upon a sort of venerated and venerable member of the comic book establishment. But there again, I was in San Diego; it was a bit of a blur. I'm not going to say it didn't happen, but as I remember it, it was pretty soon after agreeing to do the story that Julie said, "How do you feel about maybe Curt Swan drawing the last story?" And I was delighted; there's nobody I would've rather had do it because to me... I've gotta be frank—this is just my personal taste; I didn't like the John Byrne Superman run. John Byrne has done some wonderful art in the past; he's a very good comic book artist... but the approach to Superman to me, and again this is purely personal... I'm not making any kind of universal value judgements here. To me, the approach to Superman seemed wrong. As I remember it, John Byrne had adored the [first] Christopher Reeve *Superman* film, which looking back, wasn't that good a film. In much the same way that the *Batman* television show was allowed to disfigure the

*Swan's animals had just as much charm and elegance as his people — particularly Krypto and the other "super-pets" of the Weisinger era.*

I think that the things we read during our childhood, perhaps make that incredible lifelong impression upon us. But I'd been soaking up all of Curt's imagery for all those

*Swan's depiction of technology, as shown in the scenes on these two pages, was always fantastic and engaging. His work conveyed a strong optimism for the future that young readers found fascinating and appealing.*
All © DC Comics

years, so when it came time to write the story, then...Yeah! Right from the first page, I was kind of thinking Hmm... the *80-Page Giant*, the Silver Anniversary of Superman. Big silver statue of Superman on the front of it. And I was thinking, yeah, okay, so a big statue of Superman, that would be good. (Laughter) Yeah, first page: there's a big statue of Superman in the park, and then it kind of led on from there. And the characters that I included in the story were the ones that, to me, were what Superman was all about. And that included The Legion of Super-Heroes. I think it was Curt who did some of the first few Legion of

Super-Heroes stories, or at least the covers. So they were in there, in the rich stew of Curt Swan-related imagery. I had to get them into the story. And I always liked the

way that he drew Luthor. Again, they looked about thirty-five, forty. There was something about Superman back then. He was the same age as your uncle! He was thirty-five, forty, something like that. Still young and good looking, with a slight extra thickening to the features or to the body. Yeah, Luthor was like the wicked uncle (laughter); Superman was like a kindly uncle. So I had to get Luthor in there and Krypto. And things that I couldn't fit in, like Lori Lemaris or Titano the Super-Ape, I asked Curt to have either statues or pictures of them in the Fortress. Even if I couldn't work them into the story because it was too crowded, I could at least get in references to these great icons of the Superman mythos that would shortly be vanished forever.

**Zeno:** *What you've said is coming from a personal place, which is why it will be wonderful to have in the book.*

**Moore:** I loved the man's work! With someone like Curt, you always feel that you could probably talk all day and not really scratch the essence of what made him such a great artist. His stuff had such a powerful effect on me at such an impressionable and important age, and I don't really know how to measure that. Still, looking back over my career, those last two issues of Superman... They're [on] the very, very brief, short list of stories of mine that I'm proudest of. If anything, all the dreams of comic books that I had when I was a kid, if there was any particular moment in my career where I've actually (voice wavering) fulfilled my wildest dreams, then it probably would've been on those two issues of *Superman* and *Action*.

Even the name "Curt Swan..." If someone says it, then I am back on the handmade, little hearth rug in front of the coal fire, in the terraced house down Andrews Road that I lived in. It's 1960 and perhaps there's *The Arches*, a country soap-opera, on the radio. I'm not even sure if we had a television. And I'm either on the hearth rug or I'm sitting in some armchair with a little, tiny stack of three or four comics and the rest of the room has been completely shut out. And I am in Metropolis, I am in The Fortress of Solitude, I'm in the Phantom Zone. Curt Swan to me is so mixed up with all my childhood memories, that it kind of brings back this warm, juvenile glow.

Also, I've just remembered. I don't know if this is of any interest, but when Curt died, I think I was just on the verge of working with him

again. We were doing *Supreme* at that point over at Awesome/Extreme. It seemed as if DC had kind of thrown away all of the things that were actually endearing about the Superman concept. I figured, well, in that case they're all just laying there upon the scrap heap; I claim salvage rights. If

they're not using these things, I can. So we were trying to come up with something which captured the magic of the imagination of

some of those early Superman stories. We were doing these kind of flashback stories which Rick Veitch was handling most of, because he is very adept at mimicking the style of that old stuff. I think we'd gotten Jim Mooney to do a Suprema story, which was very much in the mode of the stuff that

Jim had done on Supergirl back then. And that was great! I think that we were talking about getting Curt Swan to do... It was perhaps something for what was going to be the *Supreme* eighty-page giant,

but which incomprehensibly turned out as two forty-page half giants, or whatever. But I think we were talking about getting Curt to do a sort of Superman flashback story. And I was thinking this would be terrific! We'd get Jim Mooney and Curt Swan, and all of these guys who'd kind of been squeezed out of Superman. And be able to give them some work—get to work with them again, more importantly. So I wasn't being entirely altruistic. (Laughter) Then we heard that Curt had died. A crying shame, although I'd done the one story — that final Superman story — with Curt. Probably, it was being greedy to expect to do another one. But that just came into my mind, that there was another Alan Moore/Curt Swan Superman-like story that just never made it. Maybe in heaven, if it gets published some way...

©2002 Curt Swan Estate

*BEST WISHES TO YOU, DICK.*

IT'S A MAN! IT'S A PLANE! NO, IT'S A BIRD-IT'S SWANMAN!

*Swan pokes fun at himself in this sketch for the fanzine* Differo *from 1968.*

*Swan supplies a lesson in how to draw from a story in* Superboy #10 (1950).

**Swan:** Well, I think that he didn't interfere too much, but if he saw that Weisinger was getting a little out of hand with the talent—the creative people, let me say it that way. Then he would jump in and side with them and say, "Hold off."

**Wrona:** *Right. Tommy Tomorrow, did you like doing that?*

**Swan:** Eh... Yeah, it was all right. It was kind of science fiction stuff.

Murray Boltinoff was the editor on that and he'd come up with some weird ideas for scripts that I didn't cotton to. [But] I got a kick out of John Fischetti, who became a political cartoonist. [He] was inking my stuff just to tide him over—you know, in between assignments. And he was just blowing his mind inking these pencils of mine and said to me one day, "Ask Murray why don't they put out a sequel to Tommy Tomorrow and call it 'Yetta Yesterday?'" (Laughter) So the next time I saw Murray... I'm very close to Jewish people, I want to preface this by saying that. And when I saw Murray I said, 'Hey Fischetti's got a great idea. You've got Tommy Tomorrow. How about Yetta Yesterday? And Murray didn't understand that. He blanched and had a few unkind words about Fischetti. (Laughter)

**Wrona:** *How about Carmine Infantino?*

**Swan:** He was easy to work with and I liked him. I think it's mutual. Again, he's another professional and he's got a unique style of drawing which I like because it's different. A nice personality and a general all-around nice guy.

**Wrona:** *Julius Schwartz?*

**Swan:** He's terrific. "A" number one.

**Wrona:** *The best guy you've worked for?*

**Swan:** Yep, no question about it. Absolutely! Just a beautiful man, beautiful human being.

**Wrona:** *No pressure?*

**Swan:** No pressure, and if he had any criticism, he would always preface it with some remark and soften it some way. Usually constructive criticism, and of course he knew my dealings with Mort Weisinger, so he knew exactly how I felt about my work and how I used to battle verbally. It isn't that he handled me with kid gloves for that reason... No way! He respected me; let me say it that way.

**McGinty:** *Who was it that came up with the idea of pairing you and Murphy Anderson, [beginning] in the late '60s?*

**Swan:** I don't know who it was exactly, but someone saw the similarities in our work and seemed to feel that it was compatible in that sense, as it turned out to be.

**Wrona:** *Did you always work exclusively for DC?*

**Swan:** Yes, yes, all that period with the exception of about six months I worked for an advertising studio.

**Wrona:** *Do you remember the year?*

**Swan:** I was living in Tenafly at the time... I should be able to put it together. All right now, let me see. My oldest son is 39. That would be uh... Five off that would be thirty years ago. What have we got, 1953, in and about there? Come on... everybody's falling asleep. (Laughter)

**Wrona:** *Was it because you were fed up [that you quit]?*

**Swan:** Yeah, the combination of Mort Weisinger and the work was getting to me. I was getting terrible migraine headaches and had these verbal battles with Mort. So it was emotional, physical. It just drained me and I thought I'd better get out of here before I go whacko. I discovered that working in the advertising studio wasn't that great [financially], although I liked the work itself. Fifty dollars a week! We couldn't hold things together; it just wasn't enough money.

**McGinty:** *I was wondering, there were a lot of changes after Mort left and the Superman books were broken up around [different] editors and they started changing the styles. Clark had more modern dress and whatnot. After awhile, Superman and Clark looked a lot younger.*

**Swan:** Yeah, definitely. I started to put lines on Superman's face to give him some character. Mort felt I was aging him tremendously. He wasn't the only one. So I agreed, eliminated the lines and you know, it's so difficult to show expression without lines. It's almost impossible.

**Wrona:** *Even a child requires lines to show expression.*

**Swan:** That's right, exactly! Even a bawling child... It ages a child about a dozen years.

**McGinty:** *I think Julie said at some point that Superman was 29 and that was the cut-off point.*

**Swan:** Yes, they nailed it at 29.

**McGinty:** *It also seemed to me that Clark looked a lot bigger in the '60s. In the '70s, he shrunk; his shoulders were less broad. Was that somebody's idea to differentiate the two periods?*

**Swan:** Oh, you mean the figure Clark? Yes, definitely. There was a period, of course, when men's clothes styles... with the broad shoulders, that was natural. Then it evolved; narrower shoulders.

**Wrona:** *You went with the styles, then?*

**Swan:** In a sense, unconsciously.

*A rare war scene by Swan from* Star Spangled War Stories *#8 (1953).*

*An invitation acceptance note for "Superman Day" in Metropolis. At the last minute, Curt had to cancel. (Courtesy of The Superman Museum in Metropolis, Illinois.)*

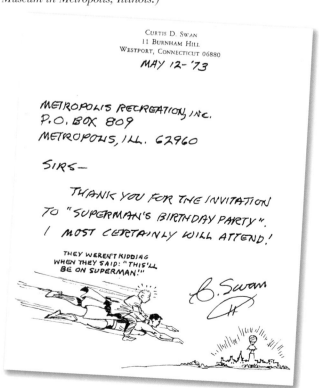

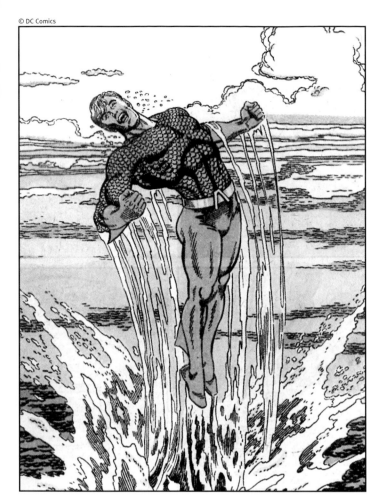

*At right a Swan "splash" page from his tenure on Aquaman.*

**Wrona:** *Was there ever a time, Curt, when you were at DC and felt that you sort of had it made? That they couldn't get rid of you because they depended on you for Superman?*

**Swan:** No, I don't think that was the reason. I felt secure. The reason I felt secure is that they thought they could assign me any job.

I don't know if I was that adaptable to that particular feature. (Laughter) It's just that production-wise they could count on me to produce that story and give them time. I suppose I'm assuming that some of the artists weren't able to do that. Although, they could have done as good a job or better.

**Wrona:** *Well...*

**Swan:** No, I'm serious. On that feature... the person probably just couldn't do it in that time.

**Wrona:** *Well, they had the best of [both] worlds because they had a really competent artist who met the deadlines. You've got to keep someone like that around.*

**Swan:** In that sense, yes, that's true.

**Wrona:** *You never had problems meeting deadlines?*

**Swan:** Very rarely. Occasionally Mort would catch me out on the golf course. (Laughter)

**Wrona:** *Did he come looking for you?*

**Swan:** No, no. He'd call the house and at that time, I think my wife wasn't working. She'd tell him, "Oh, Curt's on the golf course." And there he goes; right away Mort Weisinger smoking, smoke coming out of his ears. He's sitting in his office in the city, probably on a warm, muggy day and I'm out on the golf course. (Laughter)

**Wrona:** *Did he ever play [a round] with you?*

**Swan:** No... he kept to himself pretty much. He wasn't the easiest person to like, you know.

**Wrona:** *That seems to be consistent across the board.*

**McGinty:** *If someone met him on the golf course, he'd probably beat him. (Laughter)*

**Swan:** With the clubs. Exactly. There would be mayhem. (Laughter)

**Wrona:** *So in general, have you been pretty happy with what you've done all these years?*

**Swan:** I tell you, I feel pretty fortunate in being associated with DC. By and large I'd say, with the exception of one or two, I've been working with tremendous people. Met a lot of nice people along the way; one—Raul.

---

**March 14, 1996 (Phone Call)**

**Swan:** They've got me working on some Superman stuff here.

**Wrona:** *I picked up that* Swamp Thing *you did [#165 Apr., 1996].*

**Swan:** Oh, you did? Uh huh. Kind of weird stuff. Well, it's all pretty weird these days. (Laughter)

**Wrona:** *Isn't it, though?*

**Swan:** It's hard for me to uh...

**Wrona:** *Adjust?*

**Swan:** Adjust to it, exactly, but I'm getting a little more comfortable with it and...

**Wrona:** *Looks like you adapted pretty nicely to it.*

**Swan:** Thank you. [The] main thing is they're finally getting me work.

**Wrona:** *Right, and I also noticed that you've done some* Power of Shazams.

**Swan:** Yep. Uh huh.

**Wrona:** *So you're back on the trail again.*

**Swan:** Well, yeah. I have a couple of artist friends and they have figuratively twisted the arms of the editors to get me some work.

**Wrona:** *I've written a couple of letters myself thanking them [editors] for having you do some art.*

**Swan:** That's nice. **Wrona:** *What I'd like to see is if they [DC] could do*

a sort of "Classic Superman" with you on it for us old-time readers.

**Swan:** Wouldn't that be nice? All these little things, you know, don't seem like much but it does help and I appreciate it very much, Raul.

**Wrona:** *Curt, do you mind if I ask you some questions?*

**Swan:** Surely, go ahead.

**Wrona:** *It's just some stuff that I've always wondered about. When you first started at DC and took your portfolio down, who were the first guys that you spoke to?*

Mort Weisinger and Whitney Ellsworth. Whitney Ellsworth was the chief editor at the time.

**Wrona:** *Did they give you work immediately?*

**Swan:** Yes. They dug in the drawer and gave me a Boy Commandos.

**Wrona:** *And was it difficult for you to adapt to?*

**Swan:** No, not at all because it was really the first time that I had done comics and uh... But I was familiar with storytelling in the picture sense. And so it wasn't too difficult and in those days [the stories] were pretty mundane or quieter scripts. Not the sort of thing you have today.

**Wrona:** *Also, I saw an old issue of House of Mystery. It was number 1 and it looks like you've done a story in there called "I Fell in Love with a Witch!"*

**Swan:** (Laughter) Yes, in those days I did a variety of scripts. There were, I think, five or six editors in one office and if one didn't have work for me the next editor would open the drawer and hand me a script.

**Wrona:** *Another question: How did that whole system work out of you doing covers?*

**Swan:** Well, at the time that I did most of the covers Wayne Boring was uh... I don't know how to put this but he was disenchanted with the whole setup. Apparently, he was having difficulties with one certain editor and uh... he made the decision to move on to Arizona. And prior to that I'd been doing covers for *Superboy*, *Jimmy Olsen*, whatever they would throw at me. Then Mort Weisinger seemed to feel that I was uh... a strong person to do the *Superman* covers and so I did most of [them].

**Wrona:** *Did you sit down with Mort Weisinger and he would throw an idea to you?*

**Swan:** Oh, yeah.

**Wrona:** *At the office?*

**Swan:** Oh, yes. I went right in with the editor, in this case Mort Weisinger, and he would come up with a cover idea. Then we would discuss it and I would go into the art department, make a sketch and if he approved the sketch, then I would do the pencil sketch right there. Then Stan Kaye would stand by and he would ink it.

**Wrona:** *Did Mort ever get you to copy something. I remember that famous Jimmy Olsen Turtle Man where he's breaking that bridge [Jimmy Olsen #54]. You did that cover and it looked almost like an* Amazing Stories *pulp magazine.*

**Swan:** Oh yeah, that's possible. Uh huh. Because I really didn't understand what he [Mort] said. He wanted faceted... I said, "I don't quite dig this." I didn't use that language in those days. I probably

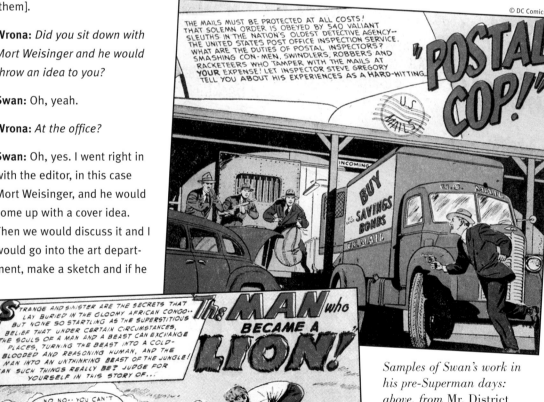

Samples of Swan's work in his pre-Superman days: above, from Mr. District Attorney #9 (1949) and at right from House of Mystery #29 (1954).

said, "I don't know what you're talking about, Mort." And he had apparently been into writing for pulps... science fiction stuff. And he must have had a copy there or something and pulled it out and showed it to me. And I said, "No problem, we can do that." And so that's how that got going.

**Wrona:** *I see. And what about your children? How did they feel about you doing comics? Did your daughters and son ever bring anyone home and say, "My father draws Superman?"*

**Swan:** Oh, they would occasionally. But their mother told them not to do that anymore. "Don't bother you father. He's making the grocery money for us and paying the mortgage." (Laughter)

**Wrona:** *Did you ever go to their schools?*

**Swan:** Oh, I did that, surely. I gave talks to classes. Then I had to put a stop to that because it was getting a little too, uh... The word would get out, you know, and of course art teachers would love to have someone like myself come in and give a talk to the children. And so I had to put a stop to it. I was getting too involved.

**Wrona:** *But your children must have loved them.*

**Swan:** Oh, yeah. (Laughter)

**Wrona:** *Quite a celebrity.*

**Swan:** Well, you know, they didn't think... eh, [of] comic book artists as celebrities, I don't think.

**Wrona:** *Really?*

**Swan:** No, not in those days. I was doing something that was very unique of course, but at the same time I don't know how they reacted to it. The expressions... I guess they were thrilled with... I don't know. (Laughter) To me, it was just bread and butter.

**Wrona:** *I understand. You were pretty unaffected by it all.*

**Swan:** Yes, exactly.

**Wrona:** *What about vacation time? How did that work out for you?*

**Swan:** Well, occasionally what happened... For several winters, we'd go down to Florida. My former wife's family had a place on one of the Keys. It wasn't theirs; they had a friend down there and they'd rent a cabin or whatever you'd call it on a little Key and we'd go there for a month's time. I'd take work with me and work while I was down there.

**Wrona:** *So there wasn't a time when you would take off for three or four weeks and travel somewhere?*

**Swan:** No, no, no. I couldn't afford it. They didn't pay very much in those days, Raul. And raising a family and everything was expensive. So I had to work the seven

*This Legion model sheet illustrates how Swan sought to give each group member distinctive characteristics beyond the differences in costume and hair style. Note the subtle facial differences between members. (From the collection of Steven Weill.)*

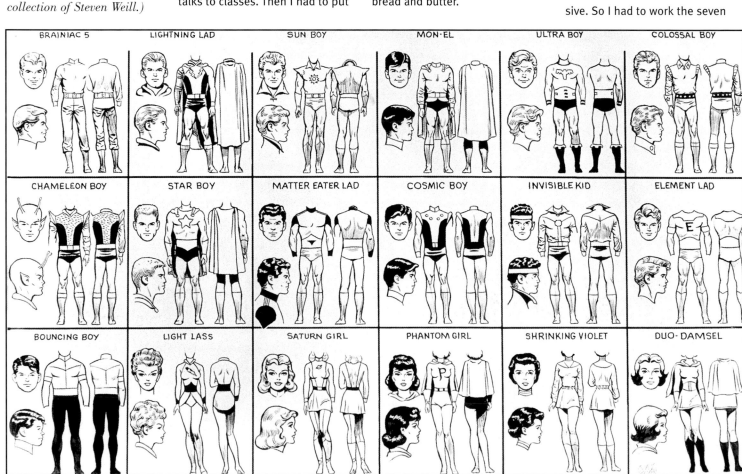

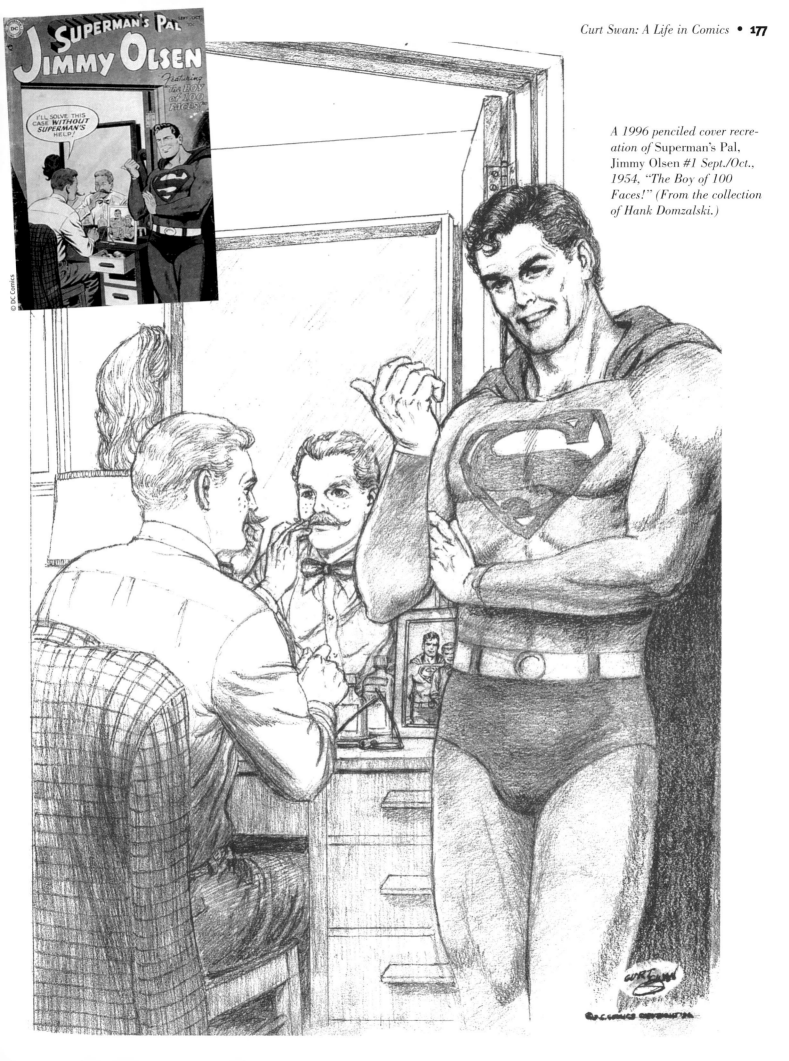

*A 1996 penciled cover recreation of Superman's Pal, Jimmy Olsen #1 Sept./Oct., 1954, "The Boy of 100 Faces!" (From the collection of Hank Domzalski.)*

QUICKLY, **LIGHTNING LAD** AND **STAR BOY** ARE DISPATCHED TO THE SCENE...

IT'S SOME KIND OF MUTATED MONSTER FROM THE DEEP!

YES... BLOCKING THE PLANT'S INTAKE VALVE...CUTTING OFF THE SOURCE OF THE WATER SUPPLY! BLAST HIM, **L.L.!**

*Swan's tenure on the Legion on Super-Heroes marked that feature's most fondly remembered period.*

days and long hours and take my work with me wherever I went. [When] I'd go to visit my family in Minneapolis, I'd take my work with me.

**Wrona:** *And then you mailed the submissions?*

**Swan:** Yes, I'd use the U.S. mail.

**Wrona:** *Did anything ever get lost?*

**Swan:** Fortunately, no.

**Wrona:** *That's amazing.*

**Swan:** Yeah, well it's not amazing but communication and everything was rather (laughter) primitive in those days compared to now.

**Wrona:** *But a lot more reliable, I guess.*

**Swan:** Well, it still is as far as I'm concerned, a safe way of sending work.

**Wrona:** *I noticed that you did a picture of yourself and Stan Kaye in one of the comics, an April Fool's issue [Superman #145, May, 1961]. It seems to me you drew yourself and Stan in a storeroom where Clark Kent was changing into Superman. Do you recall that?*

**Swan:** No, no I don't, [but] it wasn't rare that I would do this. I included my children in the crowd scenes... things like that.

**Wrona:** *Oh, is that right?*

**Swan:** Oh yeah, to get a reaction from my kids. It was fun to see how they reacted to it. And it broke the monotony, I guess, is a better way of putting it.

**Wrona:** *Yeah, yeah. I guess you heard that Jerry Siegel died?*

**Swan:** Yes he did. It's that time, you know. They're starting to pass away on us.

**Wrona:** *Well, I hope you're taking care of yourself.*

**Swan:** Oh, I take care of myself. I'm in great shape.

**Wrona:** *You sound great.*

**Swan:** I feel great.

**Wrona:** *When are you going out on the golf course?*

**Swan:** Ah, well, the weather is breaking nicely here. The sun is shining brightly and we're waiting for our dear friend Mort Walker to come back from Florida. Then we'll get back to the golf course.

**Wrona:** *You love that, eh? That's your passion, isn't it?*

**Swan:** It's a way of communing with nature and having fun with it.

**Wrona:** *Can you still do the whole eighteen holes?*

**Swan:** Oh, yes of course.

**Wrona:** *Then you are in good shape if you can do that.*

**Swan:** Why sure, I'm in fine shape. I'm in better shape than some of my younger artists around me. They're falling apart on me. (Laughter)

**Wrona:** *You've got staying power.*

**Swan:** Perhaps I've got a different... better attitude. My philosophy is a better way of saying it; that our brain is the control center in so far as our well being and longevity.

**Wrona:** *Curt, when you started drawing, did your style change? I mean did your approach to drawing change? In other words, did it get easier for you as you went along?*

**Swan:** Oh, yes. It got easier in the sense that I was never truly satisfied with what my drawing capability... ability was at that moment. So I knew and not only knew, but I made myself improve constantly. I always tell young people never, never believe that you've reached a plateau—that is, the best you can do. You can always improve. That was my attitude. And over the years, my goodness, I look at some of my early drawings and have to chuckle because it's really rather crude. (Laughter)

**Wrona:** *Well, I'll tell you, some of your older stuff had so much in the background I couldn't believe it.*

**Swan:** Yeah, I know. I drove the inkers crazy.

**Wrona:** *That Steve Brody, he didn't last too long, did he?*

**Swan:** He had health problems, too. I guess at the time that I knew him, he was a sickly person. Oh, I've got another call coming in. So I'll have to cut you short.

**Wrona:** *Thanks for the talk, Curt. So long.*

**May 17, 1996 (Phone Call)**

*When Raul Wrona and I spoke in April, 2000, we wondered if the following might have been the last interview that Curt did. At that time Raul also remembered a conversation from 1988 when Curt told him that he almost got into a bar fight while stationed in London during World War II. Some of his fellow military comrades didn't want an African-American soldier who had entered the bar to be served. Curt got all puffy as he told the others the guy had just as much right as they did to be there for a drink.*

*The initial part of the discussion which follows was about a commission that Raul had just received in the mail (seen at right). You'll see that there was some confusion as to whom was pictured with Curt and Mort Weisinger because Raul had asked for either George Klein or Stan Kaye to be depicted.*

**Swan:** Raul, how are you?

**Wrona:** *I just received the drawing. I love it!*

**Swan:** All right, glad to hear it!

**Wrona:** *There's Mort Weisinger in the background. I'm not sure; is the other fellow George Klein or Stan Kaye?*

**Swan:** Oh (chuckle), that's Murphy Anderson.

**Wrona:** *Murphy Anderson?*

**Swan:** Ha Ha Ha. I think I got a reasonable likeness, but maybe you haven't seen him before.

**Wrona:** *I thought it was him, but I wasn't sure.*

**Swan:** Okay. I'm not too good at that, Raul.

**Wrona:** *Well, it looks great. I've seen Mort and it's a dead likeness. Of course, you caught yourself beautifully, too.*

*Raul Wrona commissioned Swan to do this portrait of Mort Weisinger (left) and Murphy Anderson (right) peering over the artist's shoulder.*

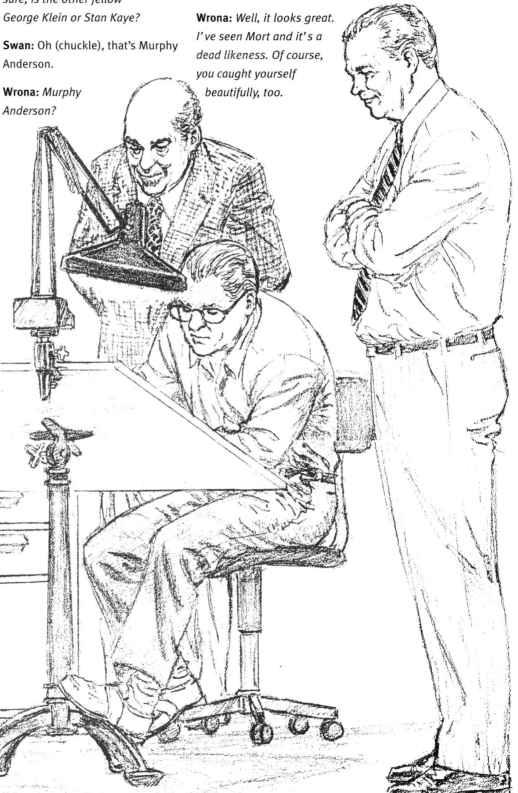

©2002 Curt Swan Estate

*A Swan sketch of the cast of characters he brought to life for several generations of readers (1985).*

**Swan:** (Chuckle) He's [Mort] a difficult one to get, and of course, I thought I'd get Murphy Anderson fairly easily, but apparently I didn't.

**Wrona:** *It's just that I wasn't expecting Murphy. But you really did catch him, no question about it. I was wondering if I could ask you something. Have you got time? It's mostly autobiographical stuff.*

**Swan:** Surely.

**Wrona:** *You were talking to me last time about Steve Brody. What is some general background about him?*

**Swan:** I didn't know too much about Steve Brody. He was the first renderer that did my pencils. I worked on Boy Commandos. And he was a good teacher. There were a lot of things I didn't know about doing comics. I was putting too much detail on each page and it was breaking his hand. (Chuckle) So he got ahold of me one day and gave me a few pointers that were very helpful.

**Wrona:** *Was he around your age?*

**Swan:** No, no. He's older. I'd say he's gotta be about 86... 87 [approximately 10 years older than Curt was].

**Wrona:** *Did he have other aspirations or was this a side thing?*

**Swan:** I don't know. He went down to Arizona and I believe got a teaching job in some school.

**Wrona:** *He stayed rendering your stuff till about when?*

**Swan:** Oh, golly, that's pretty hard to say. I'd say... he started on my stuff in '45; he worked on my stuff about three years. So that'd be about '48... '49. Soon after that, he moved to Arizona. I didn't know him personally; that is, we didn't socialize nor did we get into each other's family background.

**Wrona:** *What about Stan Kaye?*

**Swan:** We worked on covers together and he worked on some of my stories. Since I would be coming up from New Jersey, I would stop over at his house in a suburb of New York City... I got to be like part of the family there. He was wonderful; we got along famously!

**Wrona:** *Was he around your age?*

**Swan:** Yeah, he was about my age.

**Wrona:** *Did he have any other aspirations?*

**Swan:** He liked fine arts and he was offered a position at a museum somewhere in Washington, D.C. He turned it down because he didn't feel he had the qualifications. So that was about it.

**Wrona:** *What about George Klein?*

**Swan:** Well, George Klein... There again, he and I got very close. He was an only child; he didn't have any brothers or sisters. And he lived close to the office, so when I'd go into the city, I spent a good deal of time with George.

**Wrona:** *Was he around your age, too?*

**Swan:** I believe he was a little younger.

**Wrona:** *What was his background?*

**Swan:** Oh, he went to art school; I don't know which.

**Wrona:** *Did he have other aspirations?*

**Swan:** He liked to do oil paintings.

**Wrona:** *Was he good at it?*

**Swan:** Quite good, uh huh. He, like myself, and I guess most of us in this business... The comic book business was our lifeline, and so to have other aspirations was a little (chuckle) too far out.

**Wrona:** *I thought it might've been sort of like a pit stop, in order to gain some experience, then try something else.*

**Swan:** No.

**Wrona:** *When you were doing Tommy Tomorrow, do you recall who was the inker? I think you mentioned John Fischetti did some.*

**Swan:** Oh, yes, John Fischetti inked my stuff.

**Wrona:** *Did he do most of the Tommy Tomorrows?*

**Swan:** Uh... I believe he did. Yeah, he did some of the Tommy Tomorrow inks.

**Wrona:** *Did Mort Weisinger have any preferences when you were doing covers? For example, did he have recurring themes that he really enjoyed? I know that he liked when you went back to Krypton?*

**Swan:** Yes, yes. And usually he selected the cover before they plotted the story. You'd have the cover idea and then the writer and he would sit together and plot the story.

**Wrona:** *In the drawing that you sent me, he's sort of hovering behind you. Is that how you worked?*

**Swan:** (Laughter) Oh, no, no. He was quite generous. He wasn't terribly critical of my work. We... we got along fairly well. He didn't have much input into my penciling.

**Wrona:** *When you did the covers in the studio...*

**Swan:** I did them in the city.

**Wrona:** *Right. Did you do more than one?*

**Swan:** Oh, sometimes I'd do two or three covers.

**Wrona:** *In one day?*

**Swan:** Oh, yes. And Stan Kaye, he would ink them.

**Wrona:** *That was pretty quick!*

**Swan:** It wasn't. We would probably get out of the office about 6 or 6:30 and we'd go have dinner.

**Wrona:** *Did you personally help anybody in the art field? Did people come to you and ask for advice?*

**Swan:** Oh, I've had that happen but not to any great degree. So I can't say I've helped anybody, really. I would look at their art and have suggestions, but that's about it.

**Wrona:** *Do you recall in 1966, I believe they went to a smaller page size, something similar to today? Did that affect your art in any way?*

**Swan:** Fortunately, since I had a talk with Steve Brody and left out a lot of the detail, going from the large page to the smaller page wasn't that difficult. As a matter of fact, It brought in a new discipline where I had to eliminate a lot of the detail I formerly would put in.

**Wrona:** *Did that make it easier for you?*

**Swan:** Oh, yes, absolutely!

**Wrona:** *What would you do when you would have an artistically "cold" day? Did you just put everything down, pick up the golf clubs and head out?*

**Swan:** I'd go outside; I'd do anything... get away from the drawing board.

**Wrona:** *And when you came back, it would just sort of pop in?*

**Swan:** Not necessarily. Generally, it would be the next day.

*A tribute to Swan was published in the* Asbury Park Press *in two installments shortly after his death in 1996.*

**Wrona:** *And when you were really hot, I guess you didn't want to leave it?*

**Swan:** I stayed right at it into the wee hours of the morning.

**Wrona:** *So you put in some pretty long days?*

**Swan:** Oh, yes.

**Wrona:** *Did you have a minimum amount of pages that you would set per week or day?*

**Swan:** I tried to produce a minimum of two pages a day.

**Wrona:** *I just did a compilation of the amount of art that you did on* Jimmy Olsen. *I counted 1,855 pages and 127 covers. That was just* Jimmy Olsen!

**Swan:** (Laughter) That's a lot of work.

**Wrona:** *What did you think of Ray Burnley?*

**Swan:** Uh... Well, there were two brothers, the Burnley brothers; I'm trying to sort the two out. Ray Burnley—is he the one that did rendering on my stuff.

**Wrona:** *Yes.*

**Swan:** Well, I wasn't terribly fond of his work.

**Wrona:** *I agree with you. He sort of hid a lot of your stuff [and] was sort of scratchy. He didn't have a definite line.*

**Swan:** No, he didn't.

**Wrona:** *And I recall having read that article by Eddy Zeno [before Raul and I met].*

**Swan:** Wasn't that nice? A nice young man.

**Wrona:** *He's a big fan of yours, also, isn't he?*

**Swan:** Oh (chuckle), a wonderful fan. I told him one time at a convention and people were standing around... I introduced him as my adopted son. (Laughter) That struck home with him.

**Wrona:** *Well, it was a heartfelt thing that he wrote. I heard you're doing some Superman stories now?*

**Swan:** I did a few pages the other day. Then I just finished a story a little while ago. Uh... I don't know what the title is. I've got a terrible memory here. I don't think about it— you understand?

**Wrona:** *I understand. Are they throwing more work at you now?*

**Swan:** Oh, I'm getting a little more work now, yes.

**Wrona:** *I guess that makes you happy, eh?*

**Swan:** Oh, you bet! Gotta pay the rent, you know?

**Wrona:** *When are you gonna play golf?*

**Swan:** We were supposed to play yesterday, but got rained out.

**Wrona:** *Watch your back.*

**Swan:** Oh, my back's in fine shape. It's my ears [hearing] I'm having problems with.

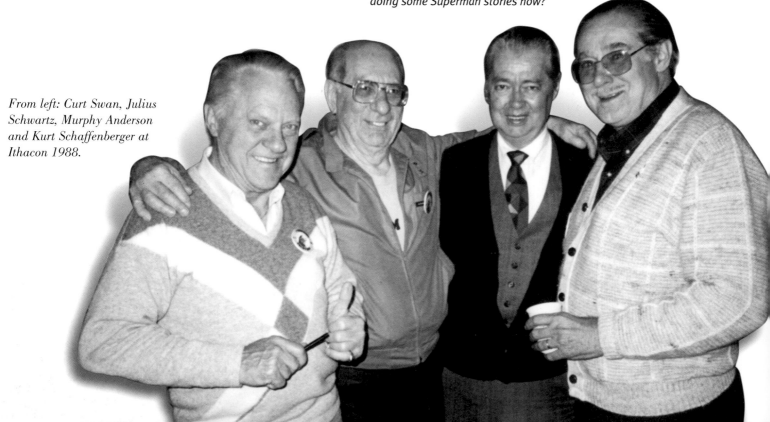

*From left: Curt Swan, Julius Schwartz, Murphy Anderson and Kurt Schaffenberger at Ithacon 1988.*

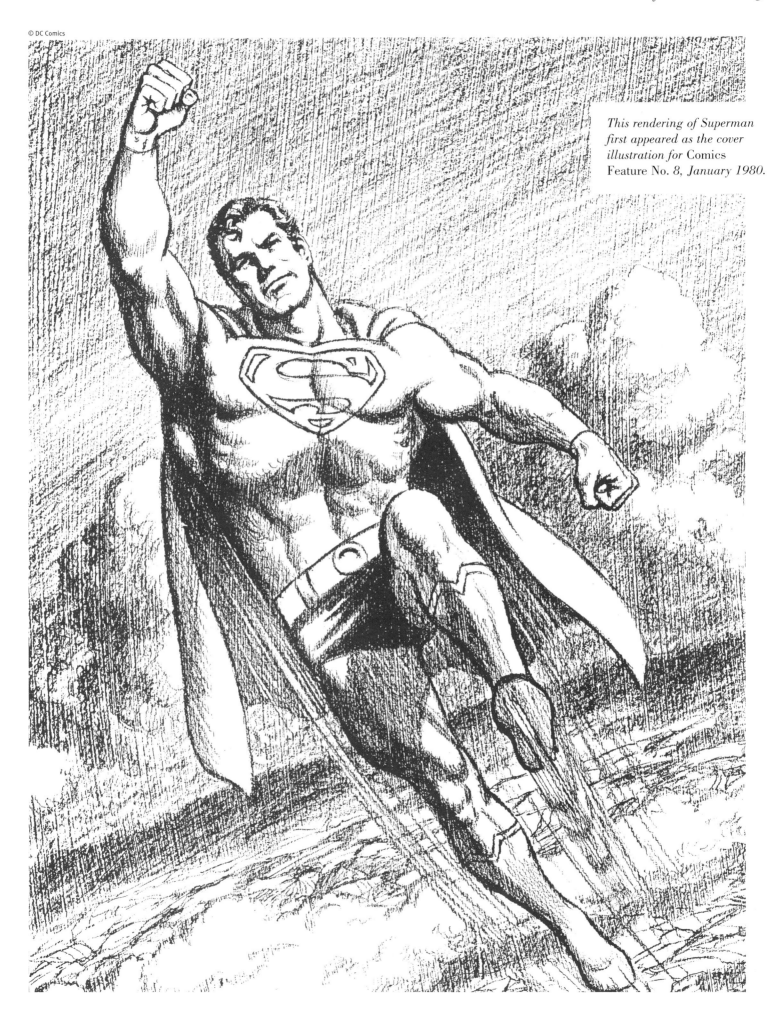

*This rendering of Superman first appeared as the cover illustration for* Comics Feature *No. 8, January 1980.*

*Opposite: Swan's cover pencils for the unpublished collection* The Greatest 1960s Stories Ever Told.

probably has something to do with the fact that both men went under-appreciated for much of their careers. But as comic book writer Roger Stern noted, "Both were very accomplished artists who were often underestimated in the range of what they were able to do."

Through nearly his entire working life, Rockwell chose not to paint anything "sordid," as he put it, portraying an idealized America. Under the editorial direction Swan received at DC (Comics Code Authority playing little if any part) along with his personal beliefs, he drew countless cover and interior scenes which also portrayed a

gentler way of life. My brother alluded to Curt's occasional picnic cover scenes as perfect examples. Swan indexer Raul Wrona, who grew up in Toronto, noted the *Superboy* comic book. "Curt's rendering of the Kent's General Store with its well stocked shelves and the town with its water tower were a place any kid from the big city would have loved to have grown up in." Roger Stern said, "There are parallels to Norman Rockwell, in the way he captured Americana." Swan's oldest daughter Karin noted how fitting it was that her dad eventually became known as the definitive artist of Superman, a character who symbolized the ideals of "truth, justice and the American way."

## QUIET PRIDE

Regarding how Swan himself felt about his occupation, cartoonist Mort Walker was right when he said his friend was "complicated." Curt indicated there were days he could only plod wearily through an assignment, especially if he didn't care for the tale he was illustrating. Yet, it's clear that at other times he was content with his lot in life, including his job as a comic book artist. He had a quiet pride in his work. Though Curt once mentioned suffering "burnout," he quickly added that he was just kidding. And one could tell by what he wrote or said that he knew he drew Superman well. To say that

©DC Comics

Swan was self-effacing is putting it mildly, though he exuded confidence when he discussed his ability to render a particular story. He enjoyed knowing that he made a lot of kids happy through his art. And there was literally a gleam in Curt's eye when he pointed out how he nailed a particular look that he was aiming for in a sketch he once drew.

As stated by those who knew him, Curt sometimes expressed his desire for more work during the last few years of his life. But he also wrote that he was as busy as he wished to be, content to have a little more time for family, friends and golf. When his health began to let him down, he remained upbeat most of the time, obviously preferring not to complain. In some ways a hard life, in other ways a good life, as is true for most of us. Pro football coach Mike Ditka once said, "Life is playing hurt." I thought of Curt when I heard that statement because no matter what was transpiring, he always produced artwork of the highest caliber. As Roger Stern said in his interview when discussing Swan's output, "There were no valleys." The fact that his work appeared for over fifty years makes that quite a testament.

*Below: A sidewalk memorial from the Swan children. Appropriately, their donations went toward funding a walkway on the Saugatauk River in downtown Westport, Connecticut.*

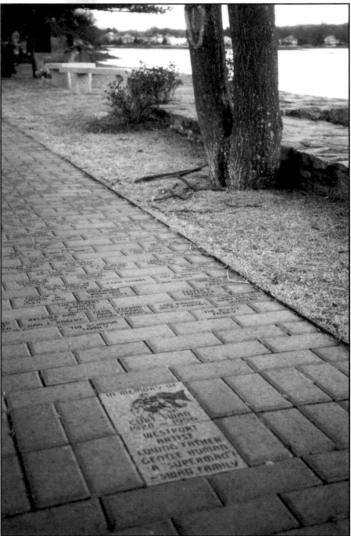

# Afterword: Thoughts and Remembrances

*Clockwise from top left: Eddy Zeno, Curt Swan, Michael Zeno, Julius Schwartz and Murphy Anderson (1993).*

## A FAN'S PERSPECTIVE

I first wrote to Curt Swan c/o DC Comics in late 1979, requesting an original cover by him from one of the great 1962 through 1964 two or three-part Silver Age novels. There was nothing to lose by asking. Of course, if it wasn't possible to grant my request I let him know his autograph alone would be cherished.

Several months passed and one day while home sick from work, the perfect antidote arrived for what ailed me. It was a contemporary page of art from *Action* #505 inked by Frank Chiaramonte with attached letter signed and dated April 3, 1980:

*"Dear Eddy, Merry Christmas!?! How about: 'Happy Easter!?' Sorry to be late in responding to your nice letter, dated Dec. 2, 1979."*

*"Sorry that I can't fulfill your request for certain covers done years ago and inked by my dear departed friend, George Klein. However, please accept the enclosed originals with my best wishes. Again, thanks for your nice letter and kind thoughts."*

We continued to communicate primarily by mail over the ensuing years. The 1987 Mo-Kan Spring Comics Festival, sponsored by the Kansas City Comic Book Club, was one of three occasions I had the privilege of meeting my friend. Immediately upon arriving home after Mo-Kan, I recorded my impressions:

Finally met Curt Swan in person on Sat., May 2. He was as kind and gentle in person as I'd gathered from our written correspondence over the past seven years. He was sixty-seven years old and looked healthy. He had a distinguished head of hair with some blonde still present with the gray; the way it receded on the side that was parted was handsome. He wore dark-framed glasses to draw, not when walking around. Curt smoked, and I believe the cigarette brand was NOW. He wore a pink polo shirt and blue jeans and looked most comfortable.

When I nervously introduced myself, he said something like, "Eddy, it's so good to see you." His hand went out immediately. Curt was a "touching" person, and several times he gently grabbed my arm to communicate in a more caring way. After doing sketches for two couples, he asked if they wanted him to inscribe, "To Mr. and Mrs. ..." before signing his name. He was very polite.

He apologized for not having answered all of my letters. I told him I was grateful that he had written as often as he did, adding, "I don't know how you've been

©DC Comics

able to put up with the pressure of deadlines for so many years." He said, "It's taken its toll." Curt also said his output had decreased because he did not draw as quickly as he used to.

Swan produced quite a few sketches for fans that day, including at least two of Wonder Woman. He drew on a large vellum type of notebook and inked with a felt pen (not a thick line). One piece had Superman in one of his classic flying poses holding a round, Brainiac-style flying saucer aloft. As he stuffed money received for the drawings into his shirt pocket, he said something like, "I feel like a carnival barker guessing peoples' weights." Then he mentioned working in a carnival as a boy.

Convention co-chair and fellow artist Mike Worley was sitting next to Curt for awhile. I heard him comment that he was watching him draw in order to improve his own skills. DC's Paul Kupperberg was there promoting his new *Doom Patrol* series set in Kansas City. He said that John Byrne's rendition of The Man of Steel was nice but it was Swan's Superman that came to mind whenever he thought about the character.

At Curt's urging, my wife and daughter accompanied me to the con the following day. When we arrived Sunday morning, Swan was already there with no one around him. It made him appear more human when I saw a small coffee stain on his pink polo shirt, which incidentally, was the same one he'd worn the day before. Obviously, he'd forgotten to pack another. I asked if we could be photographed together, wondering

if I was becoming a pest. He was most congenial and never appeared bothered. He told "Mrs. Zeno" and my daughter Mallory how nice it was to meet them while coming from behind his table. Curt borrowed a large Superman cardboard standee from a dealer, saying, "I draw him, you know," and placed it on a chair. We stood on either side of the figure and shook hands in the middle. Later that morning my wife asked me if she should photograph him sketching because there might not be another chance. Regretfully, I declined the offer, not wishing to bother him further. As we proceeded to exit, the artist sat alone at his table once more, preparing yet again to render that classic twentieth century mythological hero whom he knew more intimately than most.

The next time we met was in June, 1988 at the International Superman Exposition in Cleveland, Ohio, home of Jerry Siegel and Joe Shuster at the time they created Superman. Swan looked good, very healthy. He had no problem balancing at the edge of an elevated stage, kneeling to field questions at his 5:30 p.m. Saturday talk.

As comics writer Mark Waid (around that time the editor of *Who's Who in the Legion*) introduced Curt to the audience, he related this anecdote. When artists were asked to contribute to a publication such as *Who's Who*, they had to follow strict guidelines to fit a drawing into the allotted space. This, so it would not have to be expensively enlarged or reduced. The production staff always got a kick out of opening Curt's submitted work to see how

he placed his figures perfectly within the parameters allowed.

While speaking at the above mentioned informal one-man question and answer session, Swan described himself as extremely lucky his whole life, as modest men of accomplishment often do. He told how fortunate he was to have worked at home while his children were growing up.

There was mention of coming from an artistic family. Raised in Minneapolis, Minnesota with its harsh winters before the age of television, the kids found ways to occupy themselves while stuck indoors. They often drew animals and other objects to see if they were recognizable when held up for the others' inspection. Curt added how fascinated he, his brothers and sisters were that their father could draw beautiful peacocks. His two sisters later went to art school.

At the convention, Curt reemphasized that Al Williamson was his favorite inker, but added how much he liked Dick Giordano's inks, also. He stated that his good friend Murphy Anderson had a heavier style than the other two gentlemen.

A panel of Superman collaborators Saturday afternoon included Mike

*A Superman statue sculpted by Bud Bortner of The Kansas City Comic Book Club (for which this was the prototype) was presented to Curt at an awards ceremony in 1993.*

*This unpublished Superman page, done in 1991, combined the best of the Superman mythos down through the years. Curt did all of the artwork including the lettering.*

Carlin, George Pérez, Jerry Ordway, Kerry Gammill, Roger Stern, and of course, Curt. He received the loudest and longest applause when introduced. When Swan modestly said that he had nothing to contribute because he was not a writer, merely a penciler, Pérez intervened. He stated that his favorite work on a comic book story to that time was the only one of Swan's that he ever inked: "What Ever Happened to the Man of Tomorrow?" in *Superman* #423.

The last time I saw Curt was at the Kansas City Comic Book Convention, November 6 and 7, 1993. My brother was able to accompany me for the first time.

The first night, at an awards banquet, Curt received a Superman statue, given to the guest of honor by the K.C. Comic Book Club. The statue, we were told at the banquet by Mike Worley, was 90% bronze and 10% plastic. It sat on a rounded wood pedestal with a red "S" surrounded by a silver border on the front. The inscription was a wonderful tribute to the man, but I don't remember the exact words. Jim Shooter was one of the speakers and he waxed eloquent about what it meant to have worked with Curt on The Legion of Super-Heroes. When Swan finally came forward to accept the statue, he was so overcome with emotion that he wiped away tears on his sleeve several times. He finally uttered, "I can't speak; thank you." On the way back to his seat, he patted and one-arm hugged Murphy Anderson, then kissed Helen Anderson, Murphy's wife. Everyone at his table congratulated him; I believe he also hugged comic book artist Rick Stasi, seated to Curt's right. Julie Schwartz was not able to attend, eating a Kansas City steak while out visiting friends.

Another great thing to see at the con was how excited all the young comic book artists were when asked to pose for a photo with Curt. The group included Mike Manley, Phil Hester and Ande Parks and they spoke about how "cool" it was while walking back to their respective tables. One artist lamented that a great artist like Curt Swan couldn't get a

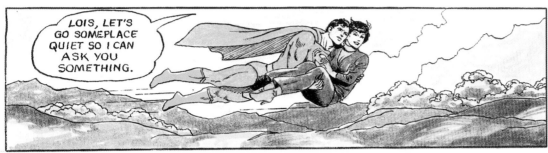

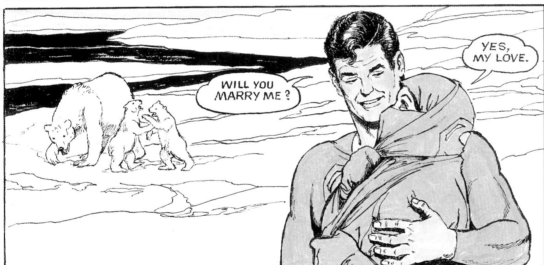

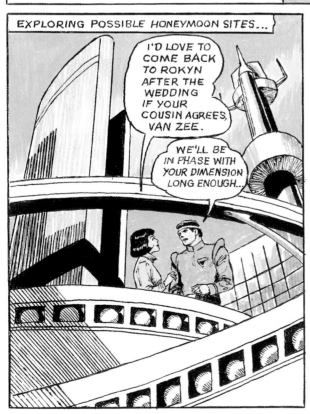

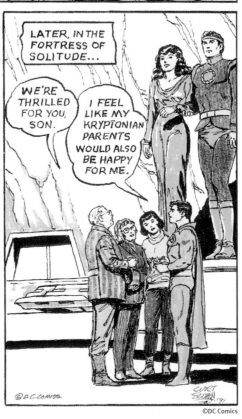

©DC Comics

penciling job at that time, saying, "It sucks."

Swan was occupied almost the entire two days talking to fans of all ages. Even kids had Silver Age comics for him to autograph. Curt also had a stack of Superman prints for sale that steadily dwindled at $5 a pop.

Swan told us about a dream of his. His dear friend, Mort Walker, hoped to offer him a job teaching the art of drawing comics soon after the International Museum of Cartoon Art opened in Boca Raton, Florida. He hoped moving south would help the arthritis in his low back and implied that it would be great to play golf year round. I said maybe he could take me to the links when I visited. Curt said something like, "Let's hope I get there to do that," but he never did.

## THE ANNIVERSARY DRAWING

The year 1995 was Curt's fiftieth anniversary as a comic book artist. I wanted to do something special for him, and so wrote a tribute which eventually saw print, thanks to *Comic Buyer's Guide* editor Maggie Thompson. This occurred in issue #1153, December 22, 1995. Back in '94, I had asked Swan to consider drawing himself surrounded by characters whose series he had illustrated during his illustrious career. It was further suggested that such a drawing be published with an accompanying article about him. On July 19, 1994 he replied, "I truly appreciate your concept of a cartoon commemorating my upcoming 50 years with DC. But, somehow, I feel uncomfortable illustrating or 'blowing my own horn' on the occasion. Like to think someone at DC will take the initiative to 'celebrate' the occa-

sion when it happens. Please, if the anniversary passes unheralded, I won't be upset. You see, since I haven't received an assignment from any of the editors for some time, my feeling is that, in their (EDITORS) eyes, I've been put out to pasture... My main concern at this time, is to remain on their corporate medical/dental insurance plan. That, to me, is far more important than accolades." Since I couldn't do anything about health benefits or the work that Curt was receiving, I continued to pursue the idea of honoring him with an article. By December 18, 1994, he agreed to do an illustration, but without mention of having it printed for the masses. Curt wrote, "I'll be happy to do the drawing as you request — and I will need reference of the Commandos and Tommy Tomorrow. I would suggest that a tight pencil would be appropriate if that's all right with you." The drawing was completed in January, 1995. It took a few months longer for Curt to change his earlier stance regarding its publication. On April 24, 1995 he relented, writing, "Please carry on with your profile of my career. It reads beautifully and the chronology seems quite accurate. When it is published (and if), I truly would appreciate a copy. You've filled in many gaps in my fuzzy memory so that I would find it a useful source. I am well and working no harder than this old hand can manage. Content to do just enough to pay the bills plus a few rounds of golf with my fellow cartoonists... P.S. Yes, use the anniversary drawing." (See page 9.)

## POSTSCRIPT

There were many highlights to Curt Swan's comics career. In the earlier course of this book, four of

them were called "zeniths," though by definition there can be only one. Let me tell you why I chose to pluralize that word, improper though it may be.

Since it's so subjective, who's to say when Curt's work reached its apex or zenith? Perhaps it depends upon one's age when first exposed to the man's work. Friends slightly older, who found these comic books sooner than I, often prefer Swan inked by Kaye while I prefer Klein. This has something to do with the fact that I first encountered Superman in comic books at age seven during the summer of '63 when Kaye was already gone. For myself and others

weaned on stories of that vintage, Klein was there as the expressively noble Man of Tomorrow became the ultimate role model. Of course, those comics fans who came a little later have often expressed their preference for Murphy Anderson inking Swan.

There's another reason to use the word "zenith" as opposed to say, for example, the word "peak." Zenith conveys something higher, loftier. As the wonderful author and Julie Schwartz's friend Ray Bradbury might say, it's a term full of "zest" and "gusto." And finally, though pluralizing the word involves the blatant use of hyperbole, this is about a comic book artist, after all!

*Swan's illustration for a comic convention program cover.*

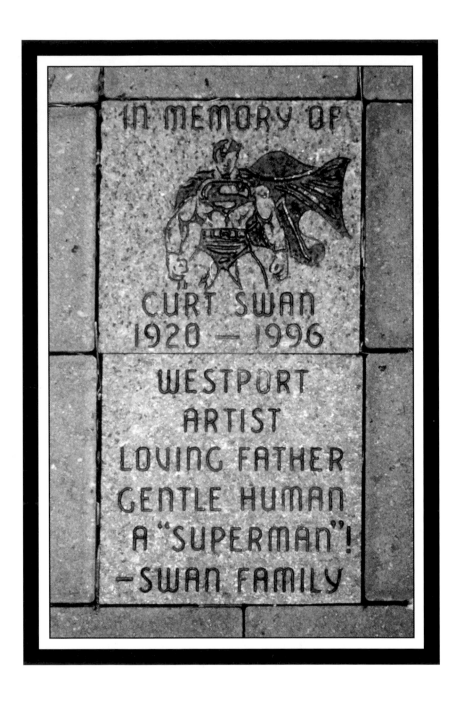